A GOLDEN AGE

A GOLDEN AGE

ART AND SOCIETY IN HUNGARY 1896–1914

Gyöngyi Éri - Zsuzsa Jobbágyi

With Essays by

Iván T. Berend

Lajos Németh

Ilona Sármány-Parsons

Published by Corvina / Barbican Art Gallery
Center for the Fine Arts, Miami

THIS PUBLICATION ACCOMPANIES
A Golden Age: Art and Society in Hungary 1896–1914,
an exhibition organized by Barbican Art Gallery
Corporation of the City of London,
with the Hungarian Ministry of Culture and the Hungarian National Gallery,
and the Center for the Fine Arts Association, Miami

Selection by GYÖNGYI ÉRI and ZSUZSA JOBBÁGYI
UK co-ordination by CAROL BROWN and JOHN HOOLE
US co-ordination by ROBERT FRANKEL

Barbican Art Gallery, London,
25 October 1989–14 January 1990
Center for the Fine Arts, Miami, 16 March–27 May 1990
and San Diego Museum of Art, 10 November, 1990–5 January 1991

We should like to thank Steven L. Brezzo, director,
San Diego Museum of Art, for his assistance and
participation in the exhibition.

Designed by János Lengyel

Translations by Zsuzsa Béres and Peter Doherty

Text revised by J. E. Sollosy

Distributed in Europe by Barbican Art Gallery
and in USA and Canada
by the Center for the Fine Arts, Miami

Cover illustration:
Aladár Körösföi Kriesch:
The Fountain of Art 1907 (Detail)

ISBN 0 946372 15 2
ISBN 963 13 2925 9

Contents

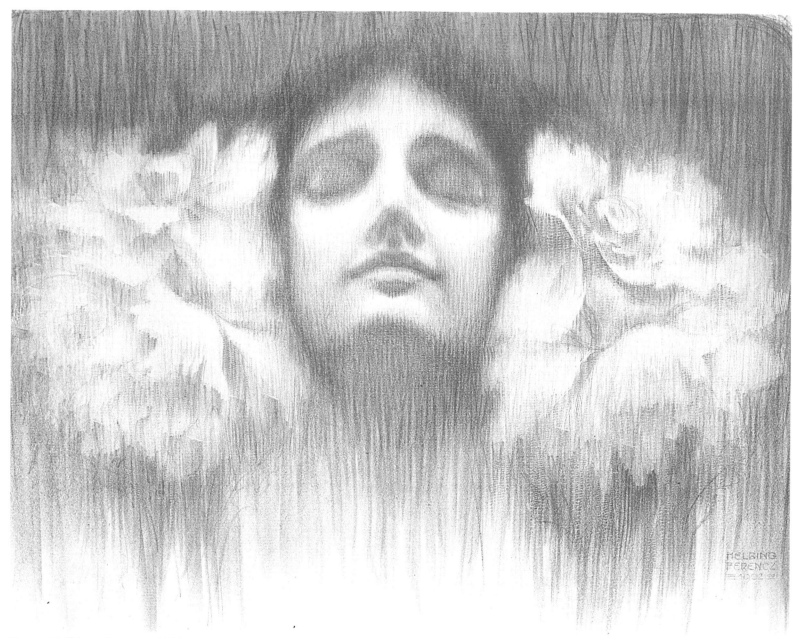

Ferenc Helbing: *Dream c.* 1900
Colour lithograph on paper, 44 × 35 cm
Hungarian National Gallery, Budapest

Preface

Since 1945 Hungary has seemed a distant place to Westerners. Today a Western tourist might stroll around the centre of Budapest and remark with surprise that the famous Chain Bridge was designed by William Tierney Clark, a British engineer, and fabricated in 1842–1849 by Adam Clark. An even more observant stroller will register that the building on the Pest side of the Danube that one faces as one crosses this bridge, with its gilded and statue covered façade, colonnaded upper story and pinnacled corners, which mark it out as an outstanding example of Hungary's distinctive brand of Art Nouveau architecture, bears in the centre of its façade the name and image of Sir Thomas Gresham, Lord Mayor of London. It was built in 1903–1916 for the Gresham Life Insurance Society Limited, and was designed by the Hungarian architect, Zsigmond Quittner. Such collaborations serve to illustrate the strong commercial and cultural links between Britain and Hungary that developed during the nineteenth century and reflect the rapid expansion that took place especially in Budapest towards the end of the century, when the country began to flex its financial muscles and to seek an independence from the Habsburg yoke.

The art of late nineteenth-century Vienna has long been recognized as a brilliant flowering of native talent, yet the developments during this period in Hungary, the smaller, but distinct half of the Austro–Hungarian empire, have been rarely considered so significant. A pioneering exhibition on this subject was held at the Hungarian National Gallery, Budapest in 1986 and it re-awakened among the Hungarian people an awareness of a long forgotten past. Now *A Golden Age–Art and Society in Hungary 1896–1914,* at Barbican Art Gallery, the Center for the Fine Arts, Miami, and the San Diego Museum of Art, attempts to recreate the original exhibition for British and American audiences, showing how artistic developments in Hungary paralleled those in Austria.

A Golden Age follows a number of exhibitions at Barbican Art Gallery that have reassessed previously overlooked periods of art production. It also offers to viewers in the United States the first comprehensive examination of this extraordinary work. Yet it is an exhibition that reveals a divergent culture that yearned for independence from the Habsburgs and, in an era of dynamic change in Eastern Europe, this awakening of Hungary contributed sharply towards an alteration in the balance of power across the continent. Not until 1918, in the aftermath of the Great War, was this freedom finally achieved.

The late nineteenth century was a time of rapid expansion in Hungary. An economic boom strengthened the country and with it came advances, not only in the arts, but in technology and the sciences. 1896 saw the staging of the Millennial celebrations which commemorated the arrival of the Magyar people in the Carpathian basin a thousand years previously. It was a spectacular display of general prosperity, but importantly, also identified a national history. The Austro–Hungarian Compromise of 1867 had given a measure of autonomy to the Hungarian people, and in the arts a new Romanticism appeared.

This search for a national identity was to characterize the visual arts at the turn of the century. Folk art and legend as well as Far Eastern art and architecture were important sources of a cultural heritage; for example, the influential architect Ödön Lechner, represented in this exhibition, derived forms and motifs from the architectural vernacular of Transylvania. A particularly rich and inventive style of Art Nouveau architecture characterized the extensive building programme which took place in Budapest following a study of European town planning. With its fine bridges, boulevards and new architecture, Budapest was firmly placed as a city of considerable beauty and importance alongside its counterparts, Berlin, Paris, and Vienna.

In the fine and applied art works by Tivadar Csontváry Kosztka, János Vaszary, József Rippl-Rónai and Lajos Gulácsy are a revelation as examples of Central European Art Nouveau less concerned with style than with a search for national identity. This exhibition traces the development of this particular variant of Art Nouveau style, demonstrating a move away from the academic, heroic art of the nineteenth century in Hungary towards a rich language that fully expressed the spirit of the times in the newly emerging country as it increasingly asserted political pressure to achieve independence.

A Golden Age could not have been created without the help of many Hungarian colleagues, to whom we are indebted. We would like to thank firstly all the lenders who have agreed that such a rich variety of work should leave their collections for so long. We would also like to mention the constructive support of the Hungarian Ministry of Culture and Education, the Hungarian National Gallery in Budapest, and the Hungarian Embassy in London. In particular, Róbert Boros, Lóránd Bereczky, Géza Csorba, Gábor Horváth and Gábor Földvári have provided invaluable assistance to the venues, and to the selectors, Gyöngyi Éri and Zsuzsa Jobbágyi, who prepared the 1986 exhibition and provided the essential continuity for the successful realization of *A Golden Age*.

JOHN HOOLE
CURATOR
BARBICAN ART GALLERY
LONDON

ROBERT H. FRANKEL,
DIRECTOR
THE CENTER FOR THE FINE ARTS
MIAMI

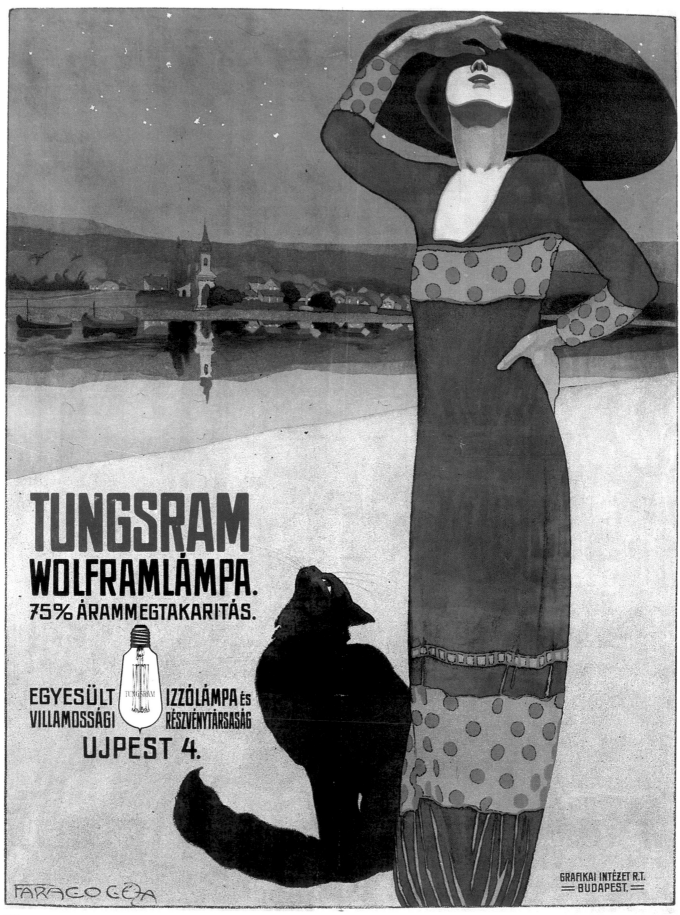

Géza Faragó: *Poster for Tungsram light bulbs c.* 1910
125 × 95 cm
Hungarian National Gallery, Budapest

From the Millennium
to the Republic of Councils

Iván T. Berend

The end of the last century saw official Hungary overcome by the complacent euphoria of the Millennial celebrations. There was, after all, something to celebrate. 1896 marked not only a thousand years in the history of the Magyars but also the seeming success of Franz Joseph's era and during the years that had passed since the Austro-Hungarian Compromise of 1867. The plans envisaged by the great nineteenth-century Hungarian reformer, Széchenyi, were not only beginning to be realized but were gathering real momentum. Between the end of the old century and 1913, the amount of railway track had trebled; a similar increase had occurred in agricultural production between 1867 and 1900, while industry had achieved a greater capacity than in the previous half century. Following the success of modernization, optimism swept the country and with it came a new pride. If, after the appearance of steam locomotives in England, the railway had become the symbol of modernity, then Hungary was taking the express towards a new era. Although the line from Pest to Vác was opened in 1846 and although Széchenyi and Kossuth had planned a national rail network, the achievement of the Reform Age was one of planning rather than accomplishment. By 1867, however, 2,000 kilometres of track linked the wheat producing regions of the South and the cattle regions of the East with Pest–and Pest with Vienna. The country's dense rail network–17,000 kilometres by 1900 and 23,000 by 1913–provided a modern transport system and, quite literally, radical new prospects for society and the economy. Taking into account the country's size and population, Hungary ranked sixth in Europe in terms of the density of its railway track, ahead of Austria and even of the United Kingdom. This indeed was a country in the vanguard. Furthermore, before the 1870s, practically everything had to come from abroad–from rails and engines to expertise and capital, but during the last thirty years of the nineteenth century the impressive Hungarian railway gradually began to stand on its own feet, nationalization bringing a unified rail system into being. The railway became a symbol of improving times, praised by poets and lauded by painters as the very embodiment of momentum, of forward surge, and the speed that had overcome lethargy.

The railway then was the driving force for general development. The new link with the once isolated regions meant that the hungry and eager markets of Western Europe were instantly brought closer. The railway also made possible an unparalleled boom in agriculture. Taking advantage of a seemingly unlimited flow of largely Austro-German and French capital, Hungarian agriculture sought and obtained credit. The Mortgage Bank and later the Land Bank were among the first to be established by foreign financial interests. In 1830 Széchenyi called credit the *sine qua non* of the country's transformation. This credit was now pouring into the hands of land-owners. After 1867 the foreign financial groups, the Viennese banks and Hungarian financial institutions mushroomed all over the country. Gold, the life-blood of the economy, flowed through the arteries of the Viennese and Budapest banks. It passed on through the capillaries of the many thousands of savings banks and credit unions being set up in almost every block in the capital and in country towns. These tiny institutions achieved importance by their accumulation of the small savings of the entire country and provided half the mortgages taken out on land.

This readily available cash was used to cover the cost of farm labour, to buy machinery, and to replace inferior cattle by Swiss dairy and beef stock. These changes meant that it was possible to engage in modern forms of agriculture. No

* Hungary became independent of Austria on November 16, 1918. The government steadily moved towards the left and on 21 March 1919 was replaced by a soviet republic with Béla Kun at its head. This Hungarian Republic of Councils fell on 4 August, when Kun and his associates fled Hungary.

longer was it necessary for one third of the land to lie fallow in traditional triple rotation. Within a few short years, modern crop rotation had improved yields enormously, and within half a century, an unparalleled 3% annual rate of increase meant that agricultural output had trebled.

Progress in the railways and in agriculture brought changes elsewhere, industry and the services improving with them. Coal mining was the first to feel the effect; pits in South Transylvania and Mohács, for example, were linked to the Austrian State Railways and the Danube Steamboat Company, and the iron industry was also developed and modernized.

In its turn, the increase in agricultural exports had a two-fold effect on industrialization. A food-processing industry emerged relatively quickly, and by the end of the century, it accounted for 40% of Hungary's industrial production. The Ganz factory also invented equipment which gave Hungarian mills both technical and cost advantages over their competitors.

In addition to their impact on the economy, the railway and food industries also brought about a major transformation of the social structure. Those previously engaged in agriculture found openings for employment in both these sectors, traditional which was to undermine the way of life. Huge numbers of landless peasants worked on the railway or as seasonal workers in refineries and mills, forming an itinerant labour force which was gradually absorbed into industry.

The Hungarian proletariat was at this time still in the process of formation. Though half could still be classified as agricultural, a new, industrial working class had already established itself in the towns and industrial centres. A large part of the skilled workforce had settled here from Austria and Moravia and, even around 1880, a considerable proportion of skilled workers in the capital were of foreign origin. The first newspapers for

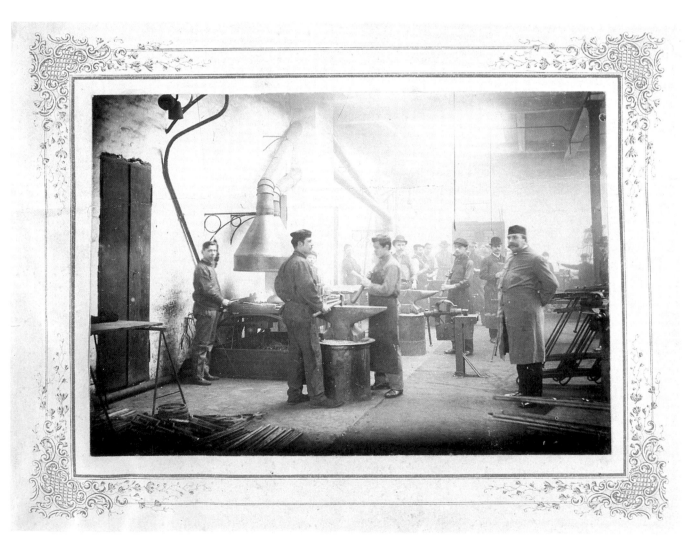

Factory interior c. 1900
Archive photo, Museum of the Hungarian Labour Movement, Budapest

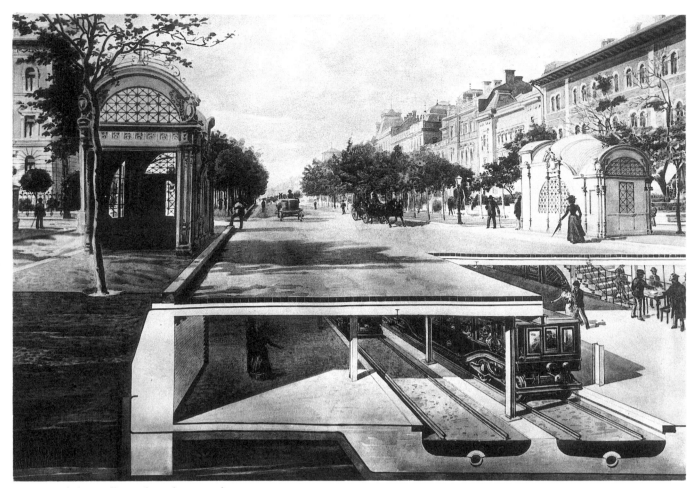

Station of the Millennial Underground
Budapest 1896
Designed by Albert Schickedanz and Fülöp Herzog

workers in Hungary were published in German, the language of the trade unions. Around the time of the Millennial celebrations, however, a second generation of native industrial workers had developed.

In 1873 the unification of the three towns of Pest, Buda and Óbuda brought the city of Budapest into existence; with a rapid annual growth of 5% it soon became the bastion of Hungarian industry, welding the Hungarian working class together in its development. An insignificant town of 100,000 in the 1850s, Budapest swelled into a metropolis with dizzying speed. By the beginning of this century, its population reached over one million. By then, two principal thoroughfares, one a circular road and the other a triumphal avenue with the continent's first underground railway running beneath it, had been built; so too had the handsome public buildings designed by Miklós Ybl, Ödön Lechner and Imre Steindl: the Customs House, the Opera House, the Parliament, Fishermen's Bastion and the Post Office Savings Bank, among others. The capital was

now surrounded by industrial suburbs. With its atmosphere and cultural vitality, the new highly cosmopolitan city also became the stronghold of a new intelligentsia, itself an important factor in the modernization of society. Jews, once excluded and then emancipated during the liberal era, drifted to the capital and into the professions in large numbers. Nevertheless, Budapest remained an island of industry and the arts set in a largely unchanged rural and agricultural sea.

Economic development and modernization were accompanied by a growth in education. József Eötvös, the other leading figure of the reform generation alongside Széchenyi, finally realized his dreams with the passing of his Education Act of 1868, which introduced free, compulsory education, launched a huge programme of school-building, and institutionalized the training of teachers. At the time the Act was passed, 68% of the population was illiterate; a figure which was to fall dramatically to 36% by the 1910s, when illiteracy was to be found mainly among the older generation. Of the young, 82% had by then com-

11

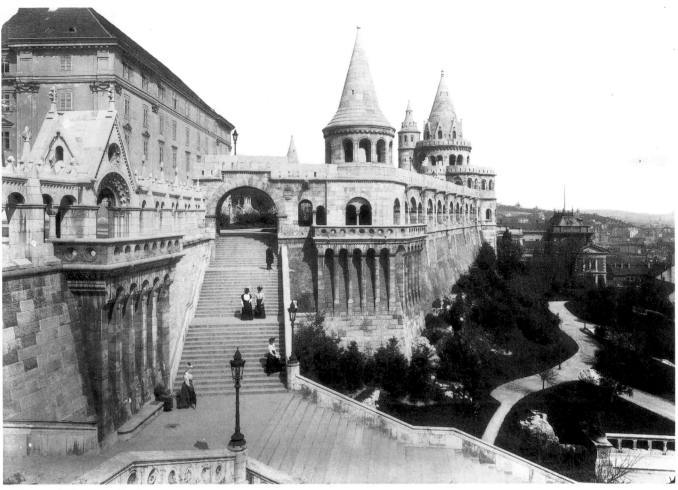

Fishermen's Bastion, Budapest
Designed by Frigyes Schulek 1899–1905
Archive photo, Budapest Historical Museum

pleted between four and six years of school. This was a major breakthrough in the elimination of medieval conditions in Hungary.

The process of modernization did more than simply abolish traditional backwardness, it also set in train the long and arduous process of catching up with the rest of Europe. The old balance of inertia had, however, been upset: backwardness brought paralysis and tension in spite of modernization. Hungary did not close the gap with industrialized Western Europe for the simple reason that more than 60% of the population continued to earn their modest livelihood in agriculture.

This state of affairs was further aggravated by the contradiction between an economy which was being streamlined and a social and political system which still retained traditional features. Despite undoubted economic progress, Hungarian society had largely conserved its old social hierarchy based on privilege of birth rather than social classification by wealth, the capitalist cri-

terion. The self-made man, the industrial baron, the banker (especially if Jewish) could not join the social and political élite, even though the liberal age had made acceptance to the gentry or even to the titled ranks through purchase possible. The Deutsch, the Weiss and the Herczog families, for example, may have bought titles for themselves through the fruits of their industry, but they remained Deutsch, Weiss or Herczog in the eyes of the old élite. In contrast, descendants of gentry families who had lost their land and lived on modest incomes still held their place at the highest level of society. Similarly, there stood an impenetrable wall between the wealthy peasant and the middle class. The peasantry, so clearly redefined by the new capitalist agriculture, were wholly excluded from society. All of this only served to emphasize traditional hierarchical divisions and prevented the broad development of a modern middle class. At the base of the social pyramid alongside a modern industrial proletariat, were even greater numbers of an

12

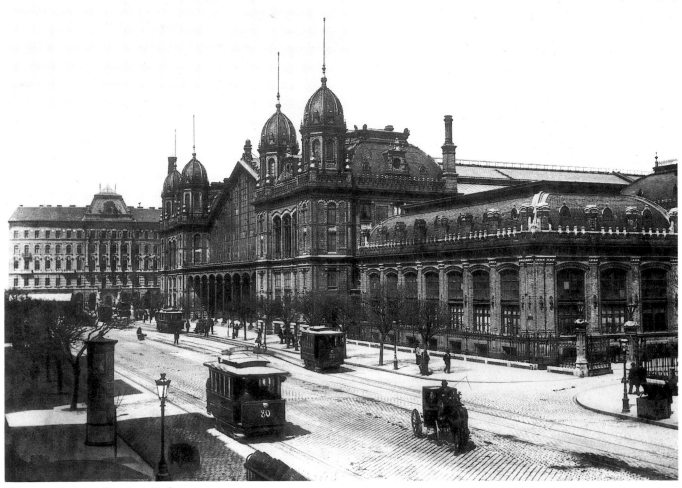

Western Railway Station, Budapest
Part of the design was from the office of Gustave Eiffel, 1874–1877. Photo by György Klösz

agrarian proletariat and a semi-proletariat peasantry living under near feudal conditions. Alongside a modern lower middle class (in the lower reaches of industry, commerce and finance) existed the old middle strata of the gentry, fallen from their former place among the élite and finding a new place within the bureaucracy and certain professions. In spite of their inferior economic position, this latter group still carried an incomparably greater social and political weight. At the top of the social pyramid a similar coupling was to be found: on one side was the old aristocracy engaged in modern agriculture, owning most of the land and monopolizing political power; on the other stood the industrial and financial oligarchy with comparable, if not greater, wealth, but without the requisite social and political standing. There had thus been only a highly restricted modernization within society; social values and behaviour, preserving the "national" values of feudal tradition, were effected in a similarly restricted way.

The backwardness of social and economic development from the sixteenth to the eighteenth century, along with the absence of a developed and integrated middle class, was seen to imply the lack of national independence and of a national independent state. This twin lack was perceived as the root of all social and economic ills. The increasingly hollow patriotic grief expressed by the nobility for the failure to become independent of Austria in 1848 was a fine excuse for not seeking out real causes and radical social solutions. The relative lack of industrialization and general backwardness seemed to be fully explained by Austrian domination.

After the euphoria of the Millennial celebrations had subsided, these complex contradictions became more obvious. They were, of course, neither unique nor exceptional; many similar phenomena were experienced by Hungary's neighbours. Such was the economic progress made by Germany, for example, that, by the beginning of the twentieth century, she had over

13

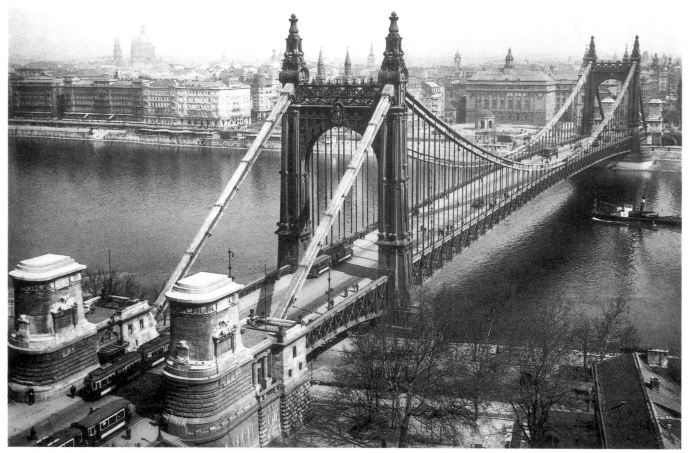

Elizabeth bridge, Budapest c. 1900
Designed by Aurél Czekelius and Antal Kherndl 1897–1903
Archive photo, Budapest Historical Museum

taken Britain and France, both of whom had a considerable head start. Even so, Germany's social backwardness, tradition-bound political system and exclusion from the rank of the colonial powers (so bitterly resented) all conjoined to create the contradictions so typical of this region. The same is even more true of Russia and Rumania, whose economic success was considerably inferior to that achieved by Hungary.

At the beginning of the century, then, clear-sighted observers recognized the painful failures and ambiguities of the process of modernization. There seemed to be a temporary halt in triumphant progress which was shaken by an awareness of the existence of monopolies, of the distribution of colonies, and by rampant militarism. The credibility of English institutions and values, models to be followed in Széchenyi's time, suddenly lessened. After many years of trying to follow their example, hard won success was only partial and called into question the desire to continue in the same direction. Furthermore, this partial success had a negative effect in that it

Sunday in City Park c. 1900
Archive photo, Museum of the Hungarian Labour Movement, Budapest

induced a revolt against the faltering values and domination of the West. In the words of Endre Ady, the great Hungarian poet of the era: *'We are demanding the most complete democracy, while the very achievements of those societies which have preceded us in culture by centuries have secretly taken away our appetites.'*

** Az élet szobra: Ady Endre képzőművészeti írásai* (The Statue of Life: Endre Ady's Writings on Art), ed. József Varga, Budapest, 1977.

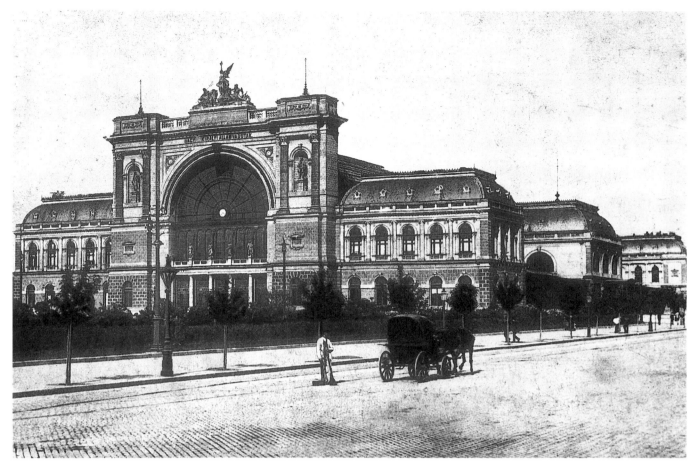

Gyula Rochlitz: *Eastern Railway Station, Budapest, built in 1882*
Archive photo, Office for Preservation of Historical
Monuments, Budapest

In the general confusion of capitalist develop-
ment, faltering modernization led to the appear-
ance of ideologies and movements offering very
different solutions. Where a panacea was sought
in a belated national revolution, especially in
Central and Eastern Europe, many national
movements opposed liberalism and idealized
volkisch (populist, introverted and xenophonic
ideas) which in some cases led to outright racism.
National Socialism advocated the struggle be-
tween proletarian and bourgeois nations, and
was to be the basis for right-wing mass organiza-
tions. Left-wing radicalism in Hungary, in con-
trast, saw the only possible solution in the fall of
capitalism and in the victory of socialism. It grew
spectacularly in strength in this period and, un-
like Marxism, considered that socialism could
only triumph at this time in the backward coun-
tries.

From the Millennium onwards, aspirations in
Hungary toward a national revolution, the emer-
gence of the short-lived Antisemitic Party led by
Istóczy and the increase in the strength of revolu-

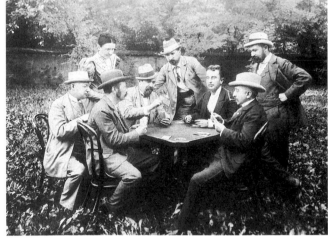

*Parliamentary representatives taking a break on
Elizabeth Island, Komárom*
(Komarno, Czechoslovakia) *c.* 1900
Archive photo, Office for the Preservation of Historical
Monuments, Budapest

tionary proletarian forces all became noticeable
at one and the same time. No single element was,
however, dominant at the beginning of the cen-
tury. The real turning point was to be the First
World War, which polarized and spotlighted la-
tent contradictions. The War, greeted with joyful
acclaim, was to cause unimaginable and unend-
ing misery. It threw into clear relief the social and
political poverty and economic inadequacy of

15

those countries which were backward and incapable of coping with a long war. For the defeated countries, the impossibility of continuing attempts to close the gap became more marked; the danger of falling further behind, and the risk of being pushed into new peripheral positions became heightened. It was now that the real passion of revolt flared up. The world had become unhinged, power (and violence) now commanded respect. The victors dictated peace terms; unexpected opportunities to redefine borders or carve up multi-national empires occurred. The opportunity to create a state had finally been given to the belated national revolutions, which had been dreamt of but scarcely hoped for in the cold light of realism.

Revolt flared in the wake of the First World War. With the collapse, after four centuries, of the Habsburg Empire, national revolution was attractive: Hungary, so to speak, had been forced into independence. From the fireworks and self-adulation of the Millennial celebrations, the road had led within twenty years to collapse and the proclamation of a Hungarian Republic of Councils. Over these twenty years, the success and inner contradictions of modernization had also generated a feeling of crisis and a desire for change in the intellectual and artistic world which was to find expression in Hungary, as elsewhere in Europe, in the avant-garde.

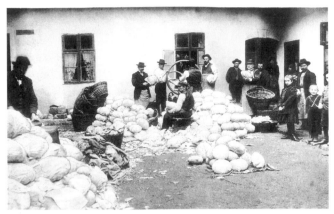

Life in Hungary. Shredding cabbage in a house in Váci utca c. 1900. Archive photo by Ferenc Kiss, Budapest Historical Museum

Calvin Square, Budapest c. 1880
Archive photo by György Klösz, Budapest Historical Museum

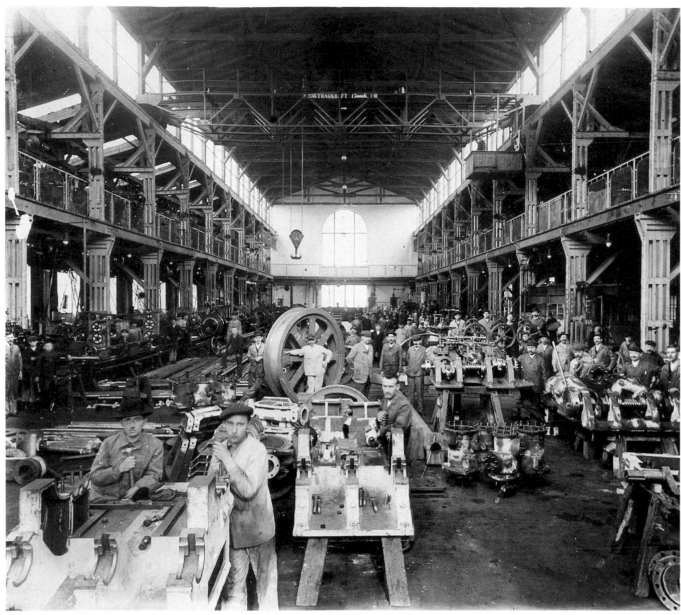

Workshop in the Láng Machine Factory, Budapest, in the 1900s
Archive photo by György Klösz, Budapest Historical Museum

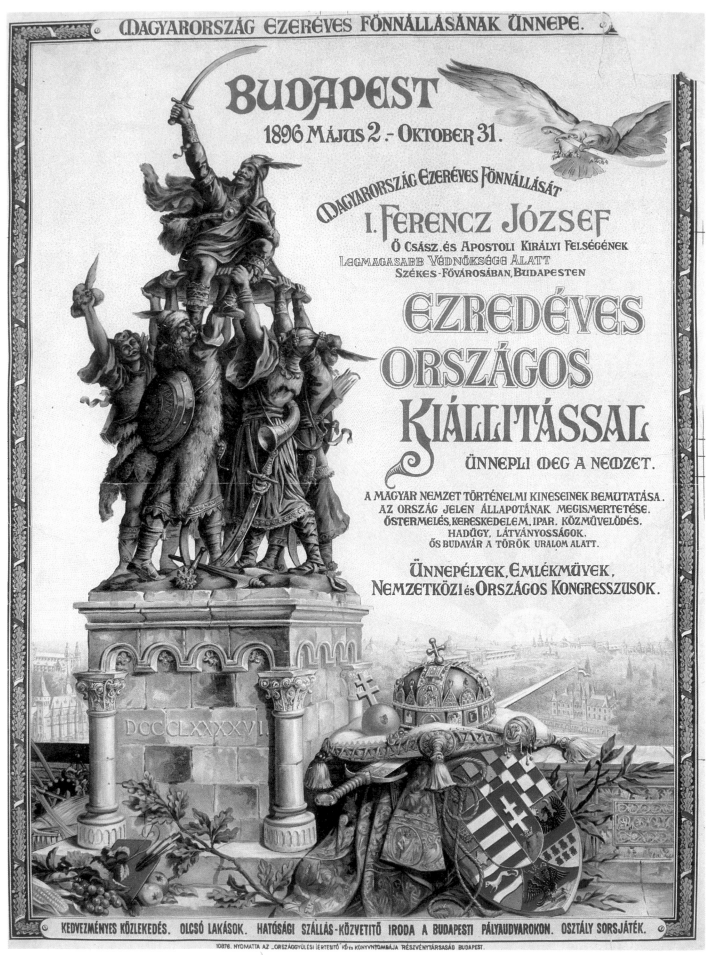

A Thousand Years of Statehood 1896. Poster, 65 × 95 cm. National Széchényi Library, Budapest

Art, Nationalism, and the Fin de Siècle

LAJOS NÉMETH

For the great European nations of the nineteenth century, historicism was an attempt to reconcile national history and tradition with the challenge of modern industry and capitalism. Hungary, in contrast, with no middle-class tradition, had not only to shape the present and the future, but also to create a comprehensible past. This was no easy task and the birth of modern Hungary was a long and painful process.

Habsburg tyranny and the spiritual terror of absolutism had destroyed national art and culture along with its rising institutions. The intelligentsia, and indeed the nation as a whole, fought for the sheer survival of Hungarian culture and attempted to keep the national spirit alive. Accordingly, the task of preserving the memory of the 1848–1849 freedom fights, of maintaining the nation's tragic fate, fell to the lot of Hungarian literature and art.

After the Austro-Hungarian Compromise of 1867, the situation changed. The resulting Dual Monarchy made Hungary internally autonomous; capitalist development took a freer course, and political consolidation enhanced the development of education and cultural life.

Hungarian capitalism, however, conserved elements of feudalism and the landed class was to preserve its hegemony for a considerable time in the intellectual and cultural sphere. It was only at the turn of the century and particularly in the first fifteen years of the twentieth century, that bourgeois intellectual aspirations gained strength. It was during this period that Art Nouveau made its appearance in the arts of Hungary.

Strictly speaking, art historians do not use the term *fin de siècle* to designate a particular period. The term has nevertheless gathered certain associations and has become synonymous with Art Nouveau, the advent of the modern period, and the emergence of the avant-garde. It stands for a kind of watershed in art history, for the final phase of Post-Impressionism and Symbolism, which ushered in the sweeping offensive of modern art. It was, in short, pluralistic in intent and orientation.

The art of turn-of-the-century Hungary bears this out: Historicism, Eclecticism and Art Nouveau lived side by side with pre-modernistic ideas, at times locked in symbiotic union, at other times engaged in a spectacular battle of wills. On the one hand, art was expected to legitimatize and propagate the *status quo;* on the other, it was regarded as a kind of 'counter-culture' which could undermine the prestige of an establishment still very much imbued with the spirit of feudalism. Though there was no such thing as an homogeneous 'Monarchy style', there were obvious similarities in architecture, interior design and the applied arts. The townscapes and art of the Monarchy's major cities, Prague, Cracow, Pozsony and Zagreb, for example, all resemble the Viennese model.

Yet each of the national minorities within the Empire strove for independence, thus strengthening nationalistic and populist aspirations. In this complex political situation, art was used not only to enhance the Monarchy's existence but also to encourage steps towards independence. These conflicting and contradictory political factors often merged, creating a perplexing situation. The monumental, representational art of the period, for instance, served as a form of propaganda and was closely associated with the series of Millennial celebrations of 1896–1897 commemorating the one-thousandth anniversary of the Magyar settlement of the Carpathian Basin.

The year 1896 had, indeed, assumed something of a mythical status in Hungarian history, and grandiose plans were drawn up to celebrate it. The programme and ideology of these celebrations reflected the complex political and social situation. While the 'one-thousandth year'

19

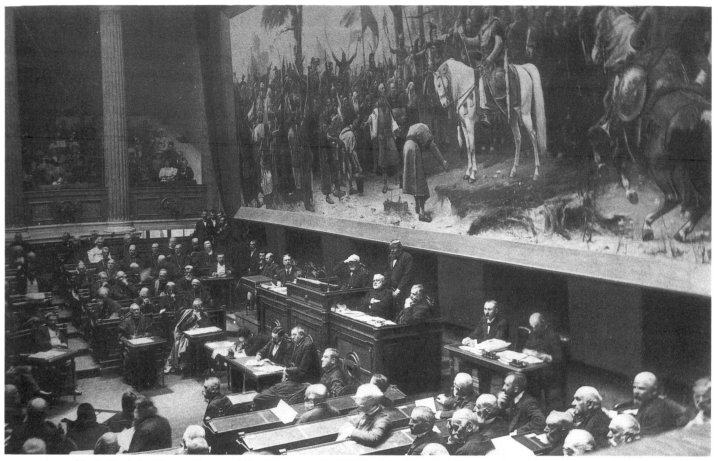

Assembly hall of the Upper House of Parliament with Mihály Munkácsy's 'Conquest' c. 1900
Archive photo of hall and detail, Budapest Historical Museum

was, above all, the festival of Hungarian state-
hood, it also had to be reconciled with loyalty to
the Habsburg dynasty. This was how, in honour
of the Magyar chieftain who brought his tribe to
settle here, the Emperor-King Francis Joseph
became known as the 'New Árpád', and even the
symbolic reincarnation of King Stephen, the
founder of the Hungarian state. Typically, when
the opera *Saint Stephen* by Ferenc Erkel was
performed at the Opera in 1885, the apotheosis
of the royal couple, Francis Joseph and the Hun-
garians' beloved Queen Elizabeth, was inserted
to coincide with the notes of the national anthem.
A further example of this blend of dynastic loyal-
ty and the yearning for national independence is
the ambivalent iconographical programme of the
decoration of the Houses of Parliament: the mural
in the Lower Chamber, renders homage simul-
taneously to Lajos Kossuth, the legendary leader
of the struggle for independence from Aus-
trian rule, and to Francis Joseph, who sup-
pressed the struggle for this selfsame indepen-
dence. The decorative schemes of numerous
other major public buildings reveal a similar
schizophrenia.

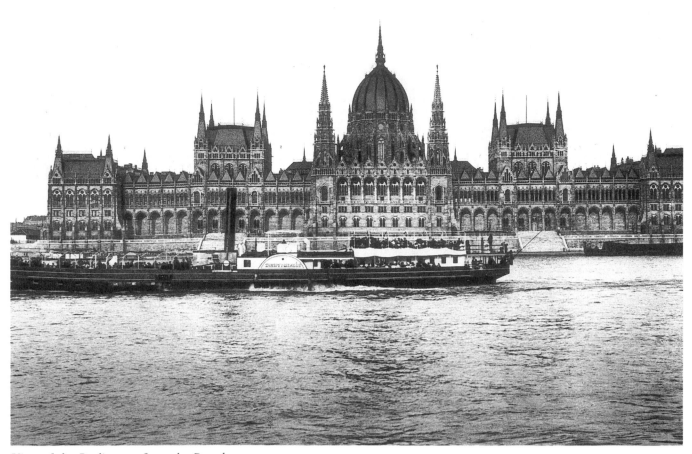

View of the Parliament from the Danube
Designed by Imre Steindl 1884–1902
Archive photo, Hungarian National Gallery, Budapest

The Millennial celebrations provide a typical example of the role the fine arts can play in the shaping of social ritual. The programme was formulated over a period of ten years, and aimed to evoke a sense of history in the public. The role of history and the arts in shaping national identity was clear even then, and, as the ideologists of the period phrased it, they helped 'the ennobling of virtue'. The 1896 celebrations served that purpose well. The ceremonial procession consisting of historical *tableaux vivants,* the equestrian costumed processions of the various counties, and the national exhibition, which presented an encyclopaedic panorama of contemporary art and popular, national culture, were all designed with this purpose in mind. The national exhibition also contained several characteristic village scenes, in which examples of Hungarian popular and folk art were collected and arranged as in an outdoor village museum. In the face of such nationalistic aspirations, however, there stood in the central hall of the Great Millennial Exhibition Francis Joseph's throne, surrounded by portraits of the members of the Habsburg dynasty. The millennial festival of 1896 was clearly meant as a celebration of aristocratic rather than middle class Hungary.

The role of the arts in monumental propaganda, and the formulation of the symbols sanctioned by the ruling social classes, was unequivocal. Its significance was particularly conspicuous in the academic insistance on classical tradition in the design of buildings and other structures made specifically for the Millennium. Although it was not completed by 1896, the building of the Houses of Parliament was essentially a part of this programme, as was the reconstruction of the Coronation (Matthias) Church, the restoration of Kassa (Košice, Czechoslovakia) Cathedral, the construction of the Kúria, to house the Royal Tribunal and the Supreme Court, across from Parliament, the construction of Francis Joseph Bridge, the laying down of the first pillars of Elizabeth Bridge, the launching of the Underground Railway service, the com-

21

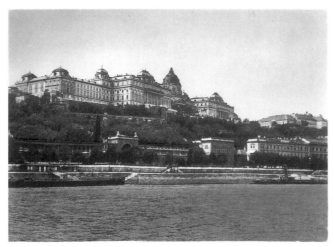

The Castle of Buda seen from the Danube
The building was redesigned by Miklós Ybl and
Alajos Hauszmann
Archive photo, Budapest Historical Museum

pletion of 500 new elementary schools, and the founding of many other new institutions.

Commissions for paintings, murals and public sculpture also formed an integral part of the programme. Monuments commemorating the Millennium were inaugurated throughout the country. Among the sculptures commissioned were such great works as János Fadrusz's statue of Maria Theresa in Pozsony (Bratislava, Czechoslovakia), the King Matthias Memorial in Kolozsvár (Cluj-Napoca, Rumania), Alajos Stróbl's equestrian statue of Saint Stephen in Buda, and, above all, the commencement of the construction of the great monumental complex in Pest's Heroes' Square, the Millennial Memorial. This grand structure, which celebrates the ideas of Peace, Progress and Labour, was intended to convey the supremacy of the Hungarian state and Hungary's loyalty to the Austro–Hungarian Empire, at one and the same time.

The programme of monumental painting was similarly impressive. Town halls, public buildings and churches were decorated with frescoes in the grand style, painted for the most part by the popular Academic painters of the era, Károly Lotz and Bertalan Székely. Amongst panel paintings, *The Recapture of Buda Castle* (1896) by Gyula Benczúr, a follower of the Piloty School, and the *Conquest* (1893), a late painting by an already lacklustre Mihály Munkácsy, were the most representative. The greatest public acclaim, however, went to the Feszty Panorama, the sensational spectacle of the 1890s. This painting, executed in a naturalist-romantic vein, evokes the story of the Magyar Conquest of the Carpathian Basin.

The large-scale construction programme of the Millennial Exhibition also mirrored the ideals of nationhood, and forged into one eclectic mass the various historical styles thought to be national in character. One such typical contemporary eclectic structure is the Fishermen's Bastion, the decorative Neo-Romanesque edifice adjoining Buda Castle. It was particularly in monumental public sculpture, however, that art was subjugated to ideology.

Clearly, with the rise of nationalism and aspirations for political independence, historical painting, too, took on an indispensable role in shaping the sense of nationhood. Initially, etchings with an historical subject satisfied popular demand, but such themes subsequently spread to painting. As early as 1840, Imre Henszlmann, the

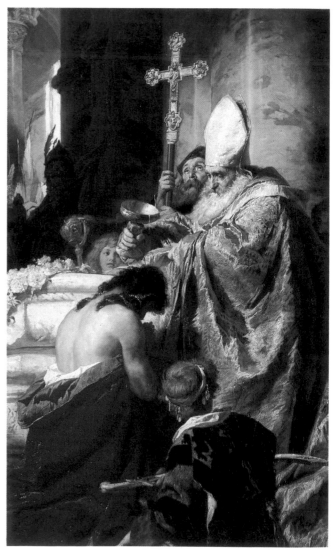

Gyula Benczúr: *The Baptism of Vajk* 1870
Oil on canvas, 89 × 114 cm (Detail)
Hungarian National Gallery, Budapest

22

great Hungarian art historian and a friend of Lajos Kossuth, pointed out that *'Hungary, which glories in its history and looks back with joy on bygone days, needs the historical painter and sculptor.'*

The importance of historical subjects became still more unequivocal following the suppression of the 1848–1849 revolution, which brought about a period of Habsburg absolutism during which the creation of a national heroic ideal and the glorification of sacrifice as a moral imperative became the primary means of keeping national sentiment alive. Even the Austro–Hungarian Compromise of 1867 could do nothing to dampen the popularity of the depiction of specifically Hungarian subjects in painting. On the one hand, the question of nationality still lacked a solution, and on the other, the liberal programme of public education continued to regard historical painting as the supreme task of fine art. *'Nobody realizes the importance of historical painting more than I do; indeed, I am convinced that if there is ever to be Hungarian painting at all, it must take the form of historical painting. In art as elsewhere, our national spirit will take a patriotic course...'* wrote József Eötvös, the Minister of Education, who was an influential political thinker and one of the greatest figures of Hungarian liberalism of the 1860s. In painting, the work of Viktor Madarász, but above all, that of Bertalan Székely, whose late-Romantic mentality was infused with Academicism, were linked closely with the Eötvös conception. Both espoused the ideology of independence upheld by the lesser nobility, but were protected from provincialism by their extensive knowledge of European art and thought.

Despite the efforts of the artistic establishment to preserve its hegemony through commissions and awards, however, this most productive period of historical painting ended in the 1890s. The obvious artistic failure of the historical works commissioned for the Millennial made it clear that the genre had become outmoded with little hope of being sustained. Popular historical subjects were still pursued in mural painting, but it was increasingly difficult to give these new content. Reflecting establishment attitudes, historical painting looked to the work of Gyula Benczúr, who blended German Academic painting with reminiscences of Venetian Baroque, for guidance. Although this form of painting was highly effective in its brilliant depiction of ob-

jects, it was already anachronistic in both form and spirit. The legacy of historical painting, which played such a decisive role in nineteenth-century Hungarian art can, however, be found even at the end of the nineteenth century and in the early years of the twentieth century, albeit markedly changed in content and aesthetic preoccupation.

The official and the plebeian democratic views of history clashed openly in historical painting. A typical case in point was the counter-exhibition staged by János Thorma after he was unable to exhibit his monumental tableau of the Arad Martyrs–the Generals executed after the suppression of the 1848-1849 War of Independence–on the occasion of the Millennial. Several members of the Nagybánya Colony, which made a major contribution to the development of modern Hungarian painting, also tried their hand at historical themes. In their work, how-

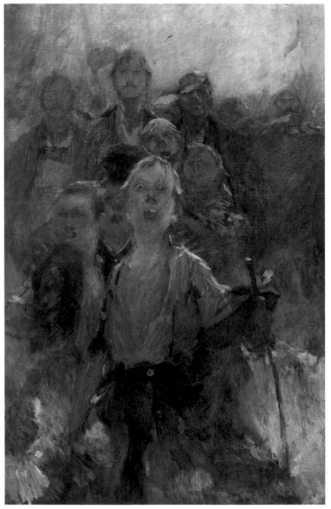

Simon Hollósy: *Rákóczi March* 1899
Oil on canvas, 92 × 127 cm (Detail)
Hungarian National Gallery, Budapest

ever, the genre was modified both in form and content, losing the elated moralizing, pathos and grand opera settings that it had acquired in the nineteenth century. In a few brilliant improvisations, however, Simon Hollósy, one of the leading figures of the Nagybánya movement, maintained the historical theme by combining it with *plein air* painting. In so doing, he instantly overcame the pitfalls of nineteenth-century historical composition–the indiscriminate use of allegory and abstraction. In the so-called 'Rákóczi March' sketches, upon which he worked throughout his life, Hollósy moved beyond the framework of historical painting, and created a genre appropriate to his own plebeian and revolutionary sensibility.

Another element of late historicism appeared in Art Nouveau, particularly in the works of the Gödöllő Colony, whose greatest master was Aladár Körösfői Kriesch. Körösfői was influenced by the decorative compositions of Bertalan Székely's late mural designs, which served as a link between nineteenth-century conservative historical painting and the nostalgic interpretation of history. The Gödöllő Colony's attitude towards history highlights a further point, the importance of art in shaping national sentiment and in evoking a vision of the myth of national origin.

Bertalan Székely: *The Flight of Thököly* 1875
Oil on canvas 159 × 222 cm (Detail)
Hungarian National Gallery, Budapest

The Hun myth first appeared in the work of the medieval chronicler, Anonymus, according to whom the Magyars descended from the tribe of King Magog and *'the mighty King Attila sprang from the seed of this king. Emerging from Scythia in the four hundred and fifty first year of the Incarnation of our Lord, he came to the land of Pannonia [Hungary] with a vast army, and, expelling the Romans, took possession of the country... Much later, from the line of the same King Magog, descended Ügyek, the father of Chief Álmos, from whom descend the kings and leaders of the land of the Magyars...'*

Although scholarship based on source material has shown this myth of national origin to be unfounded, it was an influential force at the end of the nineteenth century. While the advocates of Hun–Magyar kinship were relatively restrained in the field of science and rarely ventured into popular literature, the myth persisted in the world of popular belief. In popular symbolism, however, it not only persisted, but actually assumed the character of folklore. Above all, the myth lived on in serious literature, particularly in the works of the poet János Arany (1817–1882). The Hun–Magyar myth of origin also remained a particularly popular theme in the fine arts, and was especially cultivated by practitioners of monumental propaganda. The Gödöllő artists were fascinated by this mythology and repeatedly returned to it in the decoration of Hungarian pavilions at various international exhibitions. The cult of Attila also surfaced in the paintings ornamenting the buildings designed by the group known as the Young Architects, who, led by Károly Kós, strove to establish a popular folk architecture for the middle classes. The theme was also of fundamental significance in the private mythology of the great Hungarian poet Endre Ady (1877–1919) and the painter Tivadar Csontváry Kosztka.

This was all related to the ideology of social and cultural Darwinism which had taken root in early twentieth-century Hungary, whereby culture was seen as a means of achieving equilibrium in the struggle among the species. The Magyars, as the 'People of the East', the embodiment of the 'Turanian horseman', stood alone, encircled by the Slavs and the Germans, unable to rely on

* In: *Kortársak és krónikások* (Contemporaries and Chroniclers), ed. G. Győrffy, Budapest, 1975 (2nd edition)

anything except the ancient past, the last remnant of which was to be found in folk culture.

Hungarian Art Nouveau did indeed witness a shift of interest toward provincial folk tradition. Artists regarded it as a pure source from which a new art could be created, one which avoided the pitfalls of the New Academicism. Contemporary thought posited the concept of the 'People' as the bearer of racial specifics, and so the acceptance of folk culture was expected to strengthen the national character. This new interest in folk tradition went hand in hand with the establishment of a Far Eastern connection. It was widely asserted by the influential ethnographer József Huszka and others that Hungarian folk art and Hungarian ethnic ornamentation preserved traces of an ancient Eastern, Parthian–Sassanid past as well as evidence of Hindu kinship.

There were many underlying causes for this rediscovery of peasant culture and art, not least economic. At the turn of the century, cottage industry was given greater prominence, partly due to industrial policy. Throughout the country, centres of cottage industry were established and declining peasant art was revived. The Transylvanian town of Kalotaszeg was a prime example of

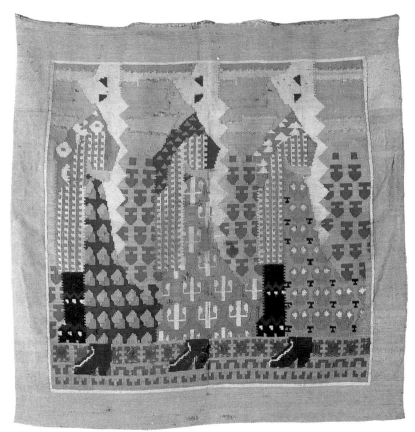

Aladár Körösfői Kriesch: *Women of Kalotaszeg* 1908
Tapestry, 193 × 111 cm
Local History Collection, Gödöllő

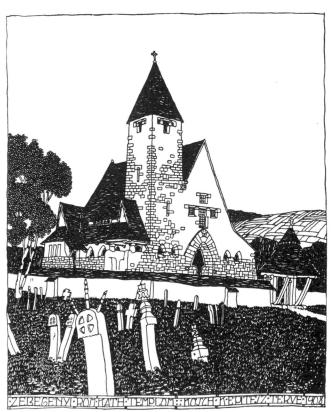

Károly Kós: *First design for the church of Zebegény* 1908
Ink on paper, 39 × 31 cm
Hungarian Museum of Architecture, Budapest

this revival. Here, following an initiative from the wife of the local Calvinist minister, the peasants once again began to cultivate the old local craft of embroidery and thereby quickly achieved national and international recognition. The embroidered felt coat of Hungarian shepherds, the *cifraszűr,* was exhibited throughout the world from the 1850s, and its ornamental motifs became decorative features in Hungarian Art Nouveau architecture. To some extent this revitalized peasant art showed the influence of Art Nouveau, but it was in turn to exert its influence on the so-called *magyaros* or Hungarian-style Art Nouveau, particularly in architecture.

This growing interest in folk art went hand in hand with more scholarly research. A number of artists, especially Károly Kós and his fellow architects, began collecting folk artefacts, and in so doing they made a survey of the best folk architecture of the Great Plain and Transylvania. This work was paralleled by the highly significant research undertaken by Zoltán Kodály and Béla Bartók in the field of folk music.

As the question of a national art reigned su-

preme, numerous ideological and formal tendencies attempted to clarify its meaning and purpose. National art was seen both as the principal tool of aspirations towards independence, a manifestation of the Hungarian instinct for survival, and as a guarantee of cultural superiority in the face of national minorities. The various views had, however, one point of concensus, namely, that despite the efforts of Hungarian national architects and the great nineteenth-century artists, a national art did not yet exist. The task of creating a national art was to fall to the artists of the *fin de siècle* and the early twentieth century.

For a while the paintings of Mihály Munkácsy were seen as the visual embodiment of a Hungarian spirit, but in the 1890s writers and artists raised on naturalism refused to accept this academic painter as the embodiment of a nascent national art.

A number of explanations were offered to account for this lack of national art. According to

the highly influential art critic, Károly Lyka (1869–1963), art within Hungary was moribund; the majority of Hungarian artists studied and lived abroad, and any foreign environment could not inspire a national, Hungarian art. The major issue was not subject matter, nor ethnography, but a 'Hungarian approach' or 'national sentiment' coupled with a characteristically Magyar style. It was thought that this could emerge only through close contact with the Hungarian landscape and its people. It was this realization which induced members of the Munich-based Simon Hollósy Circle to return home and found the Nagybánya Colony, which for a long time was seen as the first organized attempt to establish a national art. The artists who rallied around Hollósy tried to express the national character partly through their choice of subject matter and partly through the creation of a special *plein air* vernacular.

Prior to the Nagybánya experiment, others

Simon Hollósy: *Village Yard with Cart c.* 1912
Oil on canvas, 80 × 100 cm
Hungarian National Galery, Budapest

26

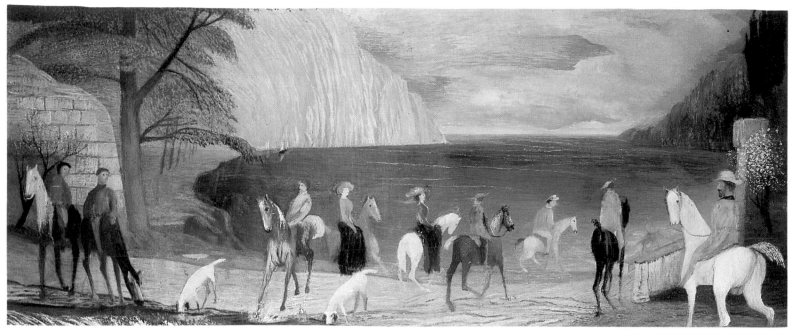

Tivadar Csontvári Kosztka: *Riders on the Seashore* 1909
Oil on canvas, 70 × 170 cm
Janus Pannonius Museum, Pécs

had attempted to produce a national art. Firstly, they called for national historicism; later they became involved in scholarship connected with the search for popular-national identity; and eventually provided the ideological framework for a national, folk-oriented Art Nouveau with a complex network of differing styles.

As the notion that national art was inseparable from folk art gathered force at the turn of the century, so formal elements of folk art were utilized. A typical case in point is the work of the Art Nouveau architect Ödön Lechner. Lechner based his art on motifs he believed to be of Oriental origin, folk ornamentation and Far Eastern architectural forms. This turn to the past became the working method of the Gödöllő Colony, who were influenced by the ideas of Morris, Ruskin and Tolstoy. It also governed the work of architects such as István Medgyaszay, Károly Kós, and, above all, Béla Lajta, who looked to Lechner for inspiration.

The painter Tivadar Csontváry Kosztka also believed that a national art would serve to legitimize the history of the Hungarians as a separate and independent people in the heart of Europe. Csontváry's work was individualistic in the extreme, but wholly nationalistic. Without the nurturing environment of Hungarian culture and its philosophical tradition, it would never have seen the light of day.

The Hungarian *fin de siècle* was an era of

choice and opportunity: the task before it was the creation of a modern Hungary. The need to gain a foothold in modern Europe and to participate in a new phase of social and intellectual development was at stake. The most clear-sighted thinkers and artists of the time were particularly conscious of this. They had much to lose, and everything to gain.

The complexity of contemporary Hungarian art stems from the diverse ways in which different artists attempted to deal with this problem. In the 1870s and 1880s, a form of realism emerged which was characterized by Bertalan Székely, the most intellectual painter of the period. By improving on reality through the abandonment of all detail held to be superfluous, this 'idealizing realism' perfectly suited the taste of the liberal-minded nobility. In the 1880s, however, the proponents of naturalism attacked this realist style for its lack of contact with life and its inability to perceive essential truths. The Munich-based Hollósy Circle, the precursors of the Nagybánya Colony, the art critic Károly Lyka and writers raised on the principles of Zola and Ibsen were the chief advocates of this new naturalism.

They hoped to shift the emphasis from an idea-oriented to an experience-based art and in the early years of the twentieth century, painters and sculptors attempted this in a number of ways. One approach remained confined to the formal critique of naturalism, and

27

countered photographic verisimilitude with an emphasis on decorative and stylized elements, a course on which Hungarian Art Nouveau had embarked.

The other path chosen by Hungarian artists led to a form of Symbolism, although in Hungary this was never an homogeneous stylistic trend. In fact, there is little work that can be regarded as wholly Symbolist. Artists either remained basically realistic with an eye trained on Symbolism, or else rose above the everyday to escape into an imaginary world. Csontváry and Lajos Gulácsy, whose work was influenced by the Pre-Raphaelites, both chose the latter solution.

The first decade of the twentieth century also witnessed the emergence of a rational approach to the representation of reality. At their first exhibition held in Budapest in 1909, a group of early avant-garde artists calling themselves 'The Eight' declared, *'We believe in nature. We do not copy it with the eyes of the Schools. We draw from it with our reason.'* This elevation of reason over emotion went hand in hand with the need to see essential forms in nature. Thus, from 'idealizing realism' to the constructive-structural endeavours of the avant-garde, the development of Hungarian art reveals a highly differentiated relationship to reality, and its modifications reflected the process of restructuring generally taking place.

Modern art was born out of the struggle against Academicism; everywhere it had to overcome institutionalized conventions and stereotypes. Art in *fin de siècle* Hungary, too, had been dominated by the stylistic ideals of Neo-Classicism blended with Academic Romanticism, and it was their formal elements and storehouse of conventions that were being varied and elaborated.

Naturalism and Impressionism developed from the conflict and produced the Nagybánya generation, who insisted on painting out of doors so that they could record what they saw immediately, without preconception. But although they rejected Academicism, these artists were unable to advance beyond the direct recording of reality. Naturally, all spiritually-inclined tendencies soon put up their defences against this.

The decorative Art Nouveau style also rejected the paraphernalia of Academicism and created its own range of schemata in the quest for style. The majority of these were in fact adaptations of the by now international traits of Art Nouveau and of Pre-Raphaelitism to Hungarian conditions. There also emerged a decorative style which was based chiefly on elements of Transylvanian medieval and folk architecture.

The important issue of style preoccupied both

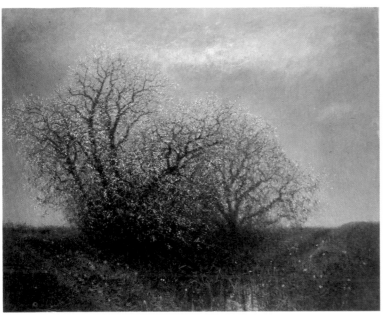

László Mednyánszky: *Trees in Bloom* 1890s
Oil on canvas, 190 × 243 cm
Ferenc Móra Museum, Szeged

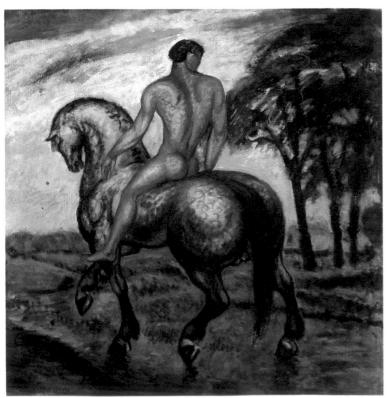

Károly Kernstok: *Solitary Rider at Dawn* 1911
Oil on canvas, 141 × 136 cm
Hungarian National Gallery, Budapest

European and Hungarian artists at the *fin de siècle,* many of whom were particularly concerned with questions of form and content. Their work was given theoretical basis by Lajos Fülep, who in his early writings regarded style as the main factor by which a permanent balance between the world as seen by the artist and a universal art might be achieved–a balance which the modern age with its emphasis on the individual had upset.

The realization that form can be autonomous was a precondition of the search for the new style. This call for a new language was formulated in theoretical works and carried through in artistic practice. In this respect Károly Ferenczy and József Rippl-Rónai played a similar role in Hungarian painting to that of Manet in France.

While the laws of form were being worked out by, amongst others, the early Hungarian avantgarde and the subsequent Activists, a new reality emerged out of the confrontation with official culture. In the so-called Arcadian paintings of the progressive group, 'The Eight', another, potentially more harmonious reality was suggested.

On this level, being modern meant more than the adaptation of a new style. It was the affirmation of a better model of existence and of a worldview in which the emphasis shifted to the promise of a better world. Reality in the flesh, however, clashed with these initiatives. Despite the great scientific advances taking place in the first years of the century and improvements in higher education, intellectual life in Hungary still bore numerous elements of the old feudal culture, the bureaucracy of the Austro–Hungarian Empire, and the ideological shackle of the churches. Almost every thinker and artist of any stature felt a discontent for, as Georg Lukács wrote, *'In Hungary revolution is just a state of mind, the sole positive and formal possibility for expressing the desperation caused by extreme isolation.'** Such desperate complaints shed light on the Sysyphean struggle waged to create a modern, progressive Hungarian culture, science and art, in an environment in which people simply drank, played cards and meddled in politics in a slogan saturated atmosphere. Yet, in the face of frequent set-backs and defeat, the intellectual core of modern Hungary was taking shape.

* György Lukács: "Ady Endre". *Esztétikai Kultúra* (Aesthetic Culture), Budapest, n.d.

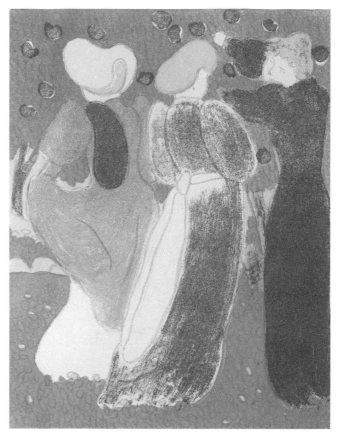

József Rippl-Rónai: *Illustration to 'Les Vierges'* 1895
Colour lythograph
Hungarian National Gallery, Budapest

Károly Ferenczy: *Portrait of Dezső Malonyai* 1904
Oil on canvas, 104.5 × 80 cm
Hungarian National Gallery, Budapest

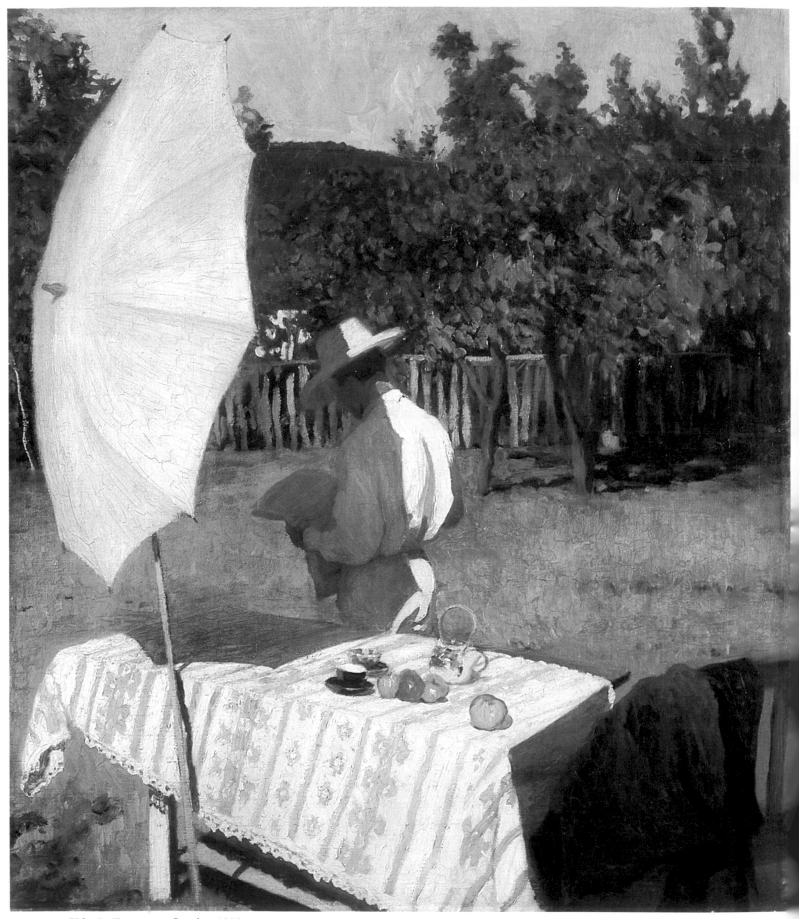

Károly Ferenczy: *October* 1903
Oil on canvas, 126 × 107 cm
Hungarian National Gallery, Budapest

Hungarian Art and Architecture 1896–1914

Ilona Sármány-Parsons

HUNGARIAN CULTURE AND EUROPE

Though the whole region of Central Europe–and so Hungary–belonged to the realm of Western culture up to the late nineteenth century, Hungary stood apart from the main current of European artistic trends. It was mainly a Catholic culture with a Protestant minority, but from an economic and social point of view it was relatively backward and riven by political tensions caused by the growing national consciousness of the individual nations that comprised it. Most of these small nations lived within the Austro–Hungarian Empire, but each enjoyed a different political status within it, determined by their own individual history.

Hungary had been a kingdom for a thousand years and its political existence was symbolized by the crown of Saint Stephen.* In the sixteenth century, the Habsburg Emperors became the hereditary rulers of the land, gradually integrating it into their multi-national Empire. From time to time, the Hungarians tried to acquire more political and economic freedom, but with very limited success. The last dramatic attempt was the revolution of 1848 followed by the tragic War of Independence of 1849, which the young Austrian Emperor, Franz Joseph, was able to suppress only with the military assistance of the Russian Tsar.

After a period of neo-absolutism and police terror, the Habsburg dynasty was compelled in 1867 by military disasters elsewhere to make a compromise with its strongest political opponent within the Empire. Thus the Austro–Hungarian Monarchy came into being. A dual parliamentary system was established on a constitutional basis with two independent governments, but control of foreign affairs, the army and import-

ant economic decisions remained in the hands of Franz Joseph's ministers. Nevertheless, the Hungarian political establishment, led by liberal politicians, exploited this limited independence to open the way to economic and social modernization, and to allow total freedom in the cultural sphere.

THE FIELD OF ART

The first liberal generation after the Compromise established bourgeois forms of state patronage, an institutional system for the arts more or less on the French pattern. Naturally, the art that flourished in this new framework in the 1870s and '80s was characterized–as everywhere else in Europe–by Historicism, both in architecture and in the applied arts. In painting, the historic themes of the heroic national past found adequate expression in romantic Academicism and what has become known as 'idealizing classicism'.

While social and economic modernization progressed rapidly, art was unable to adjust to the speed of change, and by the end of the 1880s, painting in Hungary fell far behind that of Paris, the cosmopolitan art centre of the world. Officially approved and subsidized, Hungarian art was stylistically conservative and escapist in its subject matter. It avoided the challenge of modern urban life with its social and psychological tensions, and rejected modern realism and naturalism as non-aesthetic, non-artistic tendencies. The situation was further aggravated by the lack of art sponsors within the middle class, as a result of which the free art market was both weak and conservative.

The first generation of artists to rebel against the official line of the Hungarian cultural establishment held a marginal position within Hungarian society. These artists belonged to the bohemian circles of Munich, where all of them had studied. Later they went to Paris and, al-

* Saint Stephen was the first king of Hungary, and it was he who converted his land to Christianity and received a crown from Pope Sylvester in the year 1000, thus binding Hungary to Western culture.

though they remained loyally patriotic throughout their time abroad, they were insulated from the increasingly nationalistic cultural atmosphere at home.

In the 1880s and '90s in the artistic capitals of the world, especially Paris, a disorientating multiplicity of artistic styles flourished; for the foreign art students who flocked there it was very difficult to find their way around this stimulating but bewildering world. Hungarians–not unlike their Scandinavian and German colleagues–usually arrived via Munich, having spent a few years at the Munich Academy or at one of its private art schools. Their artistic direction was often influenced by the art of realists such as Bastien-Lepage, who were exhibited with great success in international shows in Munich. The École des Beaux Arts was normally closed to foreigners and so the easiest and cheapest avenue for learning was the Académie Julien, together with a few private schools run by the fashionable masters of the official Salon. (The experimental work of the Impressionists, not to mention the Neo-Impressionists, were in the possession of a few art galleries and collectors only, and were thus inaccessible to the average foreign art student, including the Hungarians.)

Young art students formed groups generally according to their nationality. Similar attitudes and common roots automatically brought them together abroad. And there was an even more important factor which united them–the traditional role of the intellectual, especially the artist, within Central-European society. Their task was not only to create works of art that attained the ideals and standards implicit in the famous French masters, but also to be the high priests of their own national culture. They were to be the guardians of national integrity, a role even more uncompromisingly thrust upon them in the event that political independence eluded their homelands. The demands made upon them were extremely taxing: to be up-to-date and patriotic at the same time.*

These twin demands lay heavily on the artists of Central Europe, and only if one keeps the historical-political situation in mind can one understand why the art of this region was so closely tied to politics and ideology. Thus it was nearly impossible for an artist in this part of the world to concentrate only on autonomous artistic experiments, or to avoid taking sides in the ideological and social struggles of the age. By so doing, an artist could easily be outcast.

Bearing these circumstances in mind, the present study attempts to give an overall chronological sketch of the history of Modernism in Hungarian art and architecture before the First World War.

PARALLELS AND ISOLATED
ACHIEVEMENTS
OF MODERNISM BEFORE 1900

The year 1896 was a milestone in the history of Hungarian painting and architecture. The Museum of Applied Arts, the first mature example of Ödön Lechner's highly subjective Hungarian architectural style, was brought to completion. In early summer of the same year, a group of young painters went from Munich to Nagybánya, a little known town in the East of Hungary, to spend the summer there, painting.** They interrupted their journey in Budapest to see the Millennial Art Exhibition.

The Millennium was a vast display of late Historicism. Not only genuine art objects of a thousand years of historical and stylistic development were on show, but also new works of art with historical subjects. The paintings exhibited had been chosen to represent some remarkable event of Hungarian history, usually in the style of the Munich School of Academic historical painting, which is sometimes referred to as 'theatrical Romanticism'. These great canvases illustrated the conservative nature of officially inspired art, the *Weltanschauung* (worldview) which required the fine arts to depict and glorify historical events in a didactic manner. Typical examples were Gyula Benczúr's *The Recapture of Buda Castle* and Mihály Munkácsy's *Conquest*. The young painters from Munich looked at all this carefully, and were reaffirmed in their aim to turn against this official painting, and to go back to nature.

* The same patriotic pressures influenced Norwegian, Finnish, Polish and Czech artists. For example, see: *Northern Light, Realism and Symbolism in Scandinavian Painting, 1880–1910*, Brooklyn Museum, New York, 1982

** The important members of the Nagybánya Colony of painters were: Simon Hollósy, Károly Ferenczy, István Réti, János Thorma, and for a shorter period, Béla Iványi Grünwald and István Csók.

Even during the 1870s and '80s, young artists who took painting seriously and wanted to master its technical side had to go abroad, since there was no art academy in Budapest. The Vienna Academy had lost its appeal not only because of politically based prejudices against Austrian culture, but also because, since the late '60s, there were no great professors there. It was Munich which became the magnet for young artists not only from Hungary, but generally from the whole region of Central and Eastern Europe. (The South-German-Bavarian Catholic cultural heritage formed a traditional unit within Austrian and Hungarian culture, and the visual arts had always held a very important role within it, characterized by a love of sensuality.) However, by the end of the '80s, the Academy in Munich was out of touch with the latest stylistic experiments in Paris, and its style had lost relevance. Thus, the first attempts to renew Hungarian painting began when a young, sensitive Hungarian generation of painters studied in Munich.

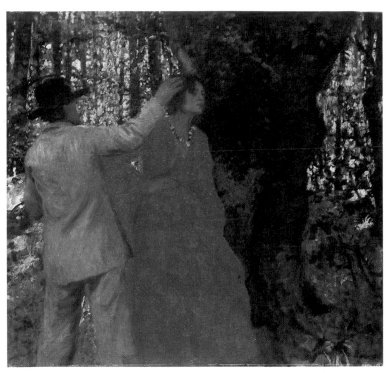

Károly Ferenczy: *The Painter and his Model in the Woods* 1901
Oil on canvas, 120 × 135 cm
Private collection, Budapest

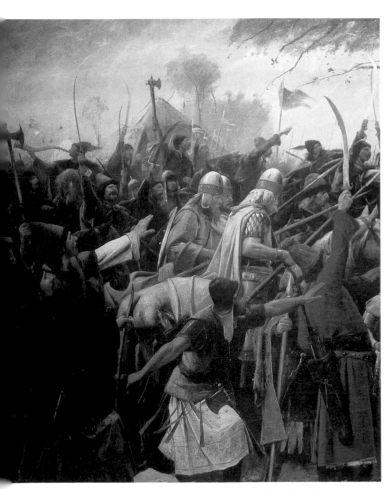

Mihály Munkácsy: *Conquest* 1890–1893 (Detail)
Oil painting in the Parliament Building, Budapest

It was in a private school, founded in 1886 by the Hungarian painter Simon Hollósy, that art students dissatisfied with the boring, dry, mechanical teaching of the Academy gathered and experimented. The precise and highly ethical naturalism of Leibl and the lyrical, gentle naturalism of Jules Bastien-Lepage most inspired them. (The exhibition of some paintings by the latter was a revelation not only for the Hollósy group, but also for German and Scandinavian painters.) Their bohemian company in Munich, which gathered in the Café Lohengrin, was open to influences from the sister arts too. According to their supporter, the critic Károly Lyka, Zola, Ibsen and Dostoyevsky were their most beloved writers and, in music, the works of Richard Wagner inspired them. Curiously enough, though, except for a few early, so-called 'fine naturalistic' pictures, hardly any sign of literary-mindedness can be noticed in their works. Their lyrical approach to nature, and their semi-religious attitude to art were both features of international Symbolism and a common aspect of the Central-European *Stimmungsmalerei* (for example: Károly Ferenczy's *Boys Playing Ducks and Drakes,* 1890).

In the so-called subtle or fine-naturalistic pictures of these painters, a gentle, pietistic and meditative mood hovers over the landscape and;

33

figures. There is a touching harmony between man and nature, and a soft, pantheistic symbolism developed out of this approach. It was Károly Ferenczy who first painted the type of harmonious compositions where colours dominate the design, and the atmosphere is full of tender lyricism, such as in his *Orpheus* of 1894.

The Hollósy private school and Hollósy's circle of friends, including István Réti, János Thorma, Béla Iványi Grünwald and Károly Ferenczy, moved in the summer of 1896 to Nagybánya, a small mining town set in picturesque surroundings in Transylvania.* Because of their desire to bring a new approach to art and to free it from the hegemony of conservative nationalistic political demands, they aroused opposition amongst the authorities, but gained as allies all the experimental writers and poets, such as József Kiss, Sándor Bródy and Zoltán Thury, who were the main representatives of literary naturalism grouped around the periodical *A hét* (The Week). The most beautiful book illustrations of an Art Nouveau flavour were born out of their friendship with these writers, such as Ferenczy's *Memory of Naples* (1896) to accompany one of Kiss's poems. Nonetheless, there was an important difference between the urban Budapest literati and the painters of Nagybánya, who were no great friends of urban culture.

The ideas that lay behind the setting up of an art community in the remote Hungarian countryside belonged to a current of thought which had been widespread in European art since the 1880s. Its adherents aspired to paint pre-industrial rural life in *plein air* (for example in Brittany), and thus to give modern art a foundation in deeper, more primal conditions of human experience than that provided by the materialistic industrial and urban modern way of life. (This is why, for example the painters of Nagybánya avoided fashionable modern urban themes with their clichés of the *femme fatale* and the fallen woman.) Their brand of aestheticism was somewhat aristocratic and escapist. For this reason, they were later regarded as the Hungarian representatives of *l'art pour l'art*. So Nagybánya had to face a long and hard struggle for acceptance, both by the art world and the public.

During the same period, the modernist painters of the Viennese Secession (founded in 1897) enjoyed immediate success, and within three years had revolutionized not only artistic life, but also public taste in the Empire's capital.** In Budapest, on the other hand, it was not until 1903 that Ferenczy's paintings (and thus the style of Nagybánya) were favourably received. The great strength of the Viennese Modernists was that the experimental artists, no matter whether they were architects, painters, or designers, or whether they preferred *plein air* or Art Nouveau, were able to bury their differences and launch a concerted attack on the conservative monopoly of art institutions and outmoded official art.

In Budapest, the situation was different. The only architect who in the early 1890's was already searching for a new architectural style was Ödön Lechner, who wanted to invent a Hungarian style, a style which was to be typical only of his homeland. A passionate patriot, he consciously experimented in his works with patriotic references by using, for example, exotic Oriental architectural forms intended to symbolize the Eastern origin of the Hungarian people; at the same time, he still used architectural elements belonging to the vocabulary of Historicism. In the decoration of his buildings, he used majolica ornaments modelled on the patterns of Hungarian peasant embroidery. The result was an appealing and unique style which became more and more organic and coherent in its form over the next few years.

At first Lechner was mocked, but he was also admired, and soon became an idol, the beloved mentor of many young architects who began to imitate his 'Hungarian style'. In fact, Lechner had been experimenting alone with creating a new Hungarian style for years before he realized how close his aims were to those of Art Nouveau. His personal taste in the other branches of the fine arts was extremely conservative; to him the task of a Hungarian painter was to depict national history in the style of Academic Romanticism.

* The only publication in English on Nagybánya is in the book Michael Jacobs: *The Good and Simple Life*. Phaidon, Oxford, 1985

** On Viennese Secession and Viennese culture see: Peter Vergo: *Art in Vienna 1898–1918*. Phaidon, Oxford, 1975; Carl E. Schorske: *Fin-de-Siècle Vienna–Politics and Culture*. Alfred A. Knopf, New York, 1980; *Vienna 1900. Art, Architecture and Design*. The Museum of Modern Art, New York, 1986

…dön Lechner: *Entrance to the Museum of Applied Arts, Budapest*

35

Much later, in 1902, the art critic Károly Lyka identified Hungarian style with 'modern style' (i.e. Art Nouveau), and from then on Lechner's followers regarded him as a Modernist.

In the field of applied arts, the first initiators of stylistic modernization were the leaders of the Museum of Applied Arts in Budapest. Jenő Radisics, the Director, came from the old liberal and very anglophile generation which negotiated the Compromise, and did much to make the Hungarian public familiar not only with Art Nouveau, but especially with the English achievements in the applied arts. Efforts were concentrated on improving the different crafts both technically and artistically so that Hungarian craftsmen could compete successfully in the market dominated by Austrian and Czech imports. In stark contrast to the situation in Vienna, where a rich upper bourgeois public had a highly developed feeling for the arts, in Budapest the furniture industry, weaving and all other trades still needed continuous and strong state support to survive. This situation was a decisive factor in the reform of Hungarian art, and took it on a different path to that of the Viennese. By 1897 Vienna and Budapest were cultural rivals within the Empire, each wishing to accentuate their differences. Vienna paid little attention to events in Budapest, and Budapest desperately tried to avoid producing anything which was similar to the angular Viennese style. They tried to find visual forms supposedly embodying the ethnic, 'temperamental' difference between Hungarians and other nations of the Empire. Instead of the geometrical style, they preferred soft, flowing lines and symmetrically arranged floral ornaments. And so the official promoters of Hungarian applied arts looked beyond Austria to France, but even more to England, for inspiration.

In these years the first Art Nouveau *Gesamtkunstwerk* or artist-designed interior in Hungary, a dining room for the aristocrat and connoisseur Count Tivadar Andrássy, was just taking shape in the studio of József Rippl-Rónai, a painter who had lived since 1889 in Paris. He had been an associate of the Nabis, and had worked for Samuel Bing's shop. His style was sophisticated and considered too decadent and individualistic for the majority of Hungarian art critics. When he exhibited some of the Andrássy dining room designs in 1898, they attacked him

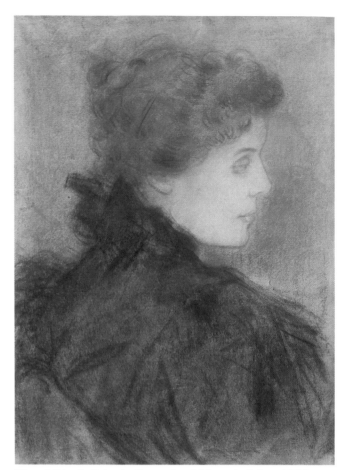

József Rippl- Rónai: *Portrait of Mrs. Andrássy* 1896
Pastel on cardboard 55 × 39 cm
Private collection, Budapest

so harshly that he abandoned design altogether. After resettling in Hungary in 1900, Rippl-Rónai had to wait till the end of 1906 for artistic recognition and public success. His early Paris style, with mainly dreamy female figures in a soft, monochrome palette, later underwent a major change. His favourite new subject became intimate family life in the small country town of Kaposvár with its cheerful interiors, and decorative but psychologically well observed portraits. After 1907, probably inspired by Gauguin and Matisse, his canvases radiate the joy of exuberant colour. He remained one of the greatest unappreciated painters of the time, who never established a school, and was supported only by a few chosen connoisseurs.*

Another isolated figure was János Vaszary, a brilliant painter who studied in Munich and Paris at the Académie Julien, and who changed his

* There is a volume of illustrations of his work with an introductory essay in English by Judith Szabadi in *József Rippl-Rónai*. Corvina, Budapest, 1983

style several times. In the early 1890s he painted in the pearl-grey, soft tones of Bastien-Lepage's naturalism. Later, he made astonishingly bold Germanic-type *Jugendstil* compositions loaded with fashionable symbolism (for example, *Golden Age,* 1897–1898). Then there was a further change to full-blooded realism in his pictures of rural life; and from about 1904 onwards, Vaszary was one of the most remarkable of the late-Impressionist masters.*

In short, the artistic 'battlefield' before 1900 in Hungary comprised isolated groups and individuals with different stylistic preferences who opposed a strong, state-sponsored conservative establishment. There was no local version of Art Nouveau as yet, but numerous masterpieces indicated that there was enormous creative potential which could be utilized to reform the fine and the applied arts.

ETHNIC HUNGARIAN ART NOUVEAU AND THE ENGLISH INFLUENCE

The Anglo–Scottish inspiration in the applied arts in Vienna was very important, but short-lived: once the Secessionists Joseph Hoffmann and Kolo Moser had crystallized their own artistic idiom, imported examples were no longer needed.

In Budapest, a small group of anglophile civil servants within the Ministry of Education and the High School of Arts influenced artistic life both through the periodical *Magyar Ipar-művészet* (Hungarian Applied Arts), which was published from 1897 onwards, and through state commissions.** It was they who invited Walter Crane to Hungary, and Crane's exhibition in October 1900 generated a vast amount of publicity. This minor late Pre-Raphaelite was taken around the country and shown the vividly decorative folk art of Kalotaszeg in Transylvania. He wrote later: *'The peculiar character of the Hungarian people lies in their rich and endless imagination in floral decoration.'* With this observation, Crane endorsed the aims of those artists who wished to create a Hungarian style by using peasant art decoration on all kinds of handicraft products, and on buildings.

The utopian dream of creating a national style *par excellence* was given strong impetus from 1903 onwards by a general change in the intellectual and political climate of the country. (Such a style even began to gain substantial financial support from the state.) The reasons for this change, which was characterized by the decay of liberalism and growing national populist tendencies, were twofold: firstly, the ruling Hungarian upper classes felt themselves threatened by the rapidly growing nationalism of the minorities within the territories of the 'Kingdom of Saint Stephen', and their fears were not unfounded. By that time, the Slovakian, Rumanian, Serbian, Croatian and other minorities constituted nearly half of the country's population. The Hungarian government reacted with more and more intolerance to this political pressure. Secondly, because a very unfavourable new Imperial Army Bill neglected Hungarian interests, different factions of the national opposition joined forces and began a Parliamentary philibuster. This was only the start of nearly four years of political crisis and the beginning of a new wave of patriotism in Hungarian culture. Consequently, there was an attempt to give national character to everything–to architecture, to painting, and even to furniture.

In Hungary, as in most of the Scandinavian and East European countries around the turn of the century, passionate romantic anti-capitalism also had nationalistic overtones. Thus the ideas behind the promotion of folk art included explicit criticism of modern capitalist urban life. The teachings of Ruskin and Morris seemed to harmonize perfectly with these ideas, and so it was easy to look upon them as prophets of the revival of peasant art. As we have seen before, to artists around 1900, folk or peasant art became the 'pure source' of ancient national forms and was seen to reflect parts of the unspoiled character of the nation. Painters and designers trod into remote corners of Transylvania to collect folk art, the patterns and motifs of which they included in their repertoire of ornaments.

It was only in 1903 that the first organized Art Nouveau Colony was established at Gödöllő,

* There is no individual book on Vaszary in English. The only book on Hungarian Art Nouveau painting in English is Judit Szabadi: *Art Nouveau in Hungary,* Corvina, Budapest, 1989
** On the influence of English Arts and Crafts in Hungary see: Ilona Sármány-Parsons: "The Influence of British Arts and Crafts Movement in Budapest and Vienna", in *Acta Historia Artium,* Tomus XXXIII 1987–88; 181–198.

near Budapest. It was the Ministry of Culture which stimulated this event by donating the looms of a bankrupt weaving factory. The task entrusted to the painter Aladár Körösfői Kriesch and the weaver Leo Belmonte was to revive the art of weaving in Hungary. They were soon joined by an old friend, the graphic artist and designer Sándor Nagy, and a group of women, some of whom were the artist's relatives, and others members of the former weaving workshop. In this way, a remarkable colony grew up.*

The Gödöllő art colony showed an overwhelming tendency towards religious symbolism coupled with a strong social conscience. To them, the artist had to be a social critic and moralist, the leader of the spiritual renewal of the world based on the establishment of the long lost unity between art and life. As Hungarian disciples of the theories of Ruskin, Morris and Tolstoy, they admired the ethical value of handicrafts and the role they played in integrating people into an organic community. They saw the realization of this in old Transylvanian folk art. In addition, especially in the heterogeneous orientation of Sándor Nagy, the teachings of the mystical *Rose et Croix* movement were mixed up with the prophetic theories of the gnostic Hungarian philosopher Jenő Henrik Schmitt, and of Nietzsche. The fusion of very different intellectual influences was brought about in an idealistic way which lacked rational systematization, was highly emotional, and was expounded in prophetic tones. Art was only a means–though the most important means–to reform life and to create a new type of person. A didactic representation of this vague message, overloaded with naive allegories, was more important than the perfection of form and artistic quality. Thus, the output of the members of the colony had an uneven quality and was often anachronistic and eclectic in style. Even so, the fairy-tale atmosphere of their works, together with their cult of peasant art and naive piety, strengthened officialdom in the belief that their Hungarian variant of folkloristic or *ma-gyaros* Art Nouveau would be the only authentic basis for a new national style.

Gödöllő reached the height of popularity after 1906, following the great success of their furniture and textile designs in an interior entitled *Home of the Artists* exhibited in Milan. From this time on the leading painters of Gödöllő obtained important state commissions until the First World War, of which the frescoes for the *Academy of Music* in 1907, for the *Church of Zebegény* in 1912, and the stained-glass windows of the *Cultural Palace* of Marosvásárhely (now Tirgu Mureş, Rumania) in 1912, are the most remarkable. Their late Art Nouveau decorative style became the semi-official style after 1906. It was by then a kind of modest modernism, which was outdated not only by comparison with the Western European avant-garde, but also with the artistic experiments of a young generation of Hungarian artists who started to exhibit around 1907. Their most important works were their stained-glass window designs, which can stand comparison with the best of the revival of this genre in England and in Europe as a whole.

THE NEW GENERATION OF MODERNISM: THE AWAKENING OF URBAN SOCIAL CONSCIOUSNESS

Though the Nagybánya group with what has become known as its 'colouristic naturalism based on synthesis' represented a high aesthetic standard and was the only alternative available for art students to the still ultra-conservative School of Fine Arts in Budapest, by 1904–1905 it was not considered modern enough by the new generation. After the group split up in 1901 and its original robust leader, Simon Hollósy, had left, Károly Ferenczy became the natural successor. Before 1900 he painted several large, symbolic canvases such as *The Three Magi*. In these he created a mystical atmosphere where man and nature seem to be cast out of the same material, yet where miracles may be expected at any moment. A mystical pantheism radiates from many of his works, evoked by the perfectly balanced compositions and a delicate harmony of tones and colours. Even when he painted his mundane household surroundings, for example in *October* of 1903, the calm, noble human figure becomes an organic part of the natural environment, and

* The most important members of the Gödöllő Colony were Aladár Körösfői Kriesch, Sándor Nagy, his wife Laura Kriesch, Endre Frecskai, Leo Belmonte, Árpád Juhász, Rezső Mihály, Ervin Raáb, Jenő Gy. Remsey, Ferenc Sidló, Mariska Undi, Carla Undi, and István Zichy. Several artists gave decisive impetus to the colony, but were not among its members, the most important being the designer, draughtsman and architect, Ede Thoroczkai Wigand.

the elegant, classically balanced composition suggests peace and harmony between man and nature, a lost paradise for urban beings.

Nevertheless, this intimate art soon began to lose the allegiance of the younger generation studying at Nagybánya. Dissatisfied with naturalism and atmospheric painting, they oriented themselves towards the new styles, especially Neo-Impressionism, although they included all kinds of stylistic experiments within this umbrella-term. Paris became the magnet, and between 1904 and 1907 a flood of young Hungarian painters went to study there. Their visits coincided exactly with those decisive years when the great retrospective exhibitions of the œuvres of Cézanne, Gauguin and Van Gogh changed the entire evaluation of the painting of the previous three decades. Some Hungarians were influenced by French Fauvism and even studied in Matisse's studio, Béla Czóbel and Vilmos Perlrott-Csaba among them. Even the old masters like Rippl-Rónai and Iványi Grünwald changed their styles in these crucial years, and one must assume that the great Post-Impressionist exhibition of 1907 in Budapest also played a role in this stylistic metamorphosis.

The great political crisis betwen 1903 and 1907 had ended in disillusionment and had brought a rapid radicalization of the social classes and the intelligentsia, and so, from about 1907 up to the First World War, a thorough breakthrough in modernism characterized all fields of Hungarian culture, from literature through music and the fine arts to architecture.

Károly Ferenczy: *The Three Magi* 1899
Oil on canvas, 154.5 × 195 cm
Hungarian National Gallery, Budapest

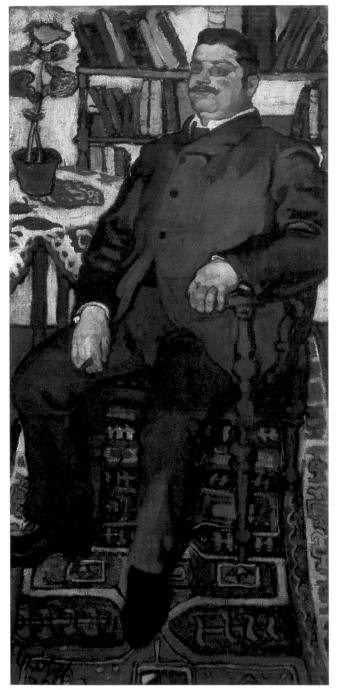

Béla Czóbel: *Sitting Man* 1906
Oil on canvas, 170 × 80 cm
Hungarian National Gallery, Budapest

ARCHITECTURE

Prior to 1907, there had been a long depression within the building industry; the larger commissions for public buildings and banks had been given to a lobby of powerful conservative architects led by Ignác Alpár, a protagonist of heavy-handed late-Historicism. Around 1905, after the fashion boom of floral Art Nouveau had faded, a new architectural approach began to take shape everywhere in Central Europe. More and more attention was paid to social requirements, to questions of public hygiene, and a socially oriented way of thinking was adopted. Rather than style, the architects and designers concentrated partly on technical problems and partly on creating the conditions for a more comfortable home environment. In Central Europe, the garden-city movement, guided by the English example, united all these different tendencies into a complex of profound reforms.

Around 1907–1908, the depression in the building industry came to an end, and a basic reform in Budapest's City Council under the neo-liberal Mayor, István Bárczy, opened up new possibilities for urban planning in conjunction with progressive social ideas. The best artistic achievements of the building-boom which lasted until the First World War were all closely tied to careful urban planning and the renewal of Budapest. A good example of this is the school in Vas Street, designed by Béla Lajta.

A handful of neo-liberal intellectuals were the initiators of this urban revival. They were all closely connected with the periodical *Huszadik század* (Twentieth Century, first published in 1900), and thus even with the social radicals. The generation of young architects* around them was ready to learn from all progressive, 'up to date' stylistic experiments, whether they came from Germany, Finland, England or Vienna.** Traditionally known as *Fiatalok* (Young Architects) it included artists and architects such as Károly Kós, Béla Jánszky and Dezső Zrumeczky. They were the real Hungarian heirs of English Arts and Crafts theory and practice, although formally they never adopted its stylistic idiom.

During their university years, these young architects took part in collecting the material for the handbook on Hungarian folk art edited by Dezső Malonyay, published between 1907 and 1922. Inspired by this work, they looked beyond folk art's formal stylistic elements and interpreted it as having symbolic value, as embodying a mysticized ideal of the good life in happy symbiosis with nature. The group also recognized the

* The most important architects of this period were Béla Lajta, Béla Málnai, József Vágó, Aladár Árkay, Marcell Komor, and Dezső Jakab.
** An exhibition of Finnish art was shown in Budapest in 1907, and for a while exerted a strong influence on local architects. Several periodicals introduced German and English architecture to specialists.

innate 'constructive' or functional character of Transylvanian wooden architecture, and its village churches and picturesque cottages. Behind the outward appearance of these buildings, they rediscovered their origins in Gothic architecture, and thus managed to find the bridge between part of the national heritage and modern, progressive architecture. Their own buildings–mainly small family houses and churches–were equally picturesque, with a fine feeling for local tradition in the use of materials, and in their basic proportions. Most of them were such excellent draughtsmen that their architectural fantasies with a folk-tale flavour form a special genre within Hungarian graphic art.

One of these young architects, Károly Kós, developed into a versatile artist–a draughtsman, printer, and remarkable writer. He was one of the first to design houses for a garden city in Budapest, with high, sloping little turrets, wooden balconies and spires. This garden city remained, however, unique in Hungary.

PAINTING: 'THE EIGHT' AND THEIR CONTEMPORARIES

In painting, the new generation which introduced fresh Paris-inspired artistic ideas into Hungarian art offered a revised interpretation of the relationship between man and nature, and was politically much more active than Hungarian painters had previously been. Mention should be made of an extraordinary exhibition of the MIÉNK (Hungarian Impressionists and Naturalists) in 1907 in the National Salon in Budapest, which was the final victory of the older generation of experimental painters over Academicism. All the important painters participated, and it was thus a similar demonstration of modernism to that of the first Secession exhibition in Vienna ten years before. This broad alliance of painters, however, did not last long: the most radical, called the Searchers *(Keresők)*, soon formed a separate group and toured the country with their works.

Even the unclassifiable individualist Lajos Gulácsy, who lived in an aesthetic dream world of his own creation and kept himself distant from politics of any kind, exhibited with this group. With their romantic symbolism, Gulácsy's early paintings were still conceived in the Pre-Raphaelite tradition. Later, his painful, self-tortured fan-

Károly Kós: *Song About Attila the King* 1909
From *Magyar Iparművészet* 1909

tasies populated by clowns and lovers, knights and sorceresses, turned into a visionary limbo. Fragile landscapes and sophisticated colour harmonies are impregnated with indefinable fears and anxieties. In the last paintings by Gulácsy, fantastic beings and mystical images emerge from the hidden world of the subconscious–a daring experiment in the revelation of the human psyche.

Another painter who trod his own path was István Csók, who in the late 1890s had close ties with Nagybánya. He was the only Hungarian painter at the turn of the century who, like Gulácsy, but in a much more earthbound way, dared to handle overtly decadent themes in works such as *Salome* or *Vampires*. Csók's women are explicitly sensual, even lushly erotic. No doubt, the fact that Csók lived in Paris between 1903 and 1909, and not in the philistine and conservative Hungarian countryside, influenced him in his daring choice of subject.

There is one great outsider of Hungarian painting who in his lifetime was never included in the Hungarian art world, Tivadar Csontváry

Kosztka. This strange, obsessed genius painted huge, visionary works in such a subjective style that they were inaccessible to the general public; his work was too eccentric even to find favour among his colleagues. As a result, his pantheistic worldview filled with heroism and emotion remained virtually unknown to his contemporaries.*

Turning back to the events of the year 1908 and to the genesis of a new stylistic trend, another phenomenon demands attention. 'The Searchers' organized readings of modern poetry at their exhibitions, inviting amongst others the greatest living Hungarian poet of the day, Endre Ady, to read his own work. The great public success of both the paintings and readings organized by the Freemasons drew the ties close between the poets and the painters. Károly Kernstok, the head of the group who from the time of their second exhibition called themselves 'The Eight' (Nyolcak), was a Freemason himself and a very open minded radical, who later became an enthusiastic socialist.** It was mainly through Kernstok that the group joined the small but vitally important circle of Hungarian intellectuals who, within a few years, changed the face of Hungarian culture. Possessing a world-wide, up-to-date cultural horizon, they tried to reform and modernize all aspects of social and political life.

'The Eight' joined this political-intellectual stream. They became for a few years the representatives of the same modernization within painting. Two theoreticians and aesthetes, the critic Lajos Fülep and the philosopher Georg Lukács, understood and interpreted their aims and their *Weltanschauung,* or worldview, best. Instead of subjective individualism, the prey of ever-changing mood, whose appropriate form is

*See on him in English Lajos Németh: *Tivadar Csontváry Kosztka.* Corvina, Budapest, 1970

** The members of 'The Eight' were: Róbert Berény, Béla Czóbel, Dezső Czigány, Károly Kernstok, Ödön Márffy, Dezső Orbán, Bertalan Pór and Lajos Tihanyi.

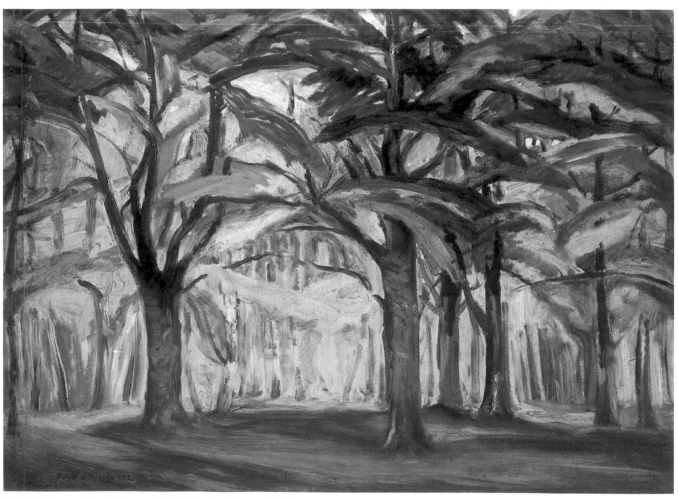

Károly Kernstok: *Autumn Ligth (In the Forest)* 1922
Oil on cardboard, 73,5 × 100 cm
Hungarian National Gallery, Budapest

Dezső Czigány: *Still-life with Apples c.* 1910
Oil on canvas, 50 × 61 cm
Hungarian National Gallery, Budapest

naturalism or Impressionism, these writers asserted that modern society needs a rational, well-organized order, the suitable form for which must be a style showing the structure of objects and of nature. Georg Lukács in his famous article, 'The Roads Parted', published in 1910 in the progressive journal *Nyugat* (West), produced a manifesto on the new style appropriate to a future public-spirited society. Not simply a response to arbitrary feelings, but a rational selection from nature, this was the artistic credo of the group. A new interpretation of traditional genres developed out of this approach. In landscape painting, townscapes dominate, while in their portraits, geometric lines are imbued with a rough, almost cruel psychological realism. The monumental artistic undertakings of the group were huge, figurative canvases, partly vehicles for

vague symbolic meanings, and partly decorative compositions of nude groups in a landscape–rationally planned arcadian scenes. For 'The Eight', the enthusiastic will to build a new society took precedence over purely formal experiments, but they were open to all modern trends. They absorbed all kinds of influences, each according to their own personality; some were inspired by Cézanne (Czigány), or by the Fauves (Czóbel, Márffy); others by Expressionist and Cubist tendencies (Tihanyi). Their natural allies were the writers of the literary periodical *Nyugat* (West, first published in 1908) and the circle of the young Georg Lukács. The patronage of 'The Eight' came from the upper bourgeoisie, which was partly Jewish, and which gave them lavish commissions to decorate their villas around 1910–1911.

Ödön Márffy: *Portrait of Lajos Gulácsy* 1907
Oil on canvas, 63 × 52 cm
Hungarian National Gallery, Budapest

Lajos Tihanyi: *Self-portrait* 1912
Oil on canvas, 65 × 45 cm
Hungarian National Gallery, Budapest

By the end of 1912, 'The Eight' had disintegrated. Possibly the political crises of that year were partly responsible; but perhaps also, the individual members of the group, having become acceptable–well-known even–might no longer have felt the necessity of belonging to a group. Their role within Hungarian cultural life had been to integrate avant-garde experiments in the fine and the sister arts into a loosely united force against the conservative cultural establishment. Their stylistic experiments inspired the later artistic avant-garde, the Activists and the early Constructivists.*

THE MODERNIZATION OF HUNGARIAN FINE ART: A EUROPEAN PERSPECTIVE

During the last two decades before the First World War, Hungarian art experienced a sudden surge of modernism and a will to experiment.

The belated modernization of Hungarian society now challenged the patriotic artistic intelligentsia, and forced them to combine their experiments in the stylistic and aesthetic fields with social, ethical and utopian ideas. Thus, Hungarian art, like most of the art of the smaller European nations (for example that of Scandinavia or Poland) was highly engaged in politics. This meant that it was quick to reflect social and political changes, new ideas, and ideologies.

There was no such forceful and cohesive art movement in Hungary as the Secession in Vienna. The breakthrough to modernism was therefore not dramatic and abrupt; it was characterized by a wide range of different stylistic experiments such as naturalism and *plein air,* Art Nouveau and Symbolism. In this respect the artistic profile of Hungary at that time shows close similarities with Scandinavian and German art; it lacked the stylistic trend of classical French Impressionism, but it had a strong local, Post-Impressionist schol which represented a transition towards a more radical Modernism.

* Publications on 'The Eight' in English are Júlia Szabó: *The Hungarian Avant-garde (The Eight and the Activists).* Hayward Gallery, London, Febr. 27 to April 7 1980, and Steven A. Mansbach: "Revolutionary Events, Revolutionary Artists: The Hungarian Avant-garde until 1920", in *"Event" Arts and Art Events,* ed. Stephen C. Foster, UMI Research Press, Ann Arbor, London, 1987

Unlike the artists of the Vienna Secession, the Hungarian representatives of Art Nouveau did not create a homogeneous local style, especially in architecture. With the exception of the works of Lechner and his followers, Art Nouveau buildings in Hungary reflect an eclectic taste which combined the formal elements of French and Belgian Art Nouveau, and especially of German *Jugendstil*. The outstanding painters of the period (Ferenczy, Rippl-Rónai, Gulácsy, Csontváry) worked in relative isolation, since state patronage favoured mostly minor talent and supported those tendencies which were regarded as typically ethnic. The search for a national style did exist elsewhere in Europe, mainly on the periphery, in Finland, in Russia and amongst Polish artists in Cracow; however, in contrast to the Hungarians, these lacked the support of state sponsorship and thus produced only a handful of works.

When comparing the Hungarian cultural climate with that of the rest of Europe, another sociological factor is evident as a local determinant: the entrepreneurial bourgeoisie, who were relatively small in number, began to play an important role in patronage only from about 1905 onwards. They were the genuine sponsors of early modern architecture and of 'The Eight', whose art was heavily inspired by the greatest masters of post-Impressionism, Cézanne, Gauguin, and finally by the Fauves and the German Expressionists.

By about 1914 Hungarian art and architecture had caught up with Modernism; it was by then reflecting the achievements of the cosmopolitan art centres of Europe; private sponsorship helped artists to continue their experiments in Expressionism and Constructivism. The artist was

Bertalan Pór: *Portrait of Ödön Lechner* 1909
Oil on canvas, 51 × 41 cm
Budapest Historical Museum

now expected to be at one and the same time modern and experimental, and a socially engaged patriot.

Within the Austro–Hungarian Empire, the Viennese Expressionist generation (Schiele, Gerstl and Kokoschka) were isolated rebels, either indifferent to politics, or disillusioned. In Hungary, their contemporaries still shared the illusions of the optimistic radical intellectual, who dreamed of victorious social revolution and had not yet sensed the coming storm of the *Weltuntergang*, the collapse of the Austro–Hungarian Empire.

45

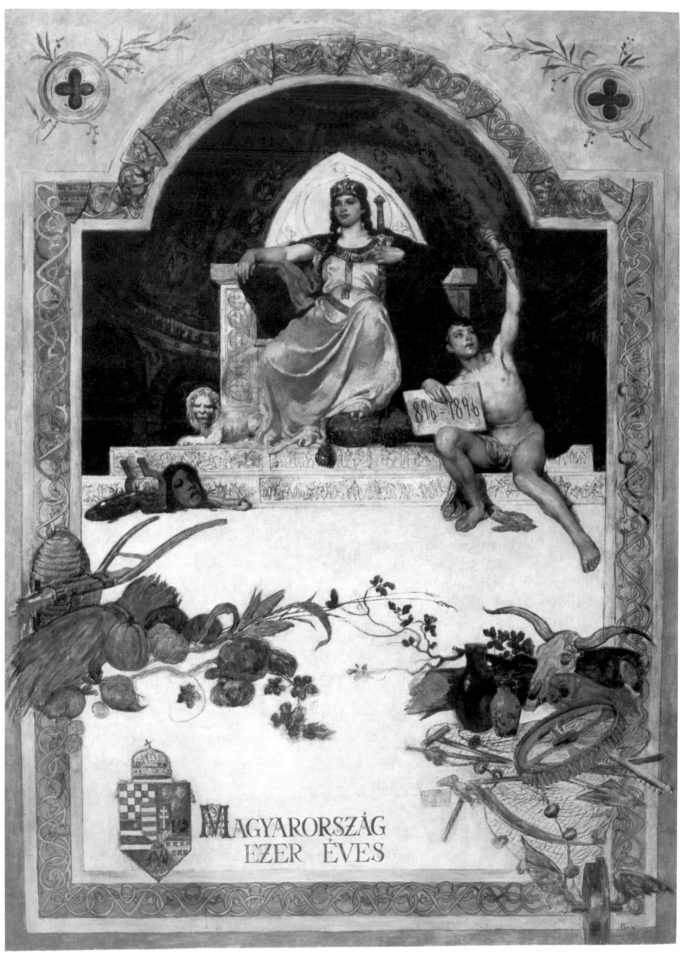

Lajos Deák-Ébner: *Hungaria* 1896
Oil on canvas, 125 × 90 cm
Private collection, Budapest

The Millennial Celebrations of 1896

The year 1896 was ushered in with a series of spectacular celebrations. Church bells tolled at midnight throughout the country in commemoration of the one thousandth anniversary of the arrival of the Magyar people in the Carpathian Basin. Through each week that followed, at least one noteworthy event marked this great historical milestone.

The three decades that had elapsed since the 1867 Austro–Hungarian Compromise had seen progress in many walks of life; now, at the time of the Millennial celebrations, they reached their zenith. This sense of 'millennial euphoria', as it later became known, was not entirely misplaced. It was based on dynamic economic development and the modernization of every aspect of life.

Economic growth was accompanied by a general flourishing of intellectual life, especially in the realm of the sciences. The final quarter of the nineteenth century saw several Hungarian inventions of international importance: the Bláthy–Zipernowsky–Déri transformer made possible the introduction of alternating current throughout Europe; the Csonka carburator revolutionized car manufacture, and the Mechwart roller-frame revived the milling industry. The current meter too was invented in Hungary, as were the crypton light-bulb, the telephonograph and even the electric floor-polisher.

Opening in Budapest in May 1896, the Millennial Exhibition provided not only an excellent summary of one thousand years of history but also furnished proof of the general prosperity of the time. Over fourteen thousand objects were displayed in historical tableaux that ranged from the tenth to the late nineteenth century. A millennial village was constructed as an open air museum which exemplified various regional and ethnic styles of architecture, while continuous performances by peasants in folk costume emphasized the richness of the country's ethnic traditions. History, culture, education, literature, industry, agriculture and the Church all participated; even Ősbudavár (Ancient Buda Castle),

the temporary entertainment quarter of the capital, found an appropriate place in the exciting cavalcade of the exhibition.

The halls of the major art gallery in Budapest, the Műcsarnok, were filled with historical paintings by officially approved artists. Many of these large paintings had been commissioned, and, though the majority were hardly more than illustrations of parables from Hungarian history presented in an Academic style, they nevertheless made an impressive display. One painting mis-

Exhibition hall at the Millennium 1896
Archive photo by Kornél Divald
Budapest Historical Museum

Ancient Buda Castle scene with the 'Harem' 1896
Archive photo by György Klösz, Budapest Historical Museum

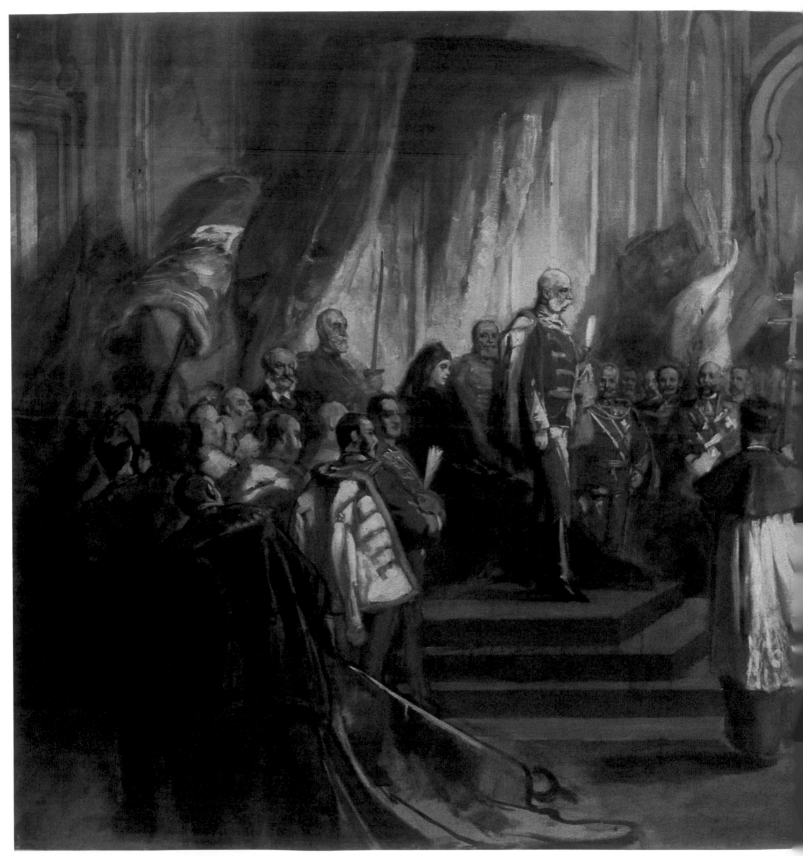

Gyula Benczúr: *Millennial Homage* 1897
Oil on canvas, 123 × 240 cm
András Jósa Museum, Nyíregyháza

sing from the collection was Gyula Benczúr's *The Recapture of Buda Castle,* a bombastic celebration of victory over the Turks after a century and a half of Ottoman domination. Although it had been painted specially for the occasion, it had failed to gain acceptance because of its immense

size, but was finally exhibited in a special pavilion of its own.

Historical *tableaux vivants* and processions added substance to sheer spectacle. Some of these are documented in *Millennial Homage,* a series of paintings by Benczúr and Ferenc Eisenhut, made in 1897. While Benczúr displays customary extravagance, Eisenhut preserves the atmosphere of these celebrations in a more authentic and yet monumental manner.

Depicting the Magyar Conquest and the defeat of the Slavs in the ninth century, the *Feszty Pa-*

49

Árpád Feszty painting the Millennial Panorama
1893–1894
Archive photo, Budapest Historical Museum

Court ball in Buda Castle c. 1890
Archive photo by Strelisky, Museum of the Hungarian
Labour Movement, Budapest

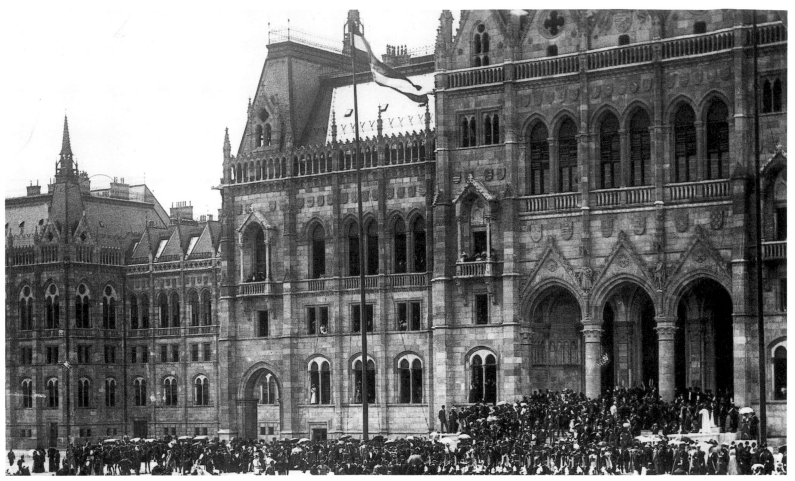

Taking the Hungarian crown to Parliament on 8 June, 1896
Archive photo by György Klösz,
Budapest Historical Museum

Ferencz Eisenhut: *Millennial Homage Procession* 1897
Oil on canvas, 180 × 290 cm.
András Jósa Museum, Nyíregyháza

Albert Schickedanz: *Museum of Fine Arts, Budapest* 1899
Watercolour on paper, 58.2 × 87.7 cm
Museum of Fine Arts, Budapest

The former 'Gloriette'
drinking fountain on Heroes'
Square with the entrance to
the Millennial Exhibition in the
background.
Archive photo György Klösz

The Millennial Monument on Heroes'
Square 1896. Designed by György
Zala and Albert Schickedanz in 1894
Aquarelle on carton, 224.5 × 70 cm
Budapest Historical Museum

norama, fifteen metres high and one hundred and twenty metres long, was a tremendous success. Panoramas were much in vogue in the latter half of the century, and so between 1893 and 1894 Feszty collaborated with several of his fellow artists to produce this enormous example, complete with diorama illustrating important events in Hungarian history.

The closing of the Millennial Exhibition in 1897 also marked the end of an extraordinary period of art of which the *Millennial Monument* in Heroes' Square in Budapest remains a lasting symbol. Erected in 1894, György Zala's creation is in every way typical of its time. Zala, together with János Fadrusz and Alajos Stróbl, was among the sculptors commissioned to work on official commissions. Such projects demanded both brilliant craftsmanship and the adaptation of standardized criteria of form, which left no scope for individual vision.

At this time, architects also turned to monumental, archaic forms for inspiration. Imre Steindl's *Parliament* building, the embodiment of constitutionality, is an outstanding example,

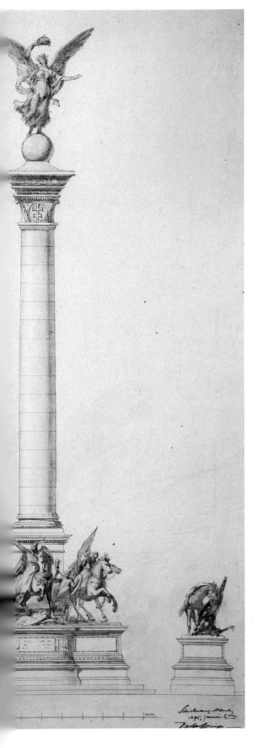

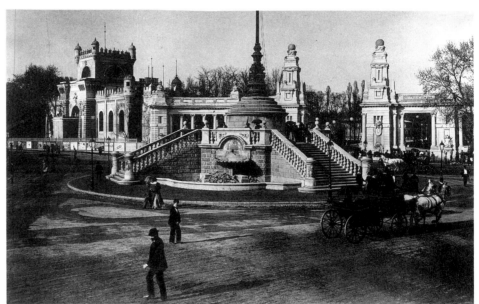

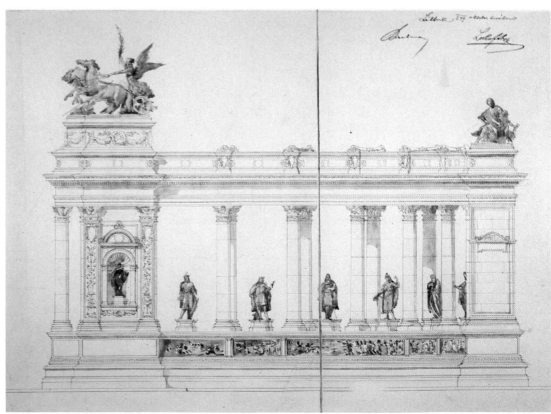

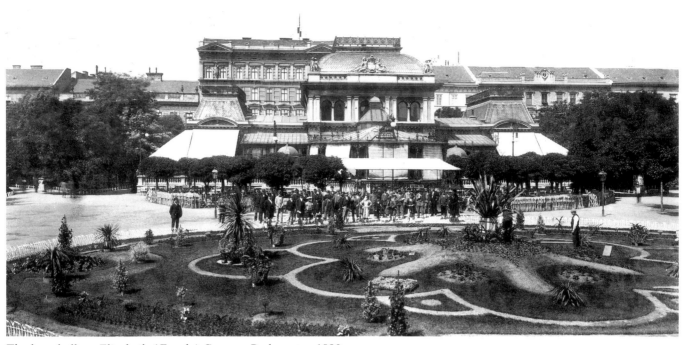

The beer hall on Elizabeth (Engels) Square, Budapest c. 1890
Designed by Alajos Hauszmann in 1873–1874
Archive photo by György Klösz, Budapest Historical Museum

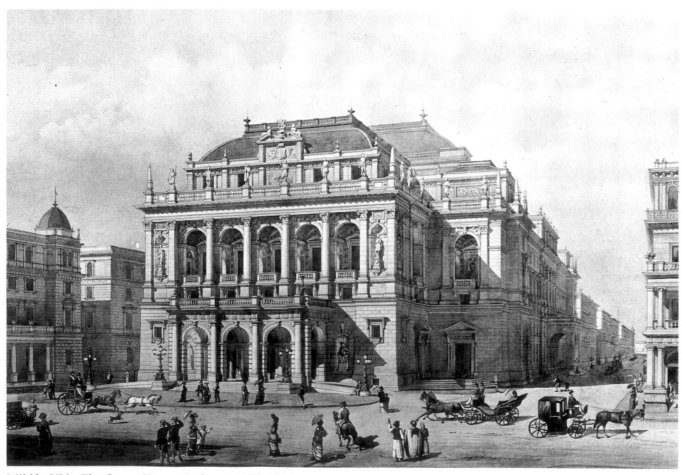

Miklós Ybl: *The Opera House, Budapest* 1875–1884
Office for the Preservation of Historical Monuments, Budapest

along with Alajos Hauszmann's *Kúria* (c. 1910), the symbol of jurisprudence, which served to house the Upper Courts, and Miklós Ybl's *Royal Palace* (1894–1900), the symbol of royal power. This residence, extended and developed by Hauszmann for the Emperor Franz Joseph was intended to be the equivalent of the Burg in Vienna.

The Parliament building, 265 metres in length, exquisitely proportioned and superbly located by the Danube in Pest, quickly attained symbolic importance for the country. Steindl adopted the internationally known 'parliament style' which was much in vogue at the end of the last century. Its handling of architectural mass and neo-Gothic detail recalls Barry's Houses of Parliament of London. Although contemporary critics were less than enthusiastic about its interior design, its frescoes and murals have since been much admired. Károly Lotz, who by the 1870s had developed a reputation as the leading ornamental painter of palaces and other public buildings, was responsible for the fresco known as *The Apotheosis of Hungary* (1896–1897). It shows brilliant handling of colour and a striking confidence in composition, and provides a good balance to the eclectic architectural interior.

Based in Paris at the time, Mihály Munkácsy had just completed a vast fresco in the stairway of the Kunsthistorisches Museum in Vienna when he was asked to undertake the mural entitled *The Conquest* (1890–1893). In accordance with the demands of the Millennial spirit, this theatrical piece, which aspires to historical authenticity, blends well with the no less theatrical architecture of the Parliament building itself.

Miklós Ybl, the architect of the Royal Palace, died in 1891, before the building could be completed. Hauszmann, his successor, followed his ideas quite closely, making only a few minor modifications. The domed central section of the Palace, reconstructed after the Second World War is, however, wholly Hauszmann's work. There was considerable damage to the building during the war: its internal architectural decoration, Károly Lotz's murals depicting *The Apotheosis of Franz Joseph* (1893) and Hauszmann's *St. Stephen's Room* were all destroyed along with most of the interior.

The late nineteenth century also brought increased concern for the protection of historical monuments. To this end, the *Church of Our Lady*

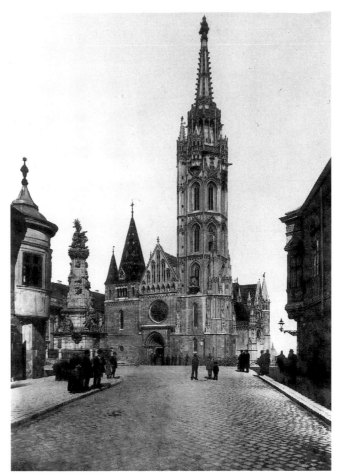

Matthias Church
The old church was redesigned in 1874–1896 by Frigyes Schulek
Archive photo, Budapest Historical Museum

(Matthias Church) in Buda was renovated in the Neo-Gothic style on the basis of Frigyes Schulek's designs. Thus the church where Emperor Franz Joseph had been crowned King of Hungary in 1867 became, like the Parliament building, a symbol of national continuity.

Schulek's work reached its peak in the restoration of historical monuments. He worked on the Town Hall of Lőcse (Levoča, Czechoslovakia), on Saint Nicholas' Church in Eperjes (Prešov, Czechoslovakia), and on Visegrád's Solomon Tower. As the Matthias Church was nearing completion, he also designed a suitable setting, the *Fishermen's Bastion*. Erected between 1899 and 1905, it proffered a magnificent panoramic view of the city from Castle Hill and acted as a dramatic backdrop to the church.

The murals of Matthias Church were painted by Bertalan Székely, who along with Gyula Benczúr and Károly Lotz, was one of the outstanding representatives of the International Academic

style. The œuvres of the three artists, however, show considerable variance: Benczúr was a first-rate craftsman who did not hesitate to place his work at the service of the aristocracy; Székely, however, worked more directly for the sake of artistic experience; and the major part of Lotz's works belongs to the realm of applied art.

While *plein air* painting left little mark on Academic artists such as Benczúr and Székely, Lajos Deák-Ébner employed its insights to impressive effect in his works of the 1870s which were influenced by his contact with the artists' colony at Szolnok in eastern Hungary. His *Hungaria,* painted in the year of the Millennium, is an example of the genre of historical tableaux.

The same period witnessed the spread of photography. After a Hungarian invention helped to perfect Daguerre's process in the 1840s, professionals and amateurs, sometimes in collaboration, sometimes in rivalry, expanded and refined its technique. Of these, the most important for the cultural history of Budapest proved to be György Klösz. He set up his studio in 1867 in Pest, and within a few decades, it became one of the country's major graphic institutions, and in time, a pioneering printing shop. Klösz specialized in buildings and townscapes, and his surviving views of *fin de siècle* Budapest are important documents of the period. He also published an album of photographic reportage entitled *A Souvenir of the Millennial Exhibition* (1904).

Lajos Góró: *Detail of the Millennial Exhibition*
India ink on paper, 27 × 13.5 cm
Budapest Historical Museum

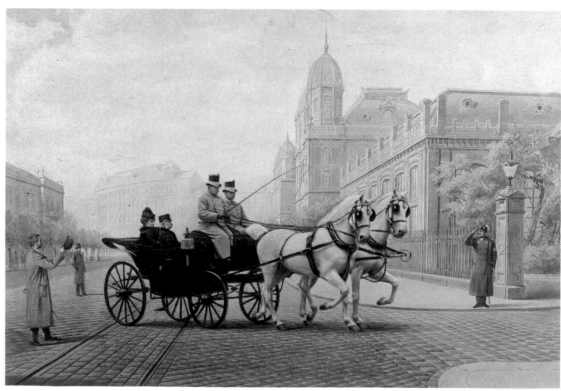

Francis Joseph I and Elizabeth on 3 October, 1897
Archive photo by Köller's heir, Museum of the Hungarian Labour Movement, Budapest

he 'Golden Age' pavilion at the Millennial Exhibition 1896
rchive photo by György Klösz, Budapest Historical Museum

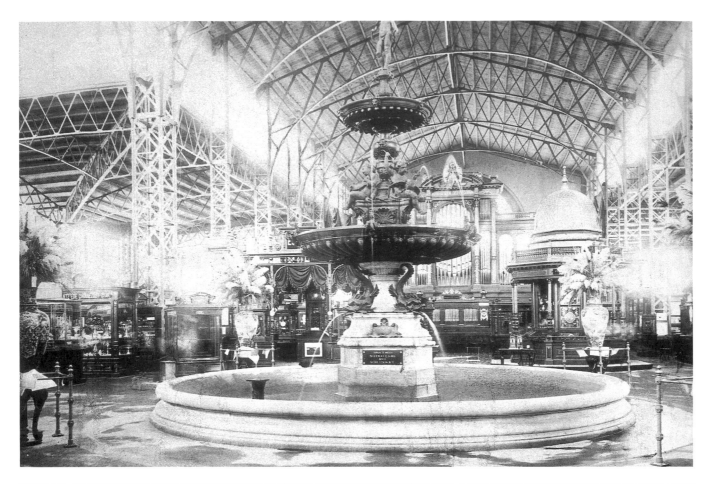

The Hall of Industry at the Millennial Exhibition 1896
Archive photos by György Klösz, Budapest Historical
Museum

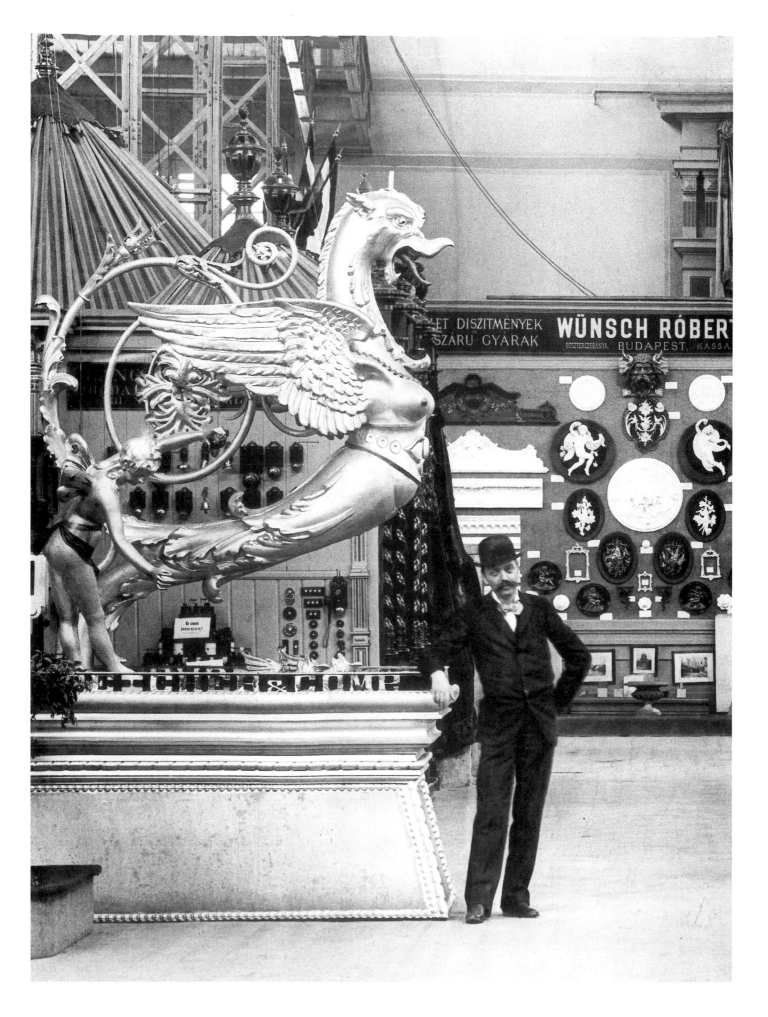

International Exposition of Industrial Art Turin 1911
Picture postcard, private collection, Budapest

The International Context

From the second half of the nineteenth century, international exhibitions played an important role in the shaping of Hungary's international relations; even mere attendance served the cause of mutual understanding. Furthermore, side by side with industrial goods and agricultural produce, the latest in art was also displayed. In the 1870s and '80s, when such industrial exhibitions were common, the pavilions were already enriched by examples of Hungarian architecture, the applied and the fine arts, as well as Hungarian handicrafts.

Governments, industrialists and artists alike had great confidence in these events; they regarded them as a forum for cultural exchange and innovation, and with it, an opportunity for trade.

Competitions for staging international exhibitions were usually announced years before they were actually scheduled, and the responsibility for designing national pavilions was assigned to the finest architects of the participating nations. Not only the works of art and commodities on show, but the exhibition halls themselves were expected to represent the level of technical development of a country.

For Hungary, participation in these exhibitions had a beneficial effect on the development of the arts, crafts, and light industry; they provided a real opportunity for exchange between artists of international reputation.

Hungary's first major success in this field was at the Paris World Exhibition of 1900. Whereas the Millennial Exhibition of 1896 had mobilized the intellectual reserves of Historicism, the Hungarian pavilion in Paris presented the first major works of the new Hungarian art. Admittedly, this was in an architectural framework inherited from the Millennium, but Ignác Alpár's interior design–in which he was assisted by Lajos Jámbor and Zoltán Bálint–already drew upon the spirit of Ödön Lechner, and served to introduce the spectacle of Hungarian history to the banks of the Seine.

One of the reasons for the great success of the Hungarian pavilion was that, at an exhibition which offered many new technological achievements and launched the twentieth century, it revived the tradition of a previously unknown culture. The *Hussar Room* in particular stirred considerable interest with its vast historical panel painting on the outer wall. Made by Pál Vágó and László Patay, this painting condensed the victorious battles of Hungarian history into a single composition. József Róna's bust of Emperor Franz Joseph clad in an hussar's pelisse was a natural compliment to the panoramic display.

The artistic changes of the post-Millennium era were manifested primarily in the products of industrial art, as well as in the work of individual designers and artists. The Zsolnay porcelain works had just concluded successful experiments with their new brand of lustrous metallic eosin glaze, a crystal glaze known to the Danes but further developed by the Zsolnay works, which was shown for the first time in Paris. They also

Wrought-iron gate designed *by Pál Horti and made by Forreider and Schiller for the Louisiana Purchase Exhibiton* 1904

employed new designers such as Sándor Apáti Abt, Lajos Mack and Harry Darilek to produce a line of decorative ware in the Art Nouveau vein. Glass mosaics by Miksa Róth, furniture by Ödön Faragó and carpets by Pál Horti were awarded gold and silver medals, and it was at the Paris exhibition that János Vaszary's work, *Golden Age* (1897–1898), one of the first Hungarian Art Nouveau paintings, was first seen by a wide audience. The Nagybánya Artists' Colony, which adhered to *plein air* painting, also made its first international appearance in Paris.

The Turin exhibition of 1902 was another important milestone in the popularization of Hungarian Art Nouveau, as was the St. Louis show of 1904, the second such exhibition on the American continent in which Hungary had participated. The first St. Louis fair in which Hungary had taken part had been held in 1878. At that time, Hungarian agriculture was represented by just a few bottles of Tokay wine, but in 1904 the pavilion, designed by Pál Horti with the help of Ede Thoroczkai Wigand, Géza Maróti and Ödön Faragó, housed a wide range of exhibits which presented a dynamic view of Hungarian industry. Folk art was also on display, especially in its *magyaros,* folk Art Nouveau variant. One of the pavilions at the St. Louis fair, for example, was conceived in the shape of a Transylvanian peasant house, and the furnishings were also made in the same new folk style. Though these exhibitions were not often greeted with critical acclaim, the designers and exhibitors were awarded numerous gold and silver medals.

The architect and ornamental sculptor Géza Maróti designed the Hungarian pavilions at international exhibitions from the early years of the century. In Milan in 1906 and subsequently in Monza and Turin, his creations proved memorable. His most successful work was the Hungarian pavilion at the Milan World Exhibition, a splendid structure decorated by the joint efforts of Maróti, Medgyaszay and the Gödöllő Artists' Colony.

By 1906 Hungarian Art Nouveau was in full bloom, and this was reflected in the material displayed at these exhibitions. Maróti's characteristic *Genius,* which adorns the roof of the Academy of Music, the *Duck Fountain* made by the Zsolnay works at Pécs, as well as several of Imre Simay's famous monkey statues, Ede Telcs's Art Nouveau statues, and jewellery by

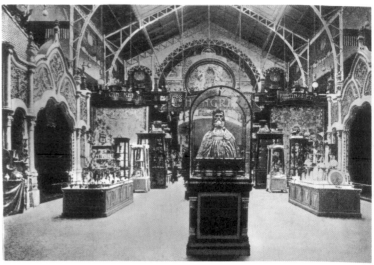

Zoltán Bálint and Lajos Jámbor: *The Hungarian exhibition at the Paris Exposition* 1900

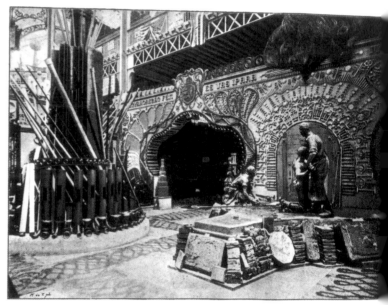

Zoltán Bálint and Lajos Jámbor: *Hungarian iron and metal industry exhibit at the Paris Exposition* 1900

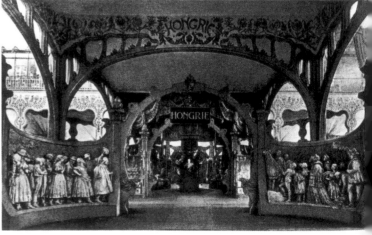

Zoltán Bálint and Lajos Jámbor: *The Hungarian Exhibition at the Paris Exposition* 1900

62

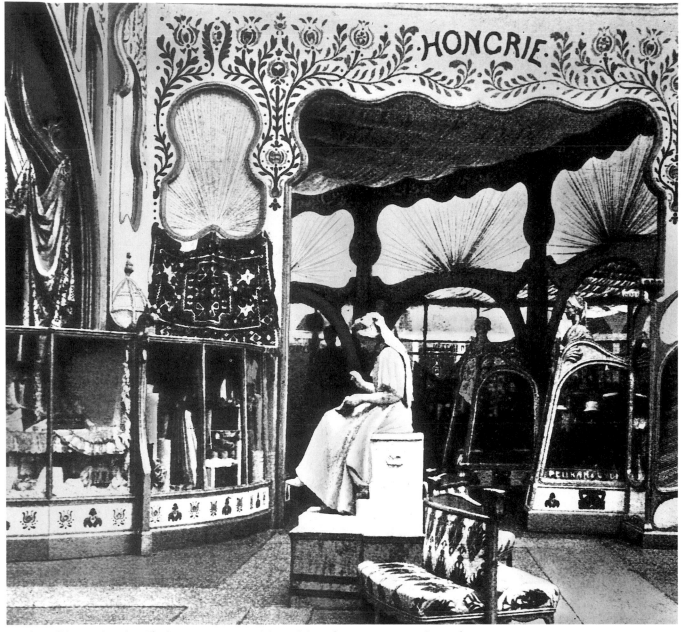

Zoltán Bálint and Lajos Jámbor: *Entrance to the exhibit of Hungarian textiles and cottage industries at the Paris Exposition* 1900

Samu Hibján and Oszkár Tarján, were all displayed in Milan for the first time.

The interior entitled *Home of the Artist* was the sensation of the furniture exhibition of Milan (1906). The interior was designed by István Medgyaszay, the furniture by Sándor Nagy, and the embroidery by Mrs. Sándor Nagy (Laura Kriesch).

Also amongst the abundant offerings of the Hungarian pavilion in Milan were elegant tapestries designed by the painter József Rippl-Rónai, drawings by Ferenc Helbing, products of the Zsolnay works and Miksa Róth's workshop, as well as furniture by Pál Horti, Aladár Körösfői Kriesch and Ödön Faragó.

Géza Maróti also designed the Hungarian pavilion for the Venice Biennale of 1909. Restored to its original form in 1984, the building has served as the venue for Hungarian art exhibitions ever since. Following the success of this design, in 1912 Maróti won the commission for the glass curtain and dome of the Opera House in Mexico City. Tiffany's of the United States undertook the manufacture of the curtain, which was composed of twenty-seven thousand glass plates, and the Jungferth Iron Works of Hungary were responsible for the external cast-iron decorative work.

According to contemporary accounts, *King Attila's tent palace* was the greatest sensation of the 1911 international exhibition of Turin. Created by Emil Tőry, Móric Pogány and Dénes Györgyi, it introduced the world of Hun mythology to European audiences. Of the pre-First World War Hungarian exhibitions, the Hungarian pavilion of the Turin exhibition was also the most homogeneous. From its architecture to the objects on display, every detail combined to present a 'revived' culture of the steppes, albeit one that was purely imaginary.

From the turn of the century to the First World War, the Hungarian pavilions were very popular at almost all the major international fairs. The large number of visitors as well as favourable articles in the press showed nothing but appreciation for this modern Hungarian art which was steeped in national traditions.

Géza Maróti: *Façade of Hungary's permanent pavilion at the Venice Biennale* 1908–1909
Picture postcard, Hungarian National Gallery Archives, Budapest

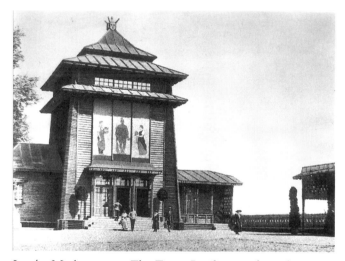

István Medgyaszay: *The Tatar Pavilion at the military exhibit on Margaret Island, Budapest* 1918
Archive photo, Budapest Historical Museum

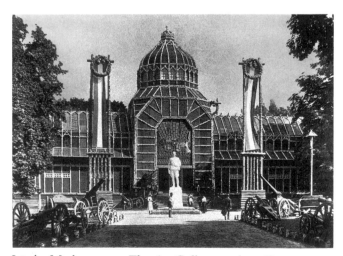

István Medgyaszay: *The Art Gallery at the military exhibit on Margaret Island, Budapest* 1918
Archive photo, Budapest Historical Museum

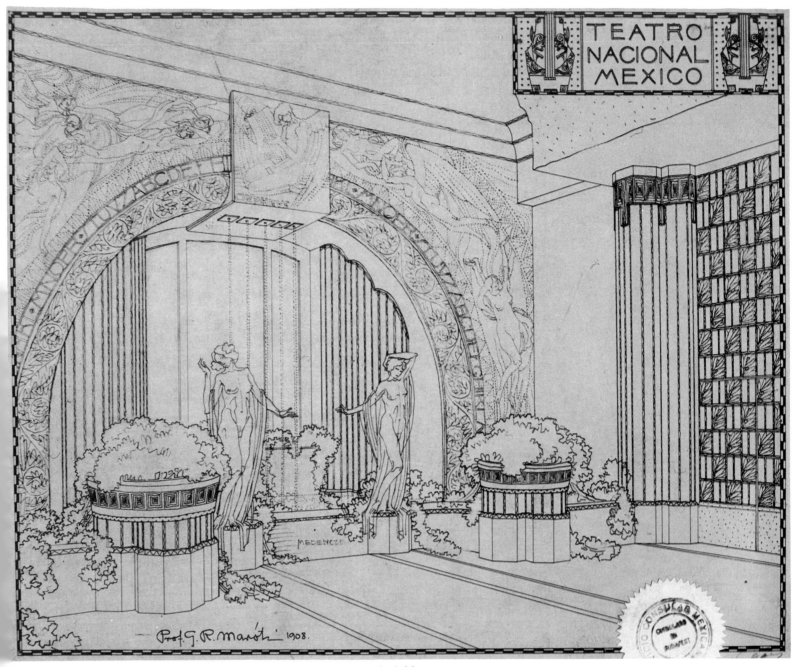

Géza Maróti: *Design for the National Theatre of Mexico* 1910. Main lobby
India ink, paper, 39 × 33 cm
Budapest Historical Museum

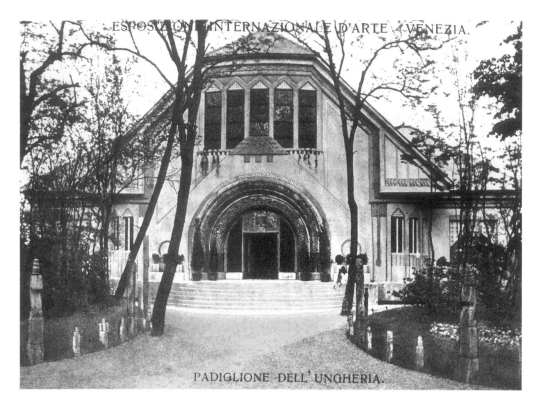

ESPOSIZIONE INTERNAZIONALE D'ARTE - VENEZIA.

PADIGLIONE DELL' UNGHERIA.

Géza Maróti: *Façade of Hungary's permanent pavilion at the Venice Biennale* 1908–1909
Picture postcard, Hungarian National Gallery Archives, Budapest

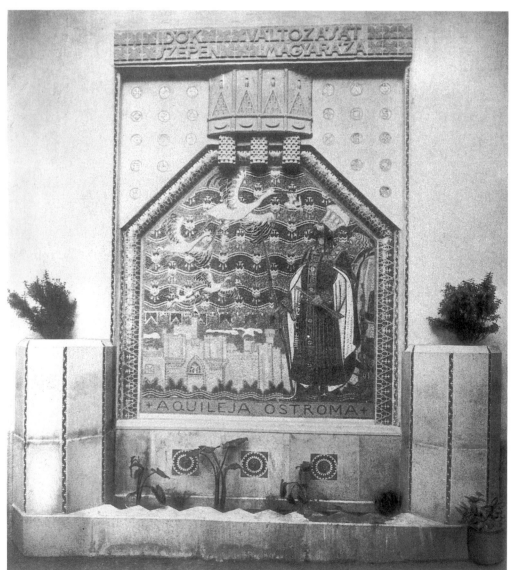

Aladár Körösfői Kriesch: *The Siege of Aquileia*
Mosaic made by Miksa Róth's workshop for the side of the Hungarian pavilion

Géza Maróti
and Sándor Nagy:
'Home of the Artist'
exhibition at the
Exposition
of Industrial Art
Milan 1906

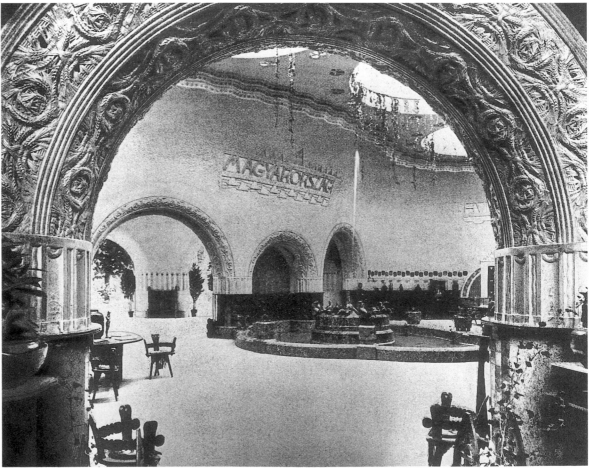

Géza Maróti:
Central hall of the
Hungarian pavilion with
the 'Duck Fountain'
at the Exposition
of Industrial Art
Milan 1906

MAGYAR VADÁSZKASTÉLY.

MAGYAR VADÁSZKASTÉLY.

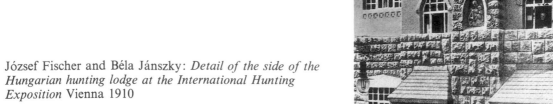

József Fischer and Béla Jánszky:
*Façade of the Hungarian hunting lodge at the International
Hunting Exhibition* Vienna 1910
Picture postcard, private collection, Budapest

József Fischer and Béla Jánszky: *Detail of the side of the
Hungarian hunting lodge at the International Hunting
Exposition* Vienna 1910

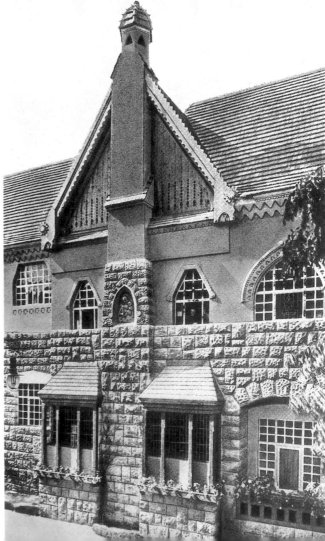

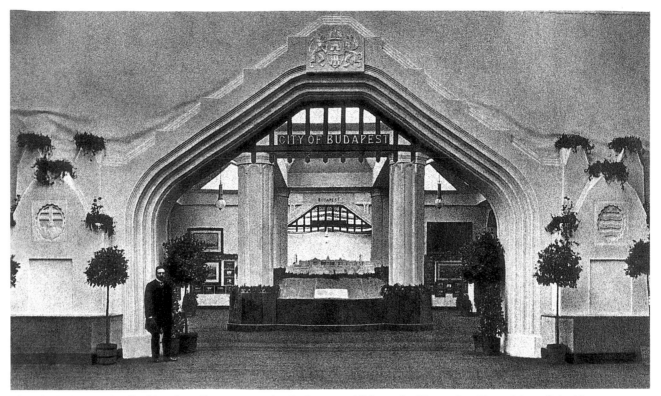

József Fischer and Béla Jánszky: *Entrance to the Budapest exhibit at the Hungarian Exposition of Architecture*
Earl's Court, London 1908. Picture postcard, Hungarian National Gallery Archives, Budapest

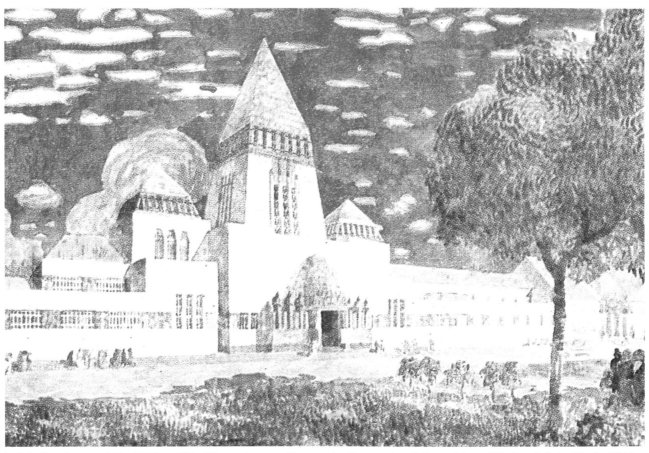

Móric Pogány and Emil Tőry: *The Hungarian pavilion at the International Exposition of Industrial Art* Turin 1911
Offical picture postcard of the exhibition, private collection, Budapest

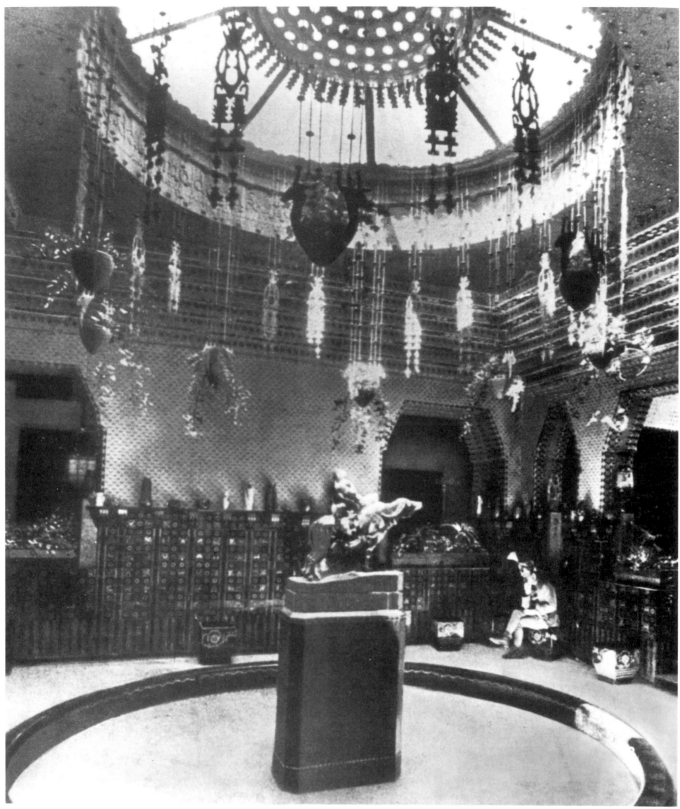

Móric Pogány and Emil Tőry: *Detail of the 42 metre high central hall of the Hungarian pavilion at Turin*

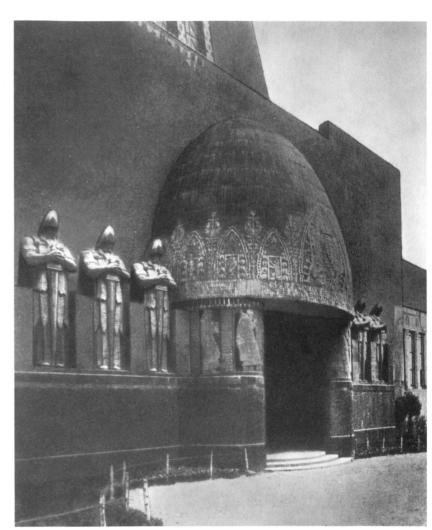

Móric Pogány and Emil Tőry: *Fantasy portrait of the building by Pogány on the official picture postcard of the International Exposition of Industrial Art* Turin 1911
Picture postcard, private collection, Budapest

Móricz Pogány and Emil Tőry: *Main entrance to the Hungarian pavilion at Turin*

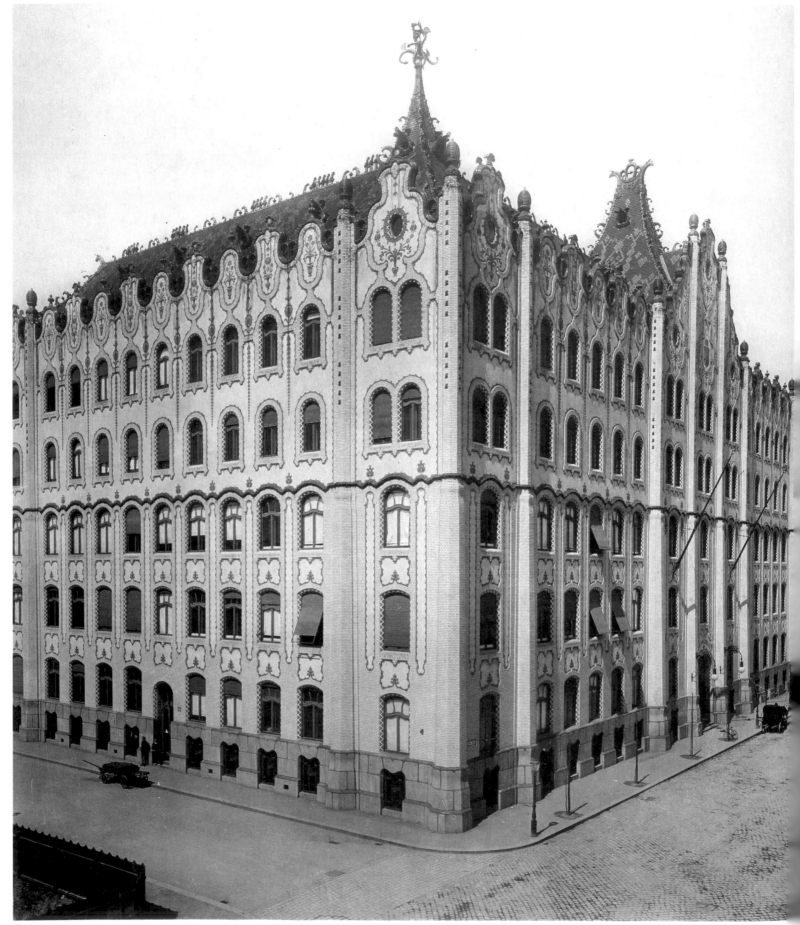

Ödön Lechner: *Postal Savings Bank, Budapest* 1899–1901
Main and side façade. Archive photo, Hungarian Museum of Architecture, Budapest

Towns and Architects

Until the middle of the nineteenth century, Budapest was an insignificant provincial settlement consisting of three small towns: Pest, Buda and Óbuda. Following their merger in 1873, however, it soon became a lively centre of economic and cultural life.

In order to develop a systematic approach to town planning, the aldermen of the city studied the transport networks of Vienna and Berlin, the structure of the avenues and boulevards of Paris, and the work of London's town planners. The result of their deliberations was the first underground railway on the European mainland, the Millennial Railway (the first was built in the United Kingdom), and the cogwheeled mountain railway on Széchenyi Hill, which was the second of its kind in Europe.

Contemporary newspapers abound with reports of openings and inaugurations: of theatres, schools, museums, bridges, and the Opera House. A new generation of Hungarian architects were setting up design practices and introducing innovations in both style and technology. Their influence spread quickly to the rapidly developing provincial towns. Supported by their patrons, they designed dozens of town halls, cultural centres, theatres and station buildings in the new style of Hungarian Art Nouveau.

By the turn of the century, there were many brilliant architects already at work, among them Béla Lajta, the representative of pre-modern architecture; István Medgyaszay, a formal and structural innovator as well as writer, editor and graphic artist; Károly Kós, who sought the roots of national architecture in medieval Transylvanian buildings; and, above all, Ödön Lechner, the pioneer of the 'Hungarian' style, and a figure of major importance in the development of modern Hungarian architecture.

Lechner's formative years encompassed the period of national struggle for political and cultural autonomy. His architectural ideas were significantly influenced by his visits to England. In 1911, he noted that *the English, when they build something in their Indian colonies, make an effort to adjust to local tastes... And if the highly cultured English feel no shame in studying the culture of their colonies (which are, after all, at a far lower level of development), striving to adapt it and combine it with their own, then we Hungarians are all the more obliged to study the art of our people, and to find some synthesis between it and our general European sense of culture!'* It was therefore natural for Lechner to draw upon the resources of Hungarian and Asian folk art, the

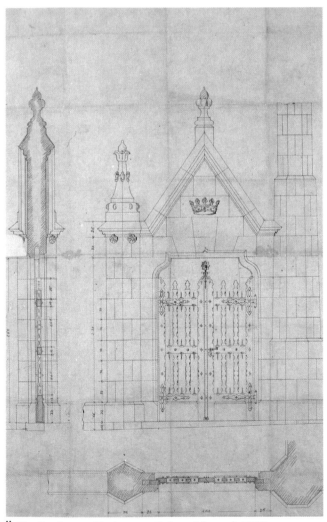

Ödön Lechner: *Biederman Palace* Mozsgó 1892
Design for the main gate
India ink, paper, 27.5 × 40.5 cm
Hungarian Museum of Architecture, Budapest

two being at that time regarded as the common ancestors of the new Hungarian style.

Lechner's major designs include the Museum of Applied Art, the Geological Institute and the Postal Savings Bank, all in Budapest. The first of these, built in 1896, stirred considerable professional and public controversy. Appearing as part of the Millennial celebrations, it was inevitable that it should attract attention, and as the first Art Nouveau building with a reinforced concrete structure, a solitary block between four streets, the Museum was a far cry from the classical models of the period. The originality of its form, the colourful pyrogranite roof tiles manufactured by the Zsolnay factory, the spatial rhythms, the ornamental adaptation of Far Eastern motifs, and the matching furnishings and accessories shocked many people.

In his design for the Geological Institute (1897–1899), Lechner turned to the so-called Upper-Hungarian Renaissance for inspiration. The ground plan, the architecture of the elevation with its hood-moulding motif, and the decorative

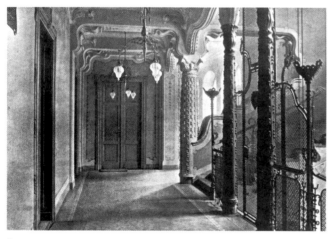

Ödön Lechner: *Postal Savings Bank*, Budapest 1899–1901
Interiors
Hungarian Museum of Architecture, Budapest

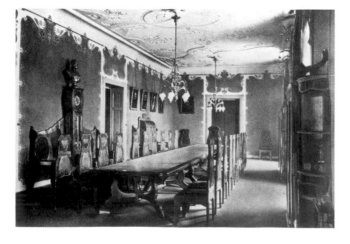

ornamentation–once again of Zsolnay pyrogranite–followed a Renaissance pattern from Northern Hungary.

The Postal Savings Bank (1899–1901) is perhaps Lechner's most truly 'period' design. The concrete and steel structure combined with Art Nouveau ornamentation produced a synthesis of modernism and the national style.

Lechner's works ranged from tenement blocks and palaces to monuments and sepulchres, some of which were never completed. During his long active years, Lechner collaborated with Gyula Pártos and numerous other architects, among them Sándor Baumgarten and, later, with Marcell Komor and Dezső Jakab, the designers of the Culture Palace of Marosvásárhely (Tirgu Mureş, Rumania, 1910) and Szabadka's Town Hall (Subotica, Yugoslavia, 1907), as well as the Black Eagle Hotel and the market in Nagyvárad (Oradea, Rumania, 1907–1909).

Béla Lajta described himself as a pupil of Lechner. In his youth he travelled extensively throughout Europe, visited a number of countries in Northern Africa, and worked for German and English architectural firms. Lajta was extremely adept at utilizing his extensive international experience in his designs. His early works were, however, very strongly influenced by Lechner. In a typical Lajta building, the motifs of Hungarian Art Nouveau and the traditions of Scandinavian brick architecture are harmoniously combined.

Lajta's sense of proportion in the disposition of architectural mass was remarkably advanced for the early years of the twentieth century and his use of new materials distinguished him from his *fin de siècle* predecessors. Integrating both English and Scandinavian achievements, his architectural studio used elements of post-Art Nouveau modern architecture. Major Lajta buildings still standing today include the former Institute for Blind Jews (1905–1908), the Jewish Charity Home (1909-1911), the school in Vas Street (1909–1912) and the Rózsavölgyi House (1911), all in Budapest. Like Lechner, Lajta also designed numerous sepulchres, mainly in Budapest's Jewish cemetery, which are still admired for their beauty and formal inventiveness.

The life work of István Medgyaszay, the only Hungarian disciple of Otto Wagner, was directed by two important factors: his tours of Transylvania, Transdanubia (western Hungary) and Pa-

Károly Kós:
*Design for the
Buffalo House
of the Budapest Zoo*
1909–1910

lotz Land (northern Hungary), where he studied folk architecture, and the introduction of reinforced concrete in building construction. These two apparently unconnected activities made it clear to him that the expression of a national character in architecture was not merely a question of ornamentation, but called for the unity of form and function.

Medgyaszay's talent is perhaps most evident in theatres, which demand vast spaces and complex planning. The theatres in Veszprém (1907–1908) and Sopron (1909), still stand. Medgyaszay's other works included several churches, the unrealized plans for a new National Theatre (1912), and the restoration of the Opera House in Budapest (1912) as well as residential buildings. He had close ties with the Gödöllő Artists' Colony, for whom he designed two houses with studios.

Károly Kós was only seventeen when in the summer of 1900 he first encountered Transylvanian architecture–a discovery which was to influence his life's work. Around Kós there later gathered a group which called itself the Young Architects, made up of Dezső Zrumeczky, Béla Jánszky, Lajos Kozma, Dénes Györgyi and Valér Mende, each of whom regarded the understanding of folk architecture as the principal condition for architectural renewal.

Kós's work, both as a scholar and designer, was influenced partly by the Pre-Raphaelite tendencies of the Gödöllő School, and partly by the achievements of the new American architecture as used by Scandinavian architects. He is par-

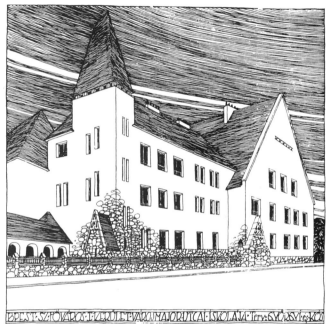

Károly Kós and Dénes Györgyi: *The school in
Városmajor utca* 1910–1911
Archive photo and design, Office for the Preservation
of Historical Monuments, Budapest

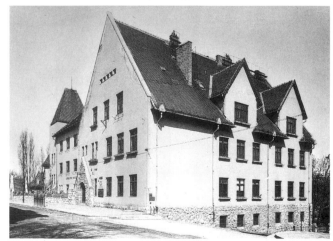

75

ticularly noted for the church in Zebegény, Hungary (1908), which combines Hungarian and Finnish architectural motifs.

Kós undertook the construction of the Budapest Zoo jointly with Dezső Zrumeczky. Of the many buildings in the complex, perhaps the most attractive is the Pheasant House with its articulated roof structure, while the one best evoking folk architecture is the Buffalo House.

In 1910, Károly Kós and Dénes Györgyi worked together on the construction of a school in the Városmajor district of Budapest. This complex, which included a kindergarten, school, day-care centre and teachers' flats, was a major project for the architects. Aladár Árkay also adapted the style of folk architecture to his designs. His principal work was the Calvinist Church in

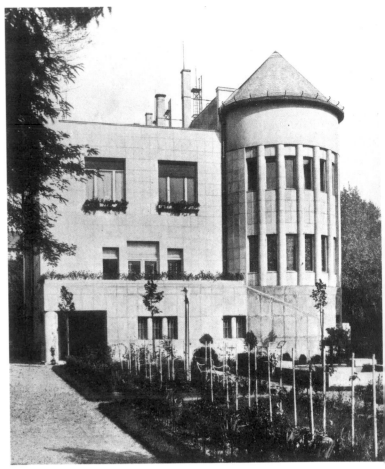

József Vágó: *The Schiffer Villa*, Budapest 1910–1912

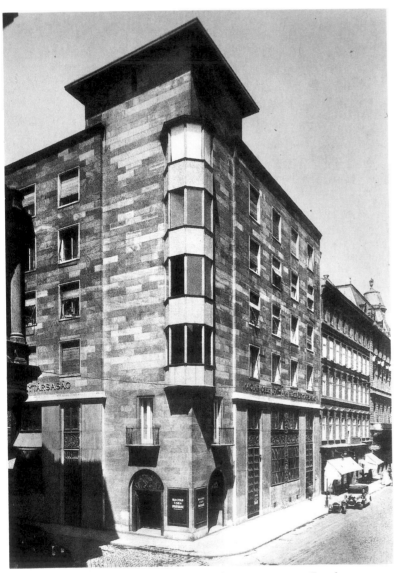

Béla Málnai and Gyula Haász: *Hungarian-Czech Industrial Bank*, Budapest 1911
Archive photo, Hungarian Museum of Architecture, Budapest

Gorkij Avenue in Budapest. Completed in 1913, it has a Greek Cross plan and carries a dome, but it is chiefly noted for its rich ornamentation.

There were many other fine architects working at the time whose designs evidence a fascinating combination of late nineteenth-century Eclecticism and elements of international and Hungarian Art Nouveau. Zsigmond Quittner, architect of the Gresham Palace (1903–1906); Flóris Korb and Kálmán Giergl, designers of the Academy of Music (1903–1907); and Ede Magyar who was responsible for the Roeck Palace in Szeged (1906-1907), are all worthy of mention. József Vágó's Schiffer Villa in the capital (1910–1912) is another excellent example of contemporary aspirations, and brought together such great artists as Károly Kernstok, who designed the glass windows, and István Csók, Béla Iványi Grünwald and József Rippl-Rónai, who painted the interior panels. Such collaboration between artists and architects changed the face of Budapest, to create a pleasant and inspiring environment in tune with the new bourgeois, middle-class way of life.

Károly Kós:
*Design for the
Buffalo House
of the Budapest Zoo*
1909–1910

lotz Land (northern Hungary), where he studied folk architecture, and the introduction of reinforced concrete in building construction. These two apparently unconnected activities made it clear to him that the expression of a national character in architecture was not merely a question of ornamentation, but called for the unity of form and function.

Medgyaszay's talent is perhaps most evident in theatres, which demand vast spaces and complex planning. The theatres in Veszprém (1907–1908) and Sopron (1909), still stand. Medgyaszay's other works included several churches, the unrealized plans for a new National Theatre (1912), and the restoration of the Opera House in Budapest (1912) as well as residential buildings. He had close ties with the Gödöllő Artists' Colony, for whom he designed two houses with studios.

Károly Kós was only seventeen when in the summer of 1900 he first encountered Transylvanian architecture–a discovery which was to influence his life's work. Around Kós there later gathered a group which called itself the Young Architects, made up of Dezső Zrumeczky, Béla Jánszky, Lajos Kozma, Dénes Györgyi and Valér Mende, each of whom regarded the understanding of folk architecture as the principal condition for architectural renewal.

Kós's work, both as a scholar and designer, was influenced partly by the Pre-Raphaelite tendencies of the Gödöllő School, and partly by the achievements of the new American architecture as used by Scandinavian architects. He is par-

Károly Kós and Dénes Györgyi: *The school in Városmajor utca* 1910–1911
Archive photo and design, Office for the Preservation of Historical Monuments, Budapest

ticularly noted for the church in Zebegény, Hungary (1908), which combines Hungarian and Finnish architectural motifs.

Kós undertook the construction of the Budapest Zoo jointly with Dezső Zrumeczky. Of the many buildings in the complex, perhaps the most attractive is the Pheasant House with its articulated roof structure, while the one best evoking folk architecture is the Buffalo House.

In 1910, Károly Kós and Dénes Györgyi worked together on the construction of a school in the Városmajor district of Budapest. This complex, which included a kindergarten, school, day-care centre and teachers' flats, was a major project for the architects. Aladár Árkay also adapted the style of folk architecture to his designs. His principal work was the Calvinist Church in

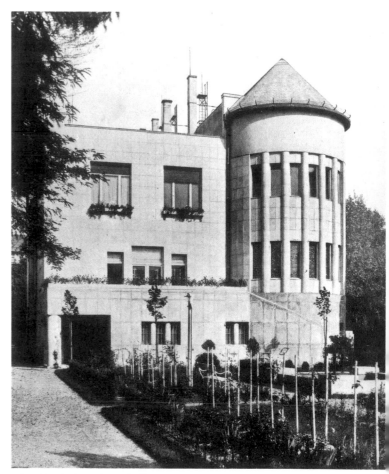

József Vágó: *The Schiffer Villa*, Budapest 1910–1912

Béla Málnai and Gyula Haász: *Hungarian-Czech Industrial Bank*, Budapest 1911
Archive photo, Hungarian Museum of Architecture, Budapest

Gorkij Avenue in Budapest. Completed in 1913, it has a Greek Cross plan and carries a dome, but it is chiefly noted for its rich ornamentation.

There were many other fine architects working at the time whose designs evidence a fascinating combination of late nineteenth-century Eclecticism and elements of international and Hungarian Art Nouveau. Zsigmond Quittner, architect of the Gresham Palace (1903–1906); Flóris Korb and Kálmán Giergl, designers of the Academy of Music (1903–1907); and Ede Magyar who was responsible for the Roeck Palace in Szeged (1906-1907), are all worthy of mention. József Vágó's Schiffer Villa in the capital (1910–1912) is another excellent example of contemporary aspirations, and brought together such great artists as Károly Kernstok, who designed the glass windows, and István Csók, Béla Iványi Grünwald and József Rippl-Rónai, who painted the interior panels. Such collaboration between artists and architects changed the face of Budapest, to create a pleasant and inspiring environment in tune with the new bourgeois, middle-class way of life.

76

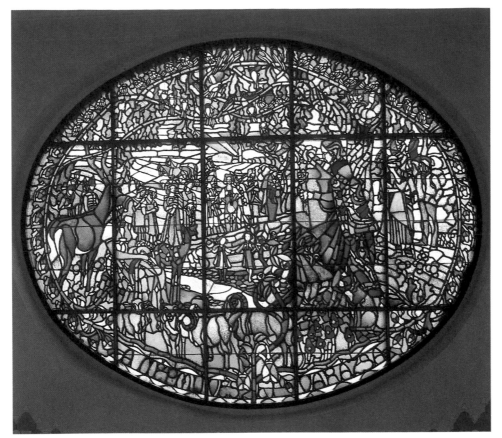

Sándor Nagy: *Hunting Gentry* 1907
Stained glass window for the Theatre of Veszprém, 220 cm

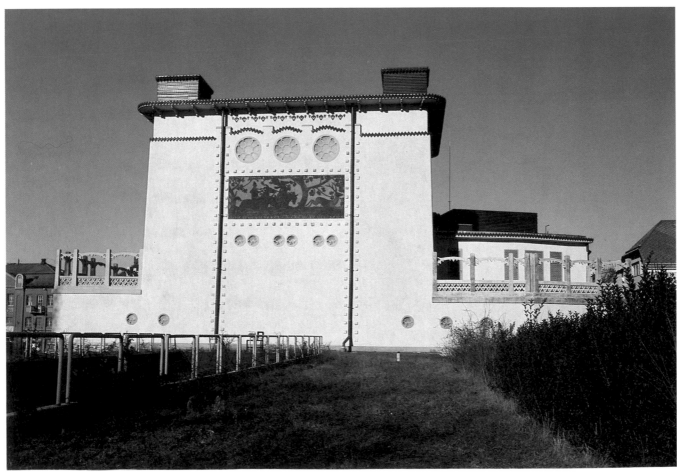

István Medgyaszay: *The Theatre of Veszprém* 1907-1908

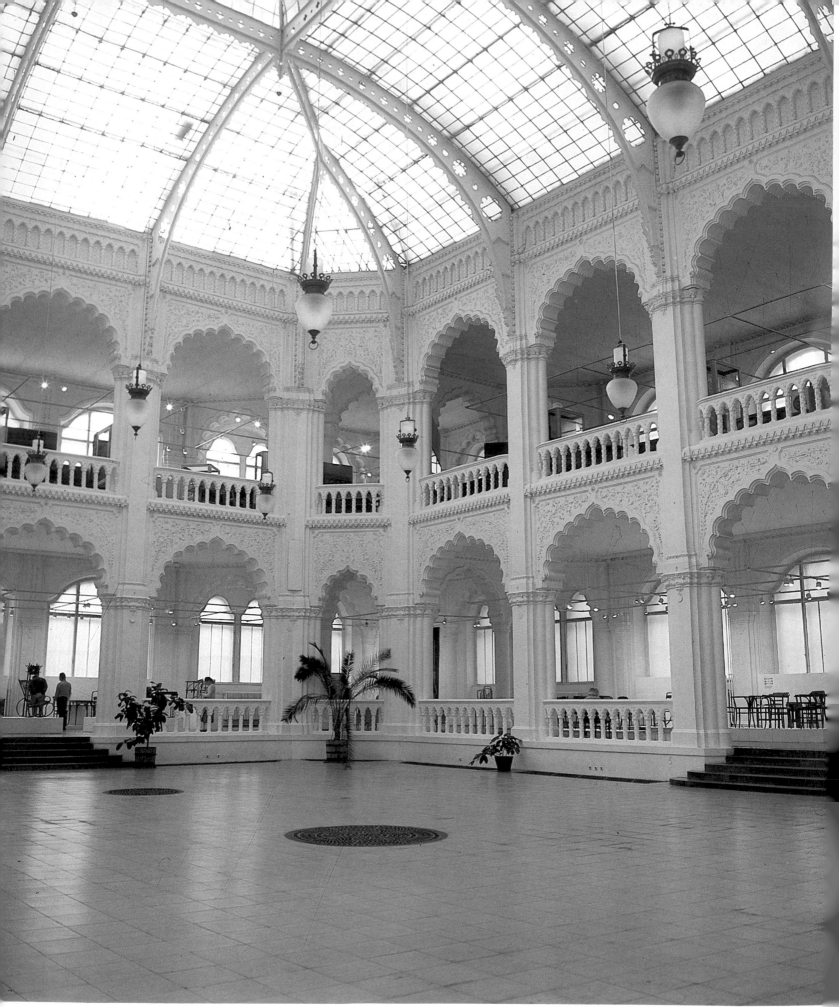

Ödön Lechner: *The main hall of the Museum of Applied Arts, Budapest* 1891–1896

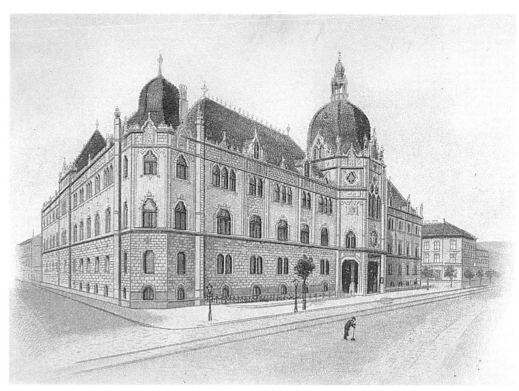

Picture postcard showing the Museum of Applied Arts c. 1900. Private collection, Budapest

Ödön Lechner: *Museum of Applied Arts around 1900*

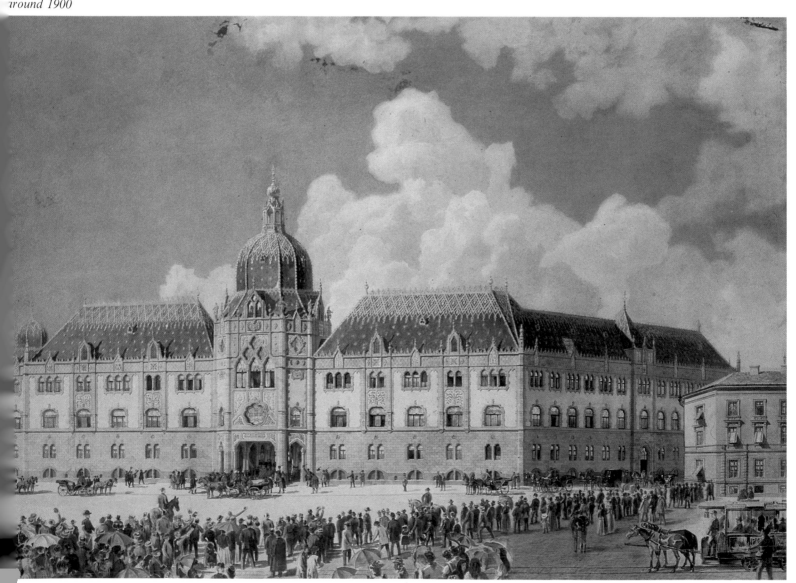

79

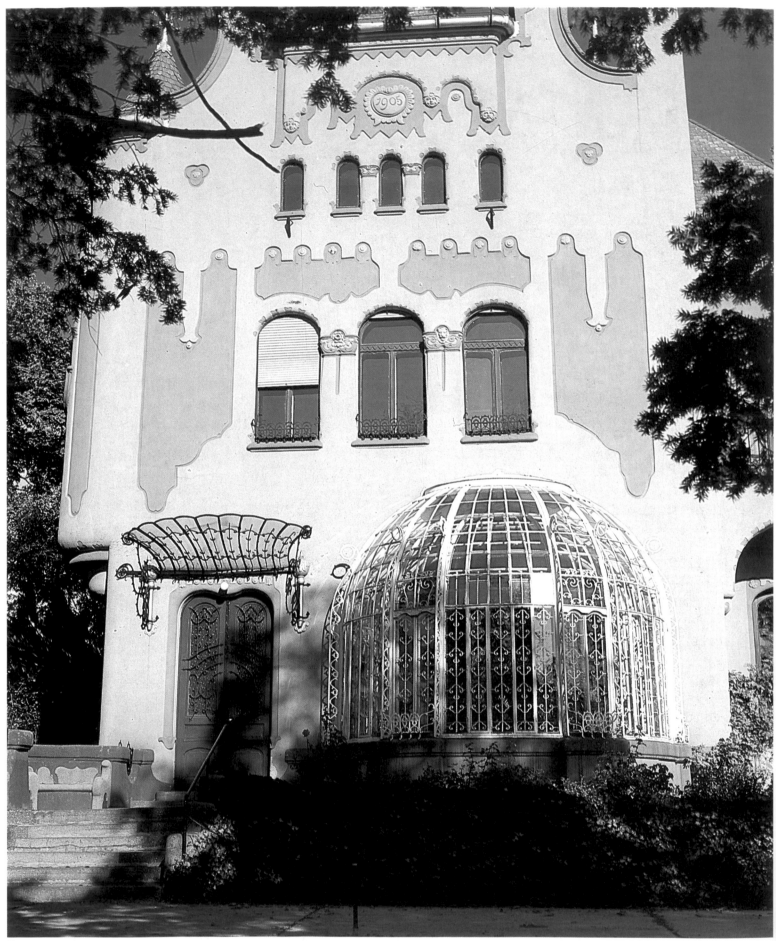

Ödön Lechner: *György Zala's studio* Budapest 1895

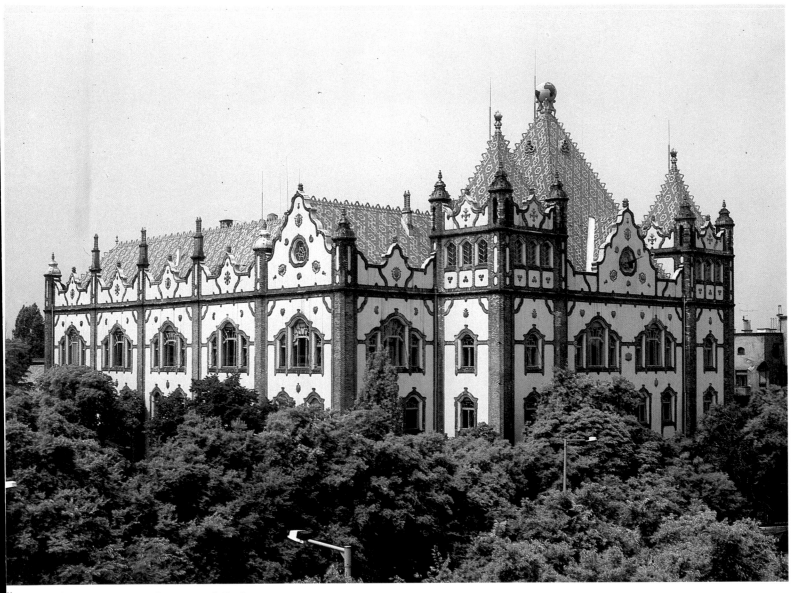

Ödön Lechner: *Hungarian Institute of Geology*
Budapest 1897–1899
Façade and detail of interior
Hungarian Institue of Geology, Budapest

Béla Lajta: *Façade of the Elizabeth Town Bank Budapest*
1911–1912
Hungarian Museum of Architecture, Budapest

Béla Lajta: *Façade of the Jewish Charity Home
on 57. Amerikai út, Budapest*
Designed in 1909, built in 1910–1911

Béla Lajta: *Side entrance to the Jewish Charity Home*

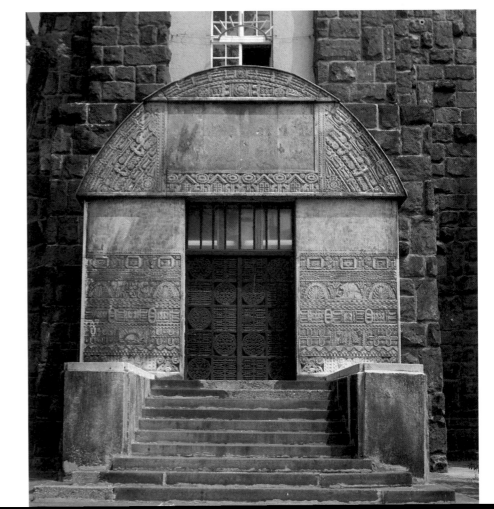

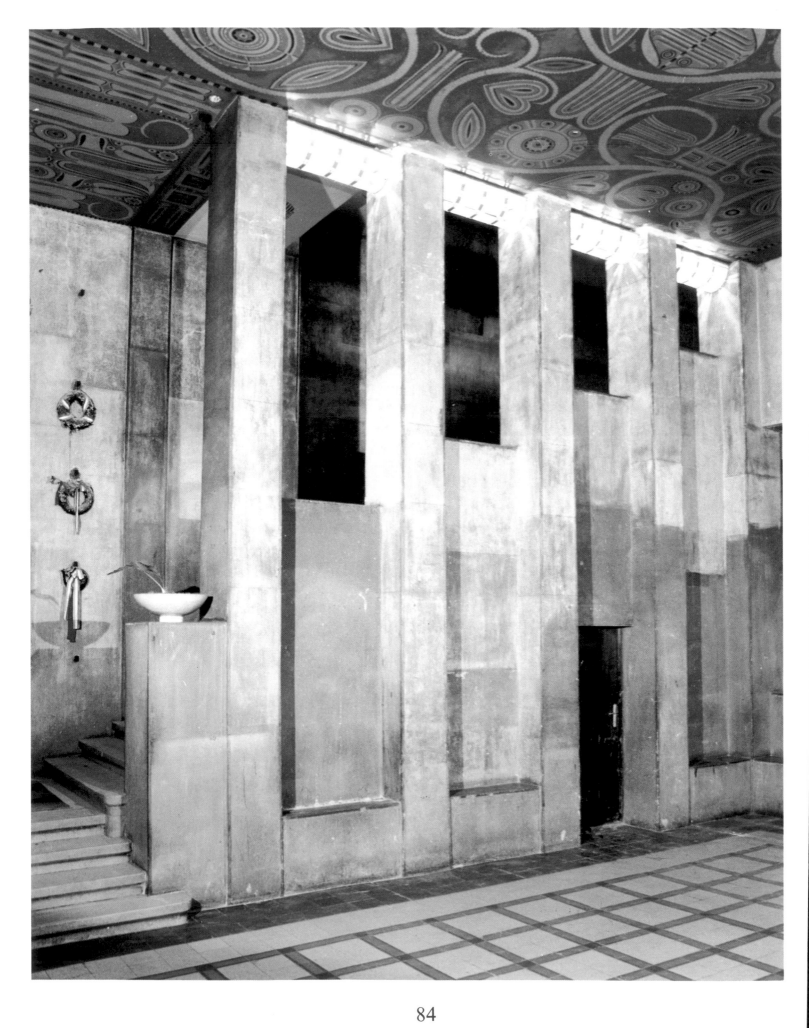

84

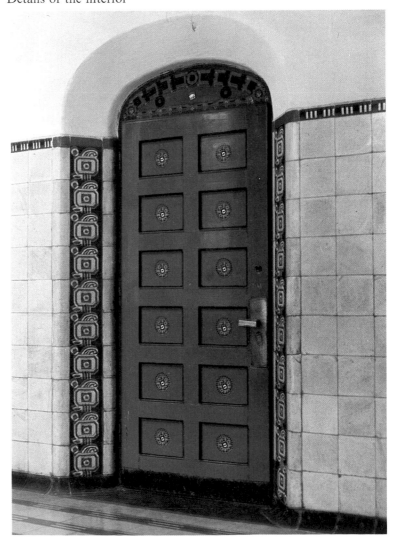

Béla Lajta: The school in Vas utca, Budapest
Designed in 1909, built in 1911–1912
Details of the interior

◁ Béla Lajta: *The school in Vas utca*. Designed in
1909, built in 1911–1912
Interior
Photo, Archives of the Municipal Council, Budapest

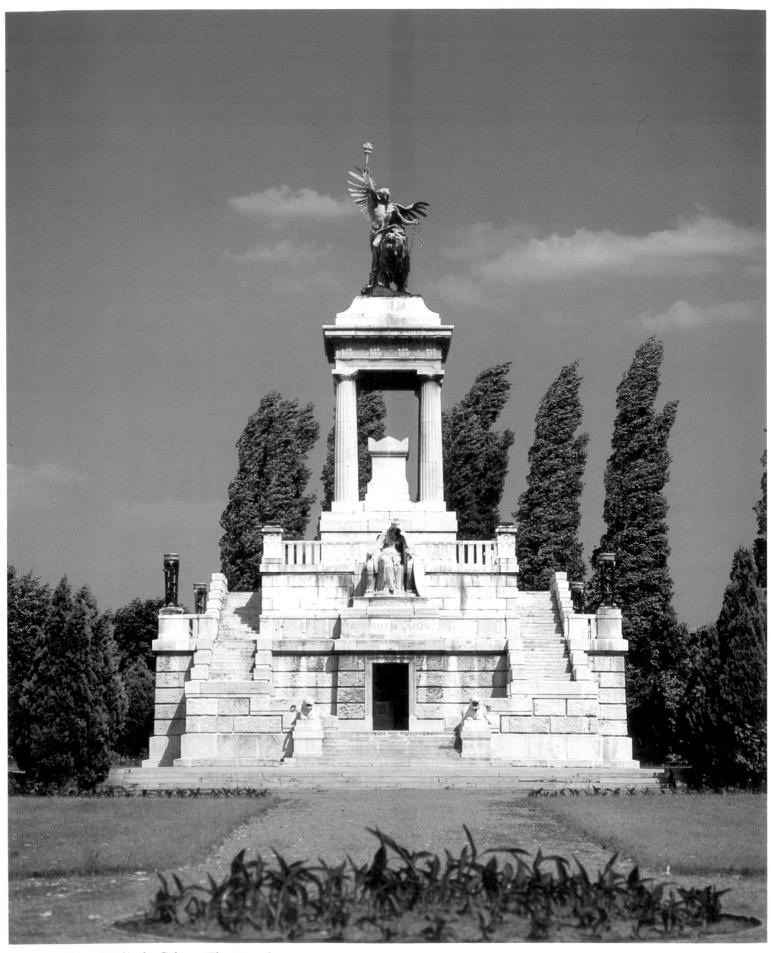

Alajos Stróbl and Kálmán Gelster: *The Kossuth*
Mausoleum in Kerepesi Cemetery, Budapest 1901–1903

Béla Lajta: *Mortuary of the Jewish Cemetery, Budapest* 1908

Funeral monument in the Kerepesi Cemetery, Budapest

Ödön Lechner and Béla Lajta: *Family crypt for Sándor Schmidl at the cemetery of Rákoskeresztúr, Budapest* 1903

Artur Wellisch: *Crypt for the Wellisch family at the cemetery of Rákoskeresztúr, Budapest* 1903

87

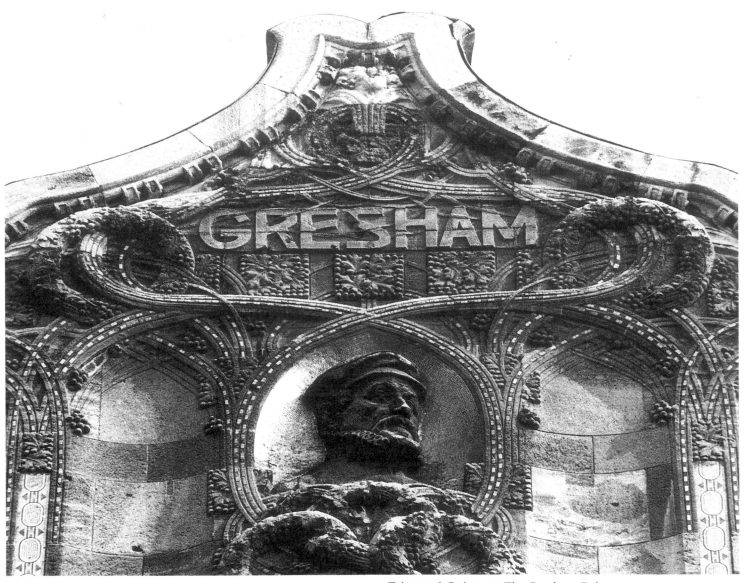

Zsigmond Quittner: *The Gresham Palace*
Detail of the façade
Budapest 1903–1906

Miksa Róth: *Staircase window of the Gresham Palace*
Budapest 1906

Aladár Árkay: *The Calvinist Church in Gorkij fasor*
Budapest 1911–1913. Main façade. Archive photo,
Budapest Historical Museum

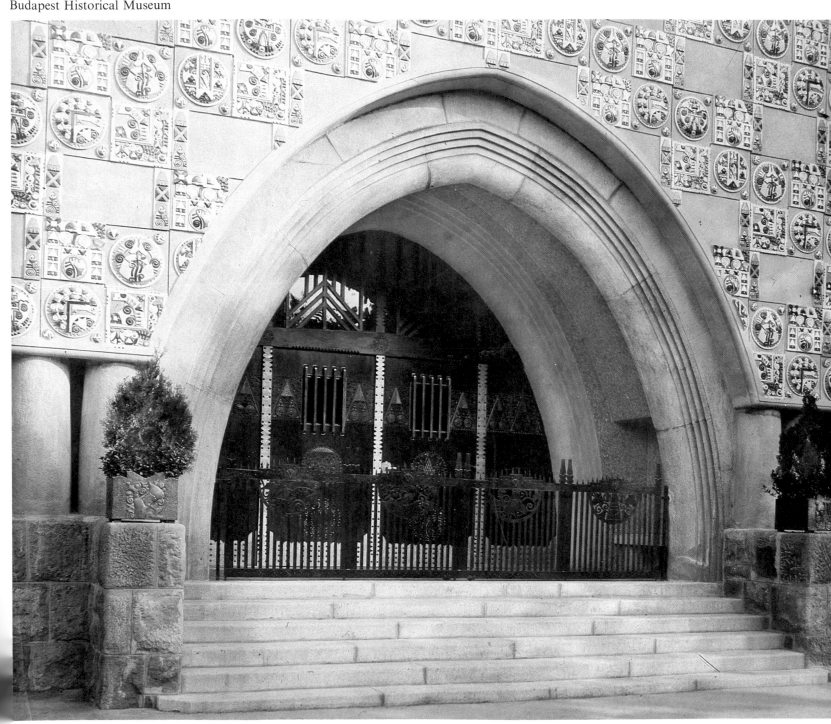

89

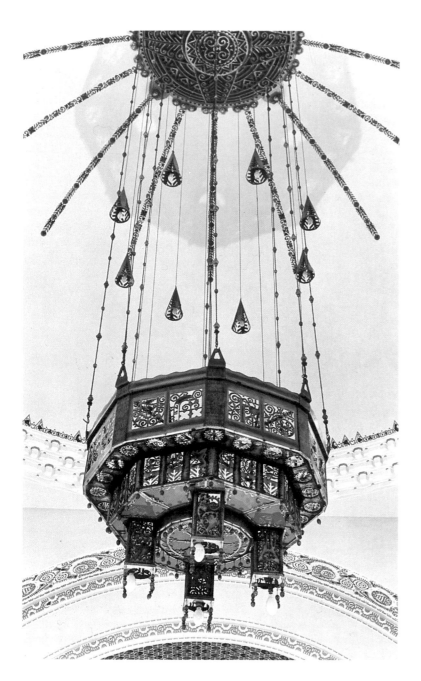

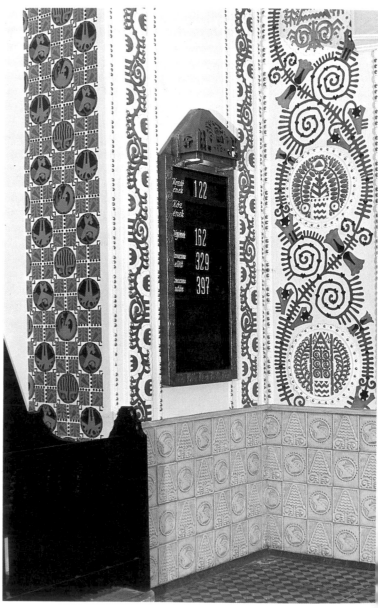

Aladár Árkay: *The Calvinist Church in Gorkij fasor*
Budapest 1911–1913. Details of the interior

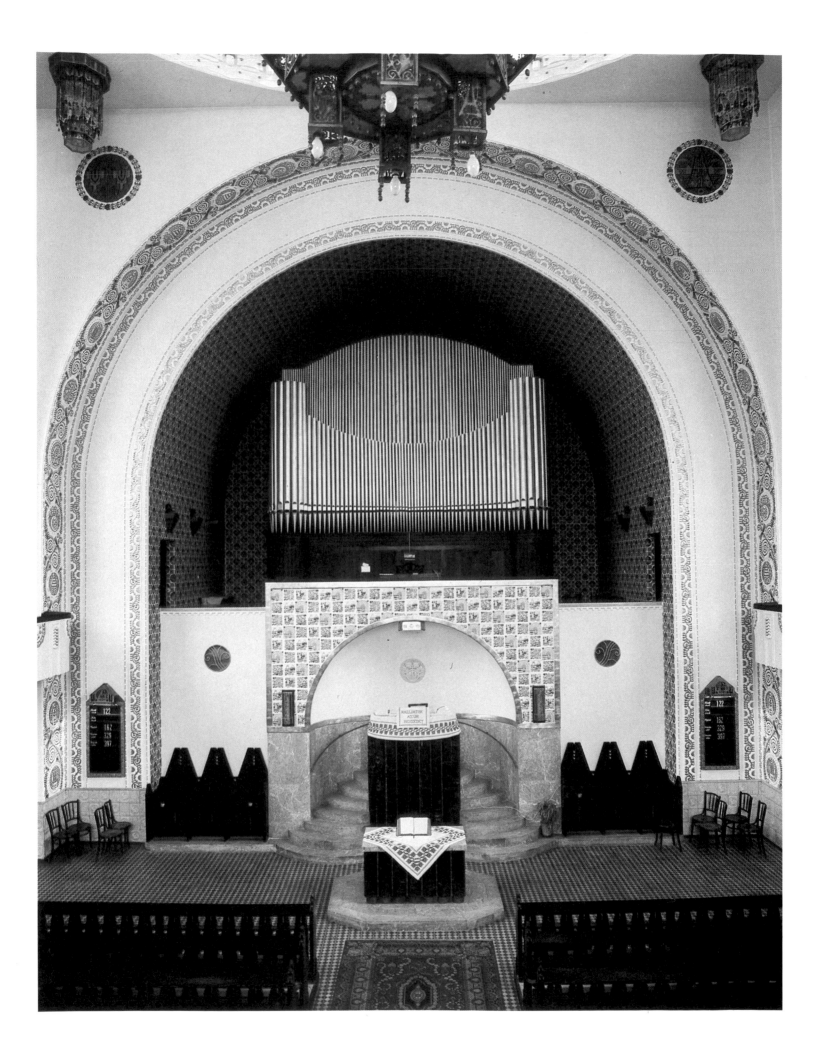

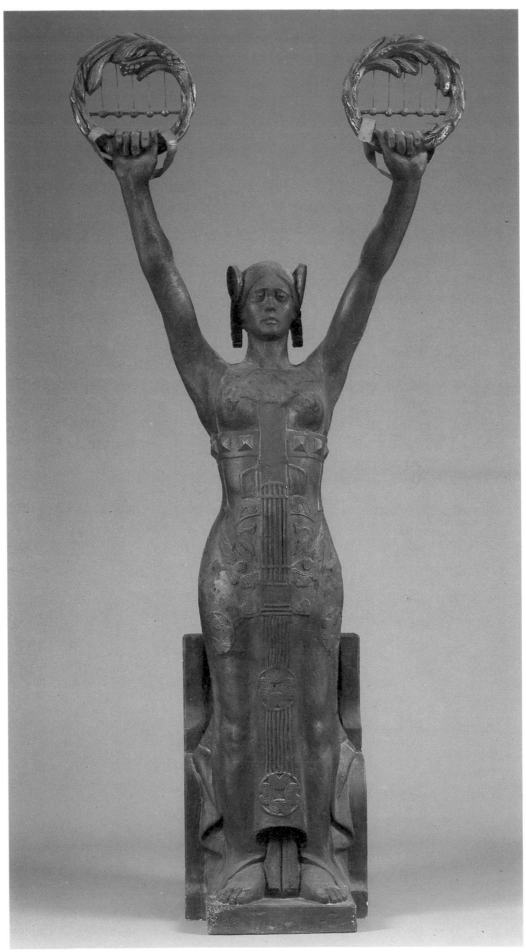

Géza Maróti: *Genius* 1904
Gypsum, 320 cm. Contemporary copy of the original statue
on top of the Academy of Music, Budapest

Kálmán Giergl and Flóris Korb:
The Academy of Music
Budapest 1903–1907. Main façade
Hungarian Museum
of Architecture, Budapest

Miksa Róth: *Mosaic with Hungarian motifs*
Sample for the wall of the staircase of the
Academy of Music, Budapest 1907
Glass mosaic, 55 × 75 cm
Private collection, Budapest

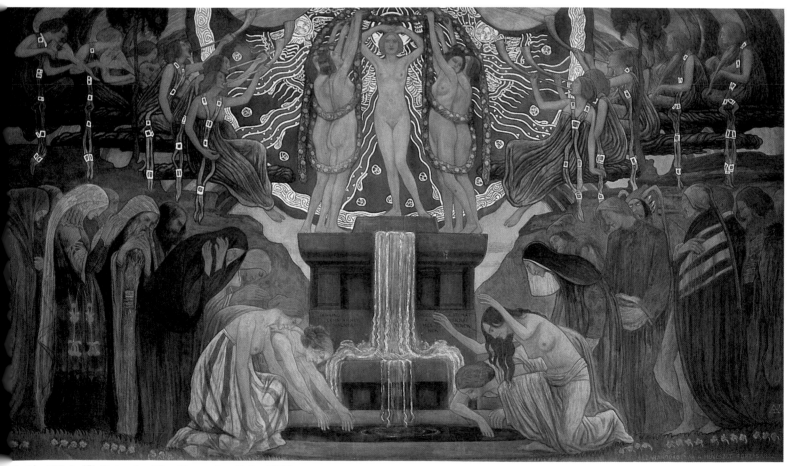

ladár Körösfői Kriesch: *The Fountain of Art* 1907
resco. Academy of Music, Budapest

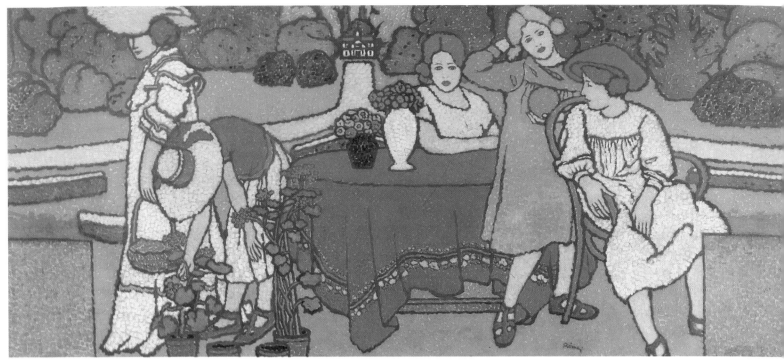

József Rippl–Rónay: *Painting for the Schiffer Villa c.* 1911
Oil on canvas, 153 × 330 cm
Hungarian National Gallery, Budapest

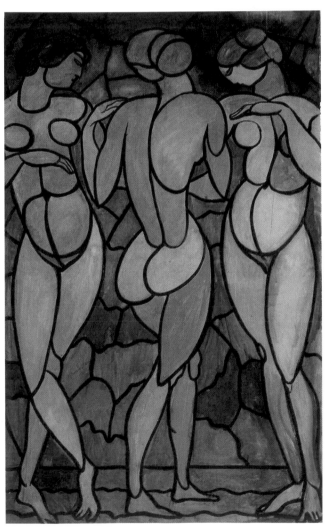

István Csók: *Painting for the Schiffer Villa c.* 19
Oil on canvas, 166 × 222 cm
Hungarian National Gallery, Budapest ▷

Béla Iványi Grünwald: *Painting for the Schiff*
Villa 1912
Oil on canvas, 131 × 360 cm
Hungarian National Gallery, Budapest ▷

Károly Kernstok: *Study for a glass window of the
Schiffer Villa c.* 1911

94

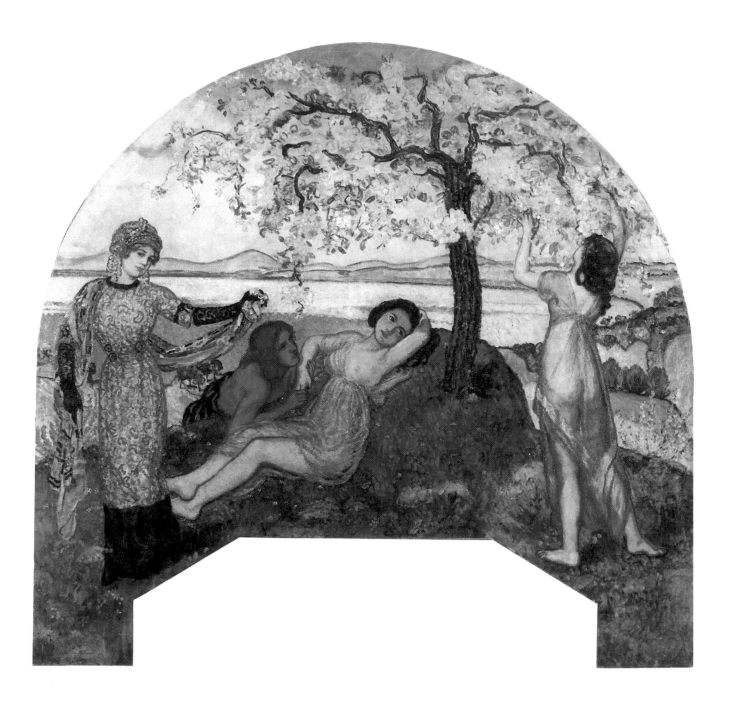

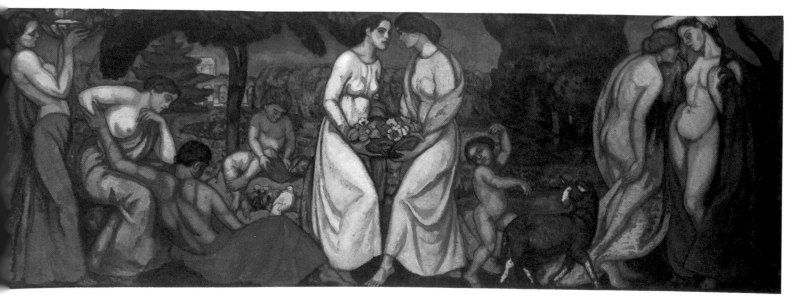

95

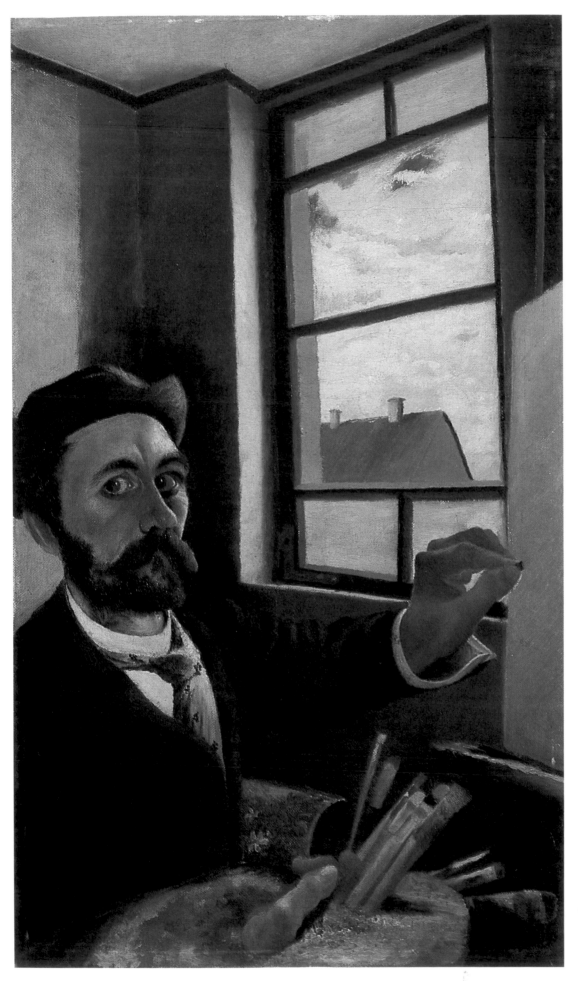

Tivadar Csontváry Kosztka:
Self-portrait as a Young Man
1896–1902
Oil on canvas, 67 × 39.5 cm
Hungarian National
Gallery, Budapest

Major Artists, Major Works

In 1897 an Artists' Ball was held at the *Műcsarnok* (Art Gallery) in Budapest, a dazzling spectacle which was to mark the meeting point of two epochs. Hardly a year had passed since the great Millennial festivities, yet the emptiness of the historical and Academic styles they flaunted had already become painfully apparent. A new style was conquering Europe, and many Hungarian artists looked to it for inspiration.

Tivadar Csontváry Kosztka (1853–1919) was one of the major artists of this new style. At the age of twenty-seven he had a vision, a divine message, indicating that he would be greater than Raphael. He spent the rest of his life attempting to fulfil this prophecy. He worked for twenty years from 1880 as an apothecary, which gave him some financial security, and he embarked on his chosen career in Munich in 1899 under Simon Hollósy, the Hungarian artist who later founded the Nagybánya Colony. It was from Hollósy that Csontváry imbibed his love of nature and *plein air* painting, something which was to determine his subsequent style. Visionary and redolent of pantheistic piety, he himself described this as 'painting along with the sun'. In an interview of 1910 he said that it was *'very bad for a picture to impress us primarily as a beautiful piece of painting. The picture should give off the life, the freshness, the wholesomeness of Nature herself.'*[*]

Csontváry's relationship to Art Nouveau is much the same as that of Gauguin; for both it was vital to escape the everyday world of the present. Gauguin found his refuge on the Island of Tahiti; Csontváry's divine mission drove him to the cradle of human culture, the Middle East. Here, Csontváry sought not only a great theme, but also the ancient source of his own Hungarian style.

Csontváry's *Self-portrait* (1896–1902) is the principal work of his early period. It presents a confident, composed, and mature artist whose harsh features and stern eyes reveal his fervent commitment, and the use of colour foreshadows the intensity of his later painting.

The work entitled *Madonna Painter* (1898) evokes the atmosphere of the narrow streets of southern Italy, and was probably made in Naples. The motif of the simple bare-footed young painter drawing a dancing woman on a wall is reminiscent of the young shepherdess of Greek mythology, who draws a portrait of her lover in the sand. This is, perhaps, indicative; Csontváry admired the humility of the craftsman more than the arrogance of professional painters.

Portrait of Csontváry (photo)

* *Csontváry emlékkönyv: Válogatás Csontváry Kosztka írásaiból és a Csontváry irodalomból* (Csontváry Memorial Volume), ed. Gedeon Gerlóczy and Lajos Németh, Budapest, 1976

97

The *Old Fisherman* (1902) foreshadows Csont-váry's later visionary work. Against a background of blue sea looms an ominous figure with rough hewn features–a survivor of some sort, perhaps a fisherman of the Adriatic. The *Praying Saviour* (1903) with its depiction of Moses in the background and the rather spectral presence of the apostles at the bottom of the picture, belongs to a subsequent, more markedly visionary period, as do *Cedars of Lebanon* (1907) and *Riders on the Seashore* (1909), in which the frieze-like procession of figures enhances a sense of enchantment.

Lajos Gulácsy (1882–1932) was another great painter who could find no place in the artistic milieu of his time. He had little sympathy with decaying Academicism, but nor could he follow the path taken by his avant-garde contemporaries. Instead, he was drawn to medieval and Renaissance Italy. His early pictures include *The Betrothal of Mary* (1903), actually painted in Italy in the manner of early quattrocento Florentine art. However, while the visual material of his world had been adapted primarily from the English Pre-Raphaelites and influenced by the Hungarian Gödöllő Colony, Gulácsy's work had a literary quality of its own, reminiscent of the anxiety of Kafka, or the more bizarre elements in the stories of Oscar Wilde and E.T.A. Hoffman. Gulácsy himself described his art as *'reminiscences, songs, visions, memories, vibrations.'* Nothing could be more appropriate.

Literature was important to Gulácsy, as it was to many other contemporary artists. One of his most curious drawings is *Madame Bovary's Friend* (1911) executed in chalk, which recreates beautifully the atmosphere of Flaubert's famous novel.

Characters from the *Commedia dell'arte* also appear in Gulácsy's paintings, although often in a sinister guise. These figures populate an imaginary world which Gulácsy called NaConxipan. In later years, when he showed signs of derangement, he tended to repaint and transform some of his early works. *Rococo Concerto* (1913), for example, which he had executed in the spirit of Watteau, was cut into three. The centre of the picture was discarded and the two remaining parts became *Chevalier aux Roses* (1914) and *The Opium Smoker's Dream* (1913–1918); the latter is considered an early precursor of Hungarian Surrealism.

József Rippl-Rónai (1861–1927) was one of the first artists to span the gulf between Western Europe and Hungary and in many ways can be regarded as a key personality of twentieth-century Hungarian art. For over ten years he lived in Neuilly, a picturesque suburb of Paris, and was an associate of the Nabis. It was here that he painted his masterpiece, *Woman in White Dotted Dress* (1889). Striking in its immediacy, it is a fine example of what he called his 'black period', when he preferred to paint his sitters against a dark background. Rippl-Rónai admired the work of Gauguin and Puvis de Chavannes, and was one of the first to accept Gauguin's belief that line and colour have an autonomous, expressive power.

In another famous painting, *James Pitcairn Knowles* (1892), himself a painter, is shown wearing a wide-brimmed hat. A man of Scots descent, he sympathized with Rippl-Rónai's aims and aspirations, was a close friend at Neuilly, and introduced him to Maillol. It was Rippl-Rónai who turned Maillol's attention to sculpture, while, in turn, Maillol aroused Rippl-Rónai's interest in the design of wall carpets, and the applied arts in general.

Skittle-players (1892) is one of the principal

Portrait of Lajos Gulácsy (photo)

works of Rippl-Rónai's black period. The figures, delineated with just a few bare contours and dark areas of colour, bear witness to the calm and economy of motion that attracted Rippl-Rónai to the game. This and other similar paintings of the time, lightly sketched with a thin coat of paint, reveal the influence of an important group of artists including Vuillard, Bonnard, Valloton, Denis and Serusier, who had studied at the Académie Julien and who came to regard Rippl-Rónai as one of their group. It was in association with these artists that Rippl-Rónai painted the best-known pictures of his Paris period, scoring his first successes abroad at a time when his countrymen were not yet ready for his art.

In the final years of the century Rippl-Rónai produced one of his finest works and one of the best examples of Hungarian applied arts, the Andrássy dining room in the Andrássy residence, Budapest (1896–1899). This piece of integrated Art Nouveau design is worthy of comparison with William Morris's Red House (1859) and Van de Velde's Bloemenwerf House, Belgium (1895). The interior differed slightly from his

József Rippl-Rónai around 1902

plans; individual pieces were made in various places; the glass work was manufactured in Wiesbaden, the ceramics in Pécs's Zsolnay Works, the furniture in Endre Thék's workshop in Pest, and the wall carpets in Neuilly (under the supervision of Rippl-Rónai's wife). Most of the furnishings were destroyed in the Second World War and only a few glasses, ceramics and one wall carpet have survived. But even these few fragments give an indication of Rippl-Rónai's attempt to establish higher aesthetic standards in industrial production in accordance with the ideas outlined by William Morris and John Ruskin in England forty years before. By this time such ideas had spread to France, too, and Rippl-Rónai's designs were very well received at the Salon of the Champ-de-Mars (1894). With the development of the Zsolnay Works of Pécs and the activity of the Gödöllő Colony, a few years later applied art also began to develop in Hungary. By this time, however, Rippl-Rónai had abandoned design in favour of painting.

János Vaszary (1867–1939) is one of the most fascinating and at the same time most controversial figures of twentieth-century Hungarian art. From his formative years until his death, Vaszary's style and themes underwent numerous changes, from Art Nouveau to Post-Impressionism. Vaszary's adoption of an Art Nouveau style was short-lived, yet one of his highest achievements, *Golden Age* (1897–1898), which was painted in this vein a year after the Millennium, shows a nostalgic yearning for a lost paradise. The frame was made by the artist and its tendril-like ornamentation acts as an extension of the elegiac, semi-visionary landscape.

Vaszary's portrait, *The Artist's Sister* (1901), is another fine example of *fin de siècle* painting. It owes its special appeal to its decorative quality and the flat ornamental character of the background which complements the shape of the sitter's dress. The lithograph entitled *Spring* (1903) already moves in another direction and provides a foretaste of Vaszary's subsequent work, its graceful charm and elegance revealing the influence of the École de Paris.

Vaszary's activities as an applied artist were confined to his Art Nouveau period. He designed posters, books and carpets, the latter having a particular freshness and vivacity, infused with observed details of Hungarian village life in stylized form.

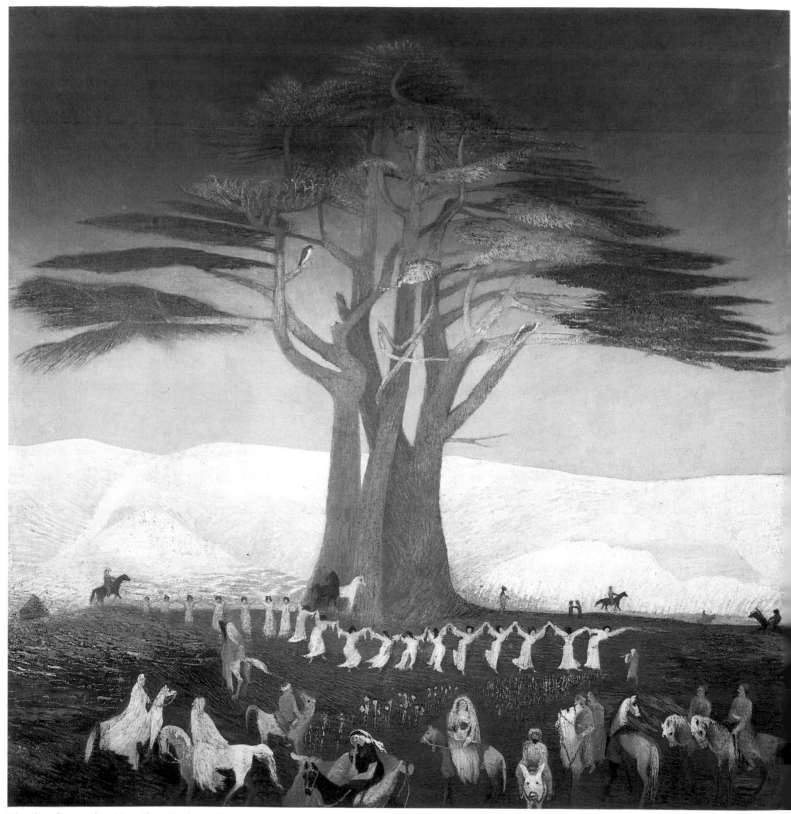

Tivadar Csontváry Kosztka: *Cedars of Lebanon* 1907
Oil on canvas, 200 × 260 cm
Janus Pannonius Museum, Pécs

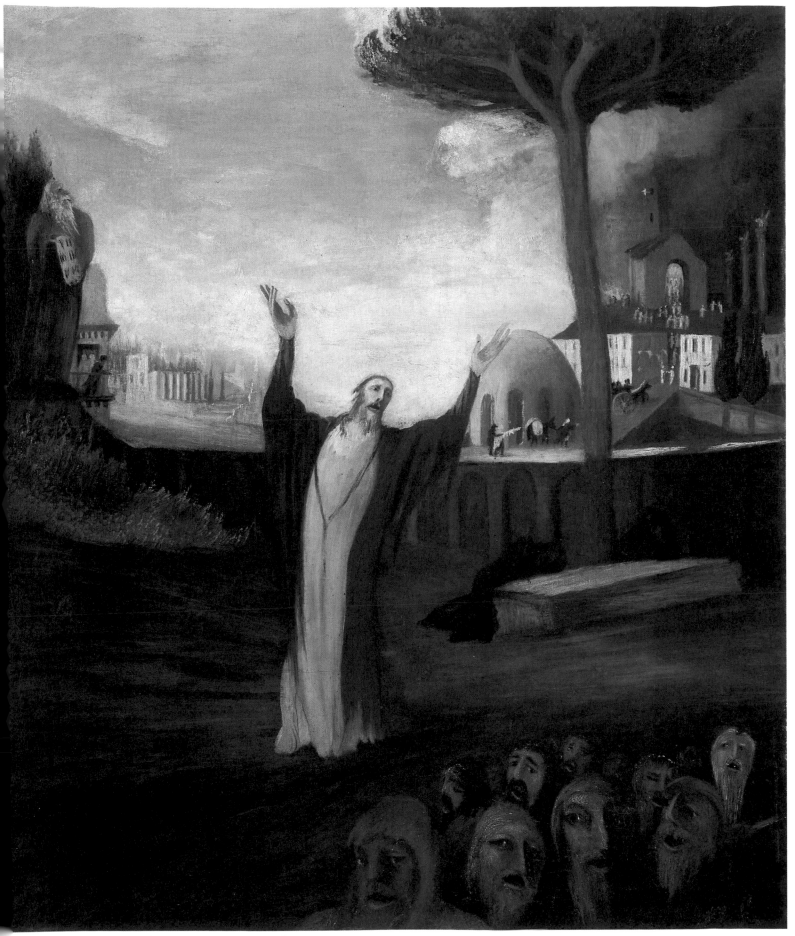

Tivadar Csontváry Kosztka: *Praying Saviour* 1903
Oil on canvas, 100 × 82 cm
Janus Pannonius Museum, Pécs

Tivadar Csontváry Kosztka: *Young Painter* 1898
Oil on canvas, 38.5 × 29 cm
Hungarian National Gallery, Budapest

Tivadar Csontváry Kosztka: *Old Fisherman* 1902
Oil on canvas, 59.5 × 45 cm
Ottó Herman Museum, Miskolc

Lajos Gulácsy: *The Opium Smoker's Dream* 1913–1918
Oil on canvas, 160 × 90 cm
Janus Pannonius Museum, Pécs

104

Lajos Gulácsy: *Chevalier aux Roses* 1914
Oil on canvas, 170 × 103 cm
Hungarian National Gallery, Budapest

Lajos Gulácsy: *The Betrothal of Mary* 1903
Oil on canvas, 43 × 52.5 cm
Private collection, Budapest

Lajos Gulácsy: *Madame Bovary's Friend* 1911
Pastel on paper, 51 × 38 cm
Hungarian National Gallery, Budapest

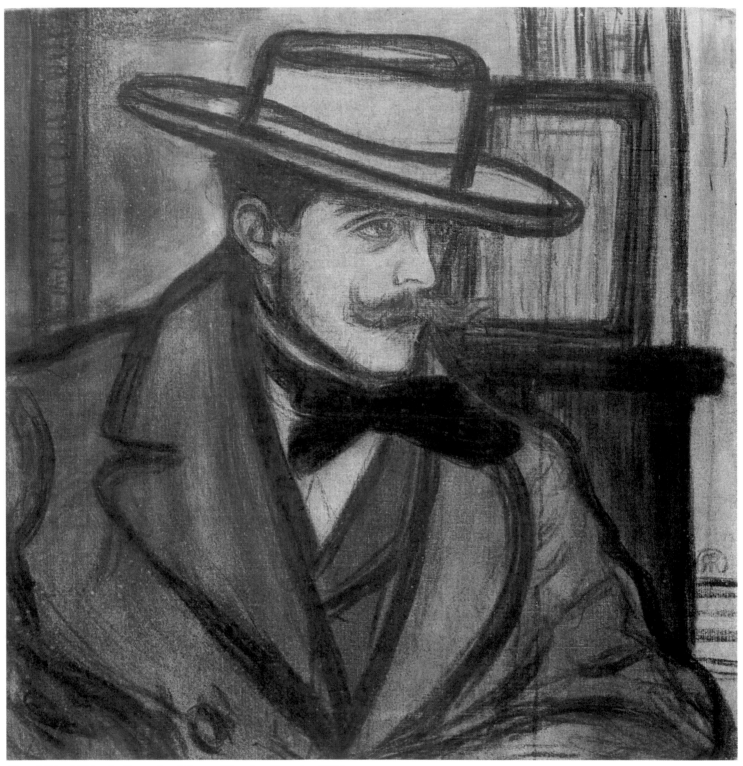

József Rippl-Rónai: *Portrait of James Pitcairn Knowles* 1892
Oil on canvas, 54.5 × 64 cm
Hungarian National Gallery, Budapest

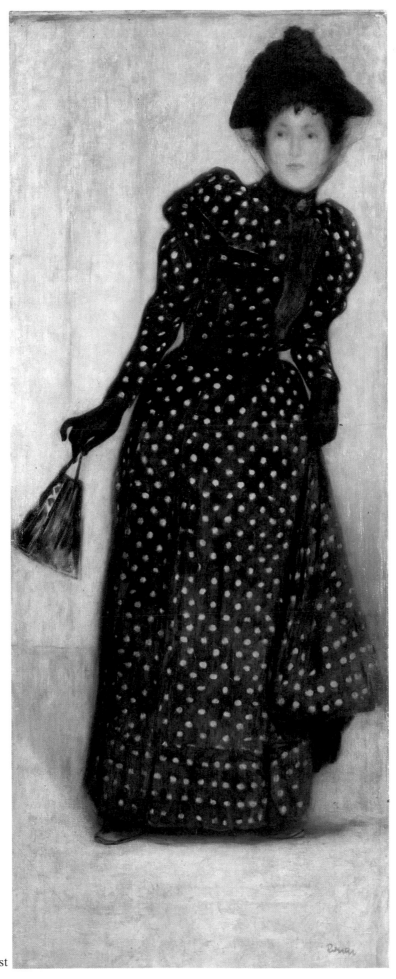

József Rippl-Rónai:
Woman in White Dotted Dress 1889
Oil on canvas, 187 × 75 cm
Hungarian National Gallery, Budapest

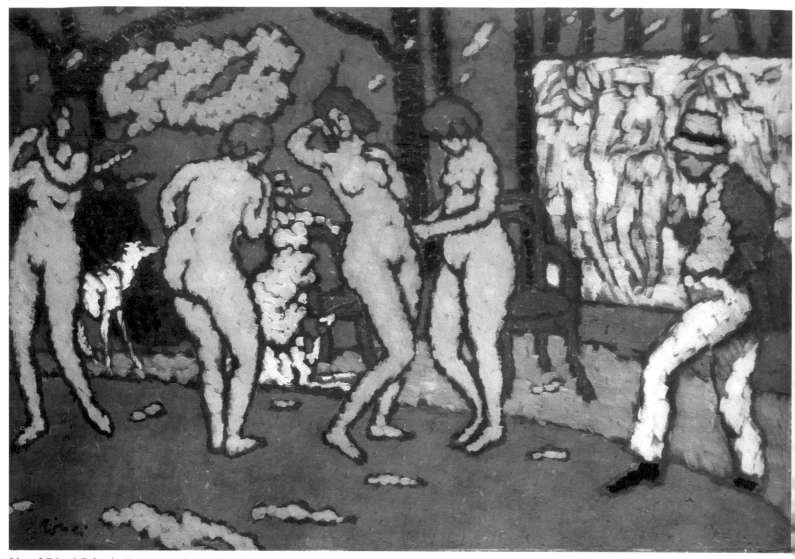

József Rippl-Rónai: *Painter with Models* 1910
Oil on cardboard, 70 × 100 cm
József Rippl-Rónai Museum, Kaposvár

József Rippl-Rónai: *Village Festival* 1895
Paper, colour lithograph, 38.5 × 53 cm
Hungarian National Gallery, Budapest

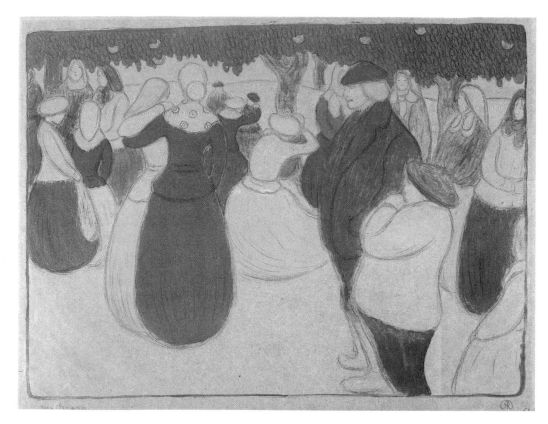

József Rippl-Rónai: *Skittle-players* 1892
Oil on canvas, 80.5 × 117 cm
Hungarian National Gallery, Budapest

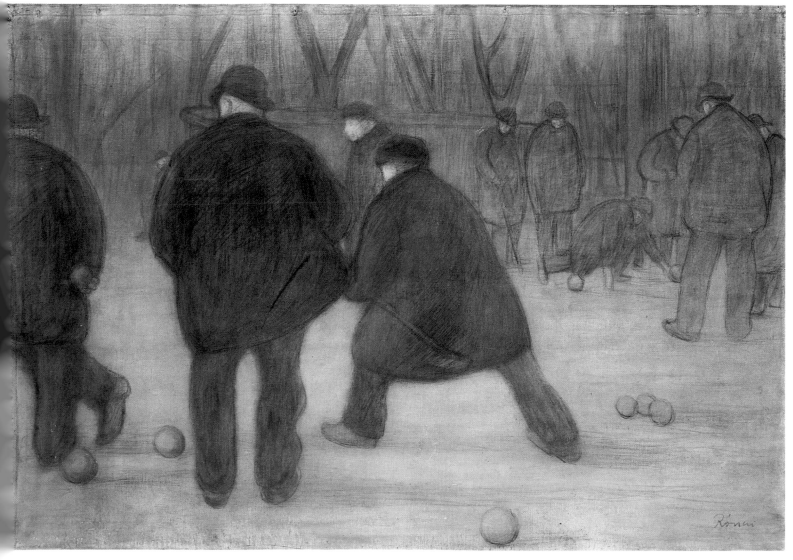

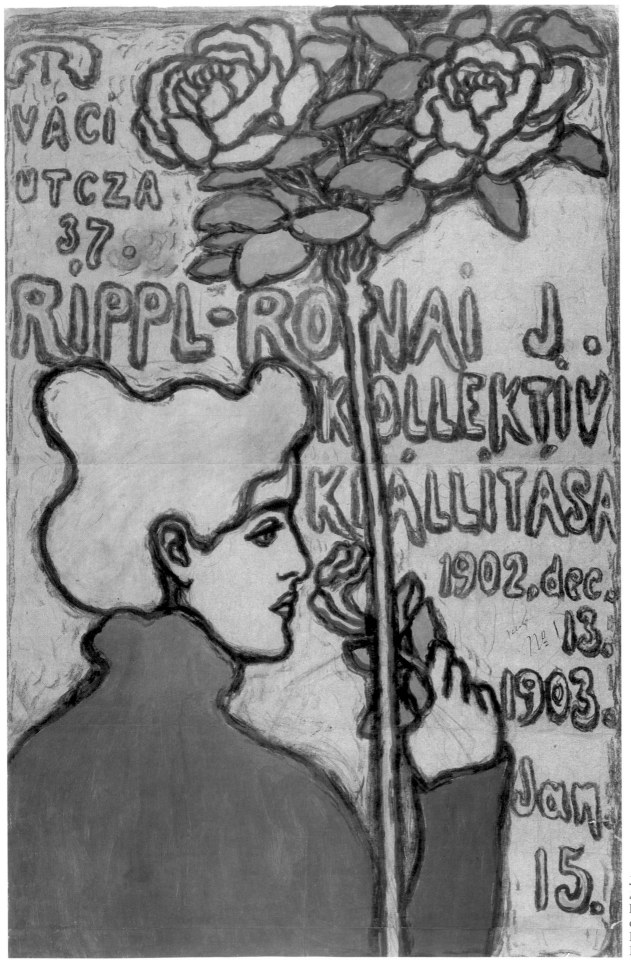

József Rippl-Rónai:
Study for a poster 1902
Pencil and charcoal
on paper, 94.5 × 22 cm
Hungarian National Gallery
Budapest

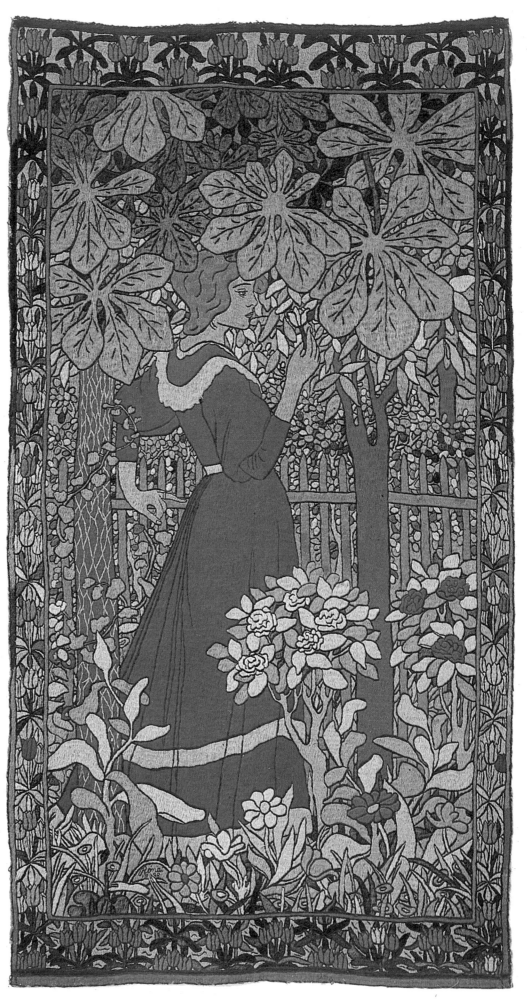

József Rippl-Rónai:
Young Woman with Rose 1898
Tapestry, 230 × 125 cm
Museum of Applied Arts, Budapest

113

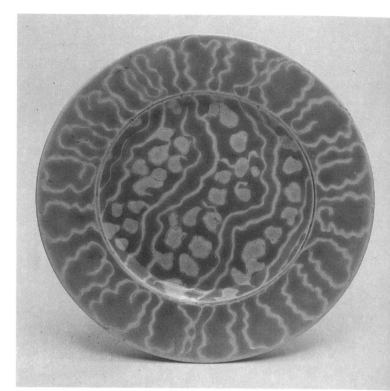

József Rippl-Rónai: *Small plates* 1897–1898. Glazed porcelain, 21.2 cm (Made by the Zsolnay factory)

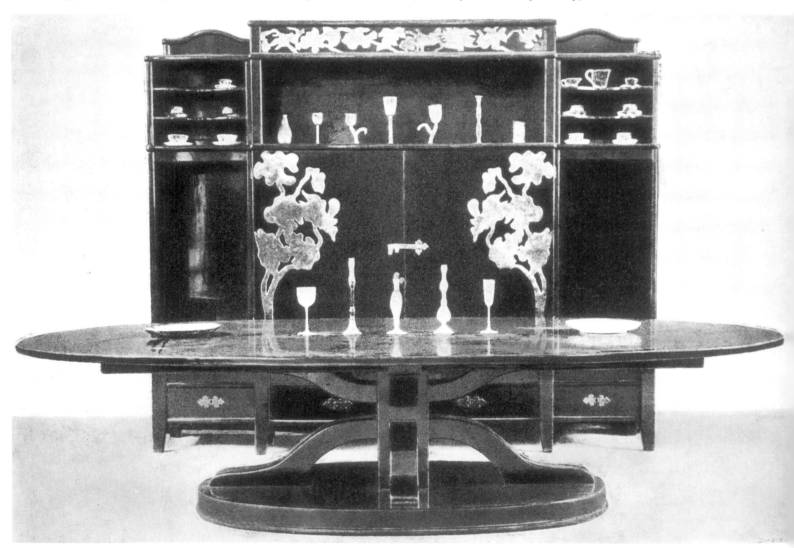

József Rippl-Rónai: *Large cupboard and dining table for the Andrássy dining room* 1896–1899

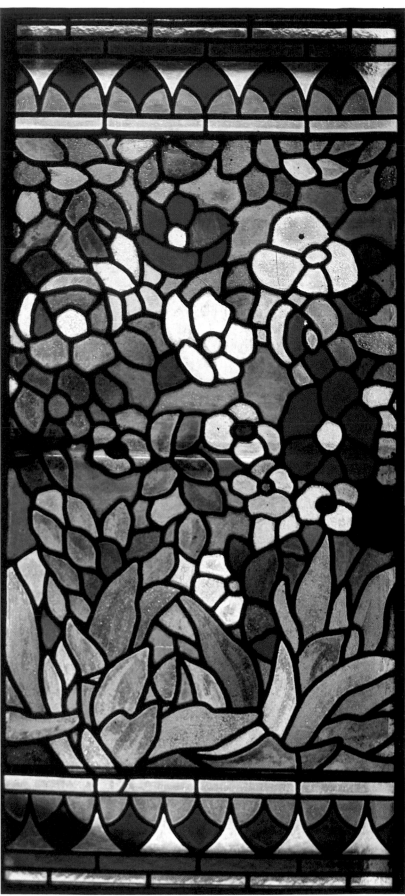

József Rippl-Rónai: *Fancy vase* 1898
Blown glass, 20 cm
Museum of Applied Arts, Budapest

József Rippl-Rónai: *Glass plate for the phone booth of the Japanese Café* 1910 (Made by Miksa Róth)
Glass, 49 × 108 cm
Museum of Applied Arts, Budapest

115

János Vaszary: *Golden Age* (Detail)

ános Vaszary: *Golden Age* 1897–1898
Oil on canvas, 92.5 × 132 cm
Hungarian National Gallery, Budapest

János Vaszary: *Spring* 1903
Colour lithograph, 32.5 × 42 cm
Hungarian National Gallery, Budapest

János Vaszary: *Portrait of a Lady* 1895 ▷
Oil on canvas, 120 × 85 cm
József Rippl-Rónai Museum, Kaposvár

118

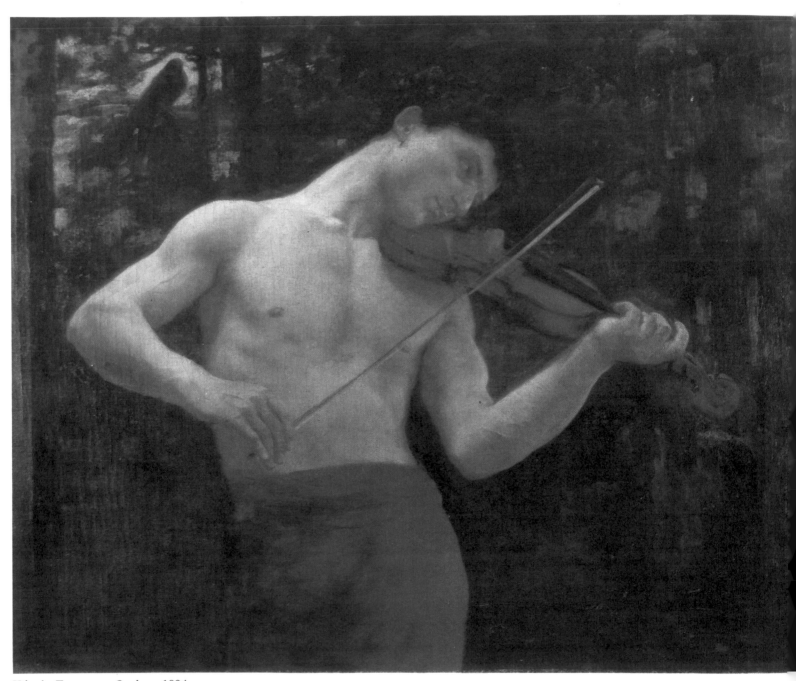

Károly Ferenczy: *Orpheus* 1894
Oil on canvas, 98.2 × 117.5 cm
Hungarian National Gallery, Budapest

Artists' Communities

At the time of the great Millennial Exhibition in Budapest, aspirations towards artistic autonomy were still impeded by centuries of foreign domination. Without a flourishing Hungarian art or art school many younger artists had to turn to Vienna and Munich for training and instruction, and they continued to study at these bastions of Academicism even when Paris had become the centre of modern experimental trends.

Simon Hollósy was one of the few who broke with this Academic training and, after finishing his studies at the Munich Academy, settled in the city to become the leading figure for the resident young Hungarian artists. The group around him was the foundation for what gradually became a private school and Hollósy, who had an excellent pedagogical sense and a charismatic personality, was to become a major influence on Hungarian students in Munich.

Hollósy's composition, *Dancing Girls at the Edge of the Forest* (1895), an early example of Hungarian Art Nouveau, is unique in his œuvre. Hollósy did not consider himself a portraitist, and although he attempted this as a commission for a triple portrait, there is a symbolic, even Bacchic quality in the depiction of the three women.

The artists of the Hollósy School drew upon French *plein air* painting for inspiration. It was not the rugged work of Courbet, but rather the naturalism of Bastien-Lepage that attracted them. Under Hollósy's influence, the circle produced a host of paintings distinguished essentially by fine craftsmanship. Two artists from Nagybánya, István Réti (1872–1945) and János Thorma (1870–1937), belonged to the group and succeeded in persuading their home town to invite the Hollósy School to Nagybánya. This was how the Nagybánya Artists' Colony came into being in the summer of 1896. Thus prepared, the young painters set about following the example of the French Impressionists by working in the open air, finding their subject in the exquisite landscape of Transylvania.

From this time, Károly Ferenczy (1862–1917) assumed an importance equal to Hollósy, and was soon to become the leading figure of the colony. The encounter with nature engendered a pantheism in his art, in which human life is seen to be integrated and at one with nature. *Orpheus* (1894) is an early example of this approach, which was followed by a series of Biblical paintings exemplifying his love of nature. The Nagybánya Colony was not primarily a child of Art Nouveau. The form of *plein air* painting preferred by its members rather utilized elements of late Realism and Impressionism, and while the purely decorative aspects of Art Nouveau were of some importance, artists of the Colony were more concerned with the idea of a bond between man and nature.

The poet József Kiss was close in spirit and style to the Nagybánya group, and inspired many of their works. Ferenczy, like William Morris, believed that illustration had an integral part to play in conveying the meaning of a poem and his illustration of Kiss's poetry was one of the most fascinating projects of the colony. The result is one of the finest sets of poetry illustrations in the Art Nouveau style.

Unlike his graphic work, there is only one painting by Károly Ferenczy which carries the stylistic traits of Art Nouveau: *Archaeology* (1896). No other composition by Ferenczy is so linear and certainly no other is as decorative.

Béla Iványi Grünwald (1867–1940) had already attended the Académie Julien in Paris by the time he joined the Hollósy circle in Munich in the 1900s, and later on he followed the group to Nagybánya. Iványi's career shows a succession of stylistic changes, but the Nagybánya period marks the high point of his work. It was at Nagybánya that he painted *Among Mountain Peaks* (1901), a picture which combines the atmosphere of *plein air* painting with elements of Art Nouveau.

István Csók (1865–1961) spent little time at Nagybánya, but the feeling for nature which he

121

discovered there exerted a great influence on his painting. But then, between 1903 and 1910, he encountered Art Nouveau in Paris. It was at this time that he painted his *Vampires* (1907), so suggestive of how Art Nouveau saw the ambiguous relationship between the sexes.

'*We know one great treasure–the greatest–and this we cultivate and seek: the joy of living ... That which proceeds from our hands afterwards, in the wake of this jubilant love of life–is our art. We recognize no other artistic programme.*'* This was how Aladár Körösfői-Kriesch outlined the ideas of the Gödöllő Colony, formed in 1902. In this statement, it is easy to recognize Morris's belief that 'art is the expression of pleasure felt in the course of work'. The Gödöllő artists regarded art as an activity of a higher order, which owing to its transcendental and symbolic nature, gave pleasure. They pressed for *Gesamtkunst,* an art that permeated everything and made life more beautiful, and which relied on one artist to design everything in an interior, thus stamping it with the force of his personality.

Besides the main school of weaving, a school of sculpture also functioned in Gödöllő, and leather work, stained-glass and furniture were also produced. As Körösfői wrote, '*most art is to be found where art encounters life, in the spirit of Ruskin*',** so giving importance to the realm of applied art. Ruskin laid the blame for inferior formal and artistic achievement at the door of industrial development and mass production and to counter this trend, he advocated the study of medieval techniques and materials. The Gödöllő Colony adopted Ruskin's concept and advocated an art in which the boundary between applied and fine art was gradually eroded.

The Gödöllő Colony was also inspired by the philosophy of Leo Tolstoy who, towards the end of his days, lived according to evangelical principles and wished to adopt the traditional lifestyle of the Russian peasant. In the spirit of Tolstoy, the Gödöllő group simplified their own lives and wished to popularize his teachings for the common good, seeking happiness in unity.

The ultimate goal of Gödöllő, however, was to establish a new kind of national art, and in so doing they cultivated folk art, in which they believed they discovered the requisite 'racial'

characteristics. The illustration of Dezső Malonyai's five volume study, *The Art of the Hungarian People* (1907–1922), made by several Gödöllő artists, among them Aladár Körösfői Kriesch, Sándor Nagy, Mariska Undi and especially Árpád Juhász, has remained a major landmark of Hungarian ethnography.

The Gödöllő community also drew abundantly on the local styles of Transylvania and Kalotaszeg. In many respects their works enter into the spirit of the Transylvanian past, and their motifs evoke the atmosphere of Transylvanian folk tales. They were imbued with mysticism and tended towards narrative portrayal. The artists of Gödöllő strove to establish an art which would allow greater individual freedom and enhance life, and sought an existence that was religiously inspired. The Christianity of the Middle Ages with its transcendental concepts became their ideal, although it was coloured by pantheism and Eastern forms of mysticism. As Körösfői wrote '*a man is a man in that he feels himself inseparably one with the Universe.*'***

The idealism and elevated morality of the Gödöllő community is unique in Hungarian art history, and its achievements are of the first importance. Its international success earned respect for Hungarian art and its reputation attracted many foreign artists to Hungary.

The painting *Ego sum via, veritas et vita* (1903) by Aladár Körösfői Kriesch is one of the most perfect expressions of the purity of this Christian faith. It displays a mentality that sought and found the fullness of life in family togetherness. Körösfői painted it after the premature death of his first child. The composition (on the right side of which members of the Gödöllő settlement are recognizable) illustrates Christian compliance with the Divine will.

Death and mortality, dear to the contemporary propensity for transcendental thinking, were recurring motifs in the works of the Gödöllő masters, especially Körösfői Kriesch. His drawings entitled *Man in Pursuit of Death* and *Death in Pursuit of Man* (1905) express the haunting awareness of the constant presence of death. In the two paintings, *The Story of Klára Zách I* and *II* (1911), he deals with a theme from Hungarian history, when in fourteenth-century Hungary, an alien king, the Angevin Charles Robert, ruled the

* Katalin Gellér and Katalin Keserű: *A Gödöllői művésztelep* (The Gödöllő Art Colony). Budapest, 1987
** *Ibid.*

*** *Ibid.*

country. Legend has it that one of the Hungarian aristocrats opposing his reign, Felicián Zách, attacked the royal family whom he blamed for the rape of his daughter. In retaliation, Felicián Zách and his entire clan were exterminated. Numerous works of art and literature had dealt with the theme in the course of the nineteenth century, when Felicián Zách became a symbol of the rebellion against foreign domination and personal sacrifice for Hungarian liberty. Körösfői Kriesch, however, was fascinated mainly by the emotional rather than political basis of this theme. Klára Zách is here the embodiment of female honesty and virtue, and only marginally the heroine of a Hungarian drama. This cycle and the frescoes of the Academy of Music, Budapest, show the interpenetration of Art Nouveau forms and ideas at their most intense.

Sándor Nagy's paintings and drawings also reflect the Gödöllő striving for the purification of the spirit. His artistic idiom is subordinated to literary and symbolic reference and a striving for a clear moral stance. A case in point is *Ave Myriam* (*c*. 1903), which is part of a cycle depicting the development of the artist's own life in its progress towards beauty and perfection. At the beginning of the cycle, the artist discovers the evangelical tenets then, finding a wife, experiences the joyous beauty of life and reaches fulfilment with the birth of a child. The artist and his wife are shown attaining the joy which comes from a life shared with others. Another fine example of the Colony's attitude to family life is Jenő Remsey's *Portrait of The Artist's Wife* (1910), in which Vilma Frey, the head of the weavers' workshop, is portrayed as a symbol of fertility. In a drawing entitled *Pelleas and Melisande* (1912), Nagy deals with a popular contemporary theme based on a play by Maeterlinck. His fairy-tale world was in keeping with the mood of Art Nouveau, and with its exaggerated, elongated lines and dynamic linear rhythms, *Pelleas and Melisande* succeeded in becoming the graphic equivalent of Maeterlinck's own literary mysticism.

The Gödöllő Colony was not only involved with painting; there was also a school of sculpture which was directed by Ferenc Sidló, and assisted in the summer by Ödön Moiret. Two architects, István Medgyaszay and Ede Thoroczkai Wigand, were also in attendance. Members of the community were also responsible for several fascinating book bindings and illustrations, particularly for children's books.

Miksa Róth, the founder of the largest contemporary glass painting workshop towards the turn of the century and the reviver of the art of glass painting in Hungary, also maintained close contact with members of the group. Like the Gödöllő artists, he was influenced by the English Pre-Raphaelites and looked to English glass painting and its leading exponents, Burne-Jones and William Morris, for guidance. Miksa Róth's career began in 1884, and from 1900 he won numerous awards and prizes, bringing the art of Hungarian glass painting to international attention. The glass windows of almost every major public and private building in Budapest of the period were made by his workshop, which continued to work successfully until the Second World War. But the First World War and its aftermath led to the dissolution of Gödöllő and other artists' groups. Their aspirations continued, however, especially through the work of the Nagybánya Colony, in one form or another, into the 1950s.

Scenes from the life of the Nagybánya Artists' Colony 1904
Archive photos, Hungarian National Gallery, Budapest

123

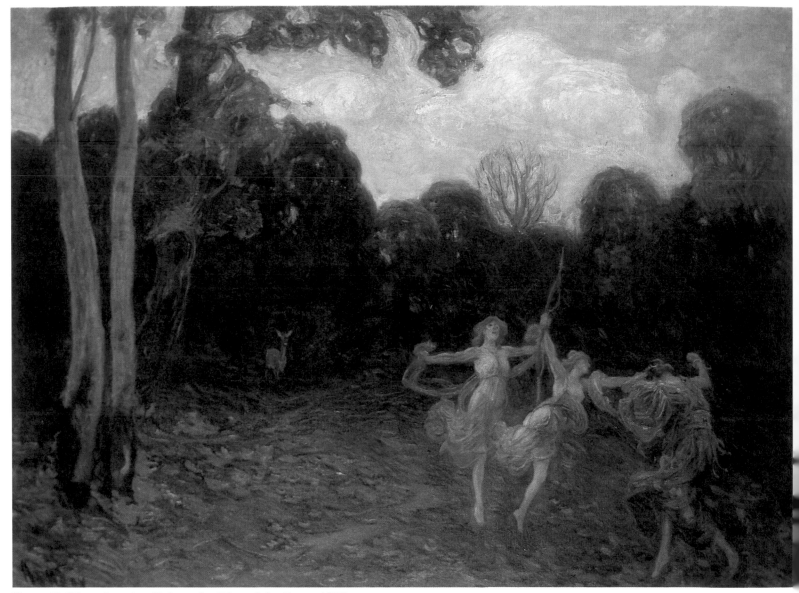

Simon Hollósy: *Dancing Girls at the Edge of the Forest* 1895
Oil on canvas, 151 × 200 cm
Hungarian National Gallery, Budapest

Béla Iványi Grünwald: *In the Valley c.* 1900
Oil on canvas, 121 × 150 cm
Hungarian National Gallery, Budapest

Károly Ferenczy: *Memory of Naples* 1896
Charcoal on paper, 63.5 × 41 cm
Hungarian National Gallery, Budapest

Károly Ferenczy: *Daphnis and Chloe* 1896
Charcoal on paper, 18.7 × 38 cm
Hungarian National Gallery, Budapest

Károly Ferenczy: *Archaelogy* 1896
Tempera on canvas, 118 × 66 cm
Hungarian National Gallery, Budapest

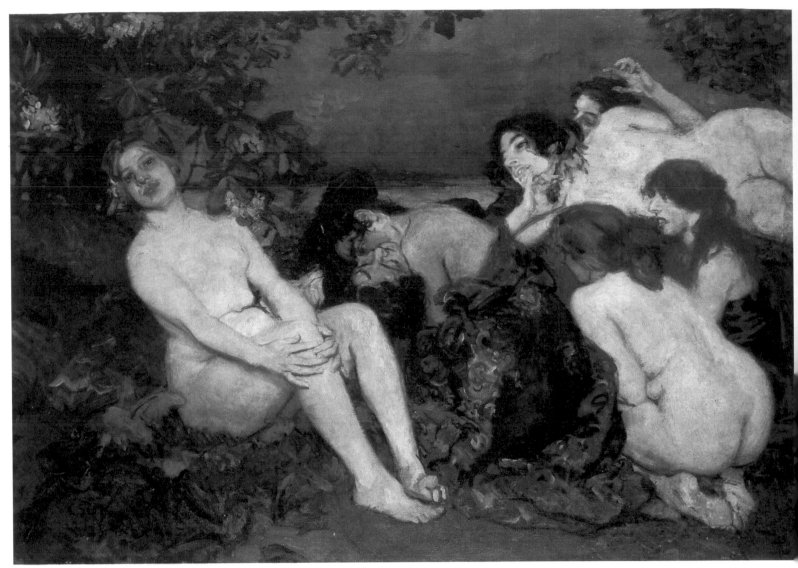

István Csók: *Vampires* 1907
Oil on canvas, 174 × 190 cm
Private collection, Budapest

Sándor Nagy:
'Home of the Artist'
exhibit at Milan 1906

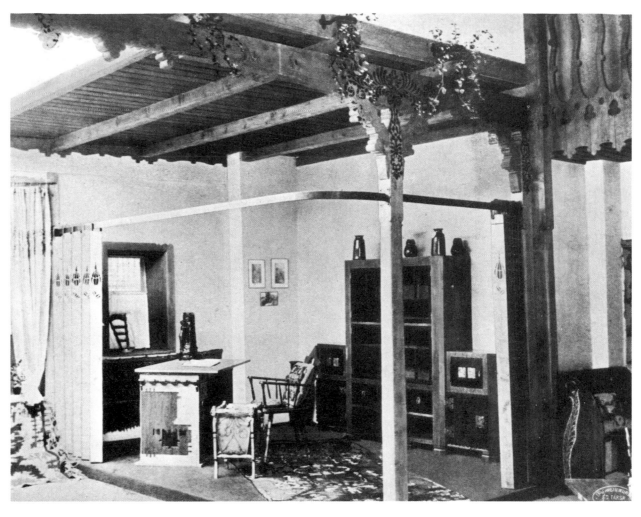

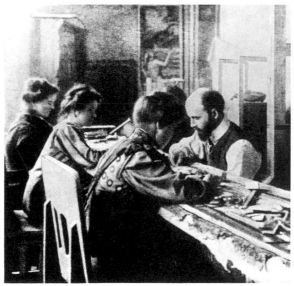

The weaving workshop at the Gödöllő Artists' Colony
Archive photo, Local History Collection, Gödöllő

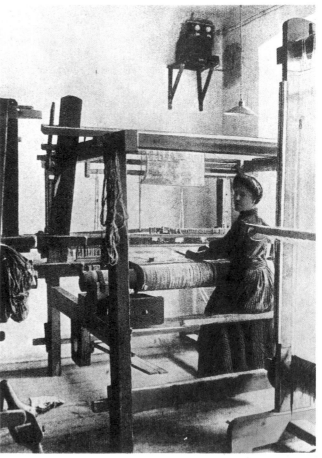

Vilma Frey at the loom
Archive photo, Local History Collection, Gödöllő

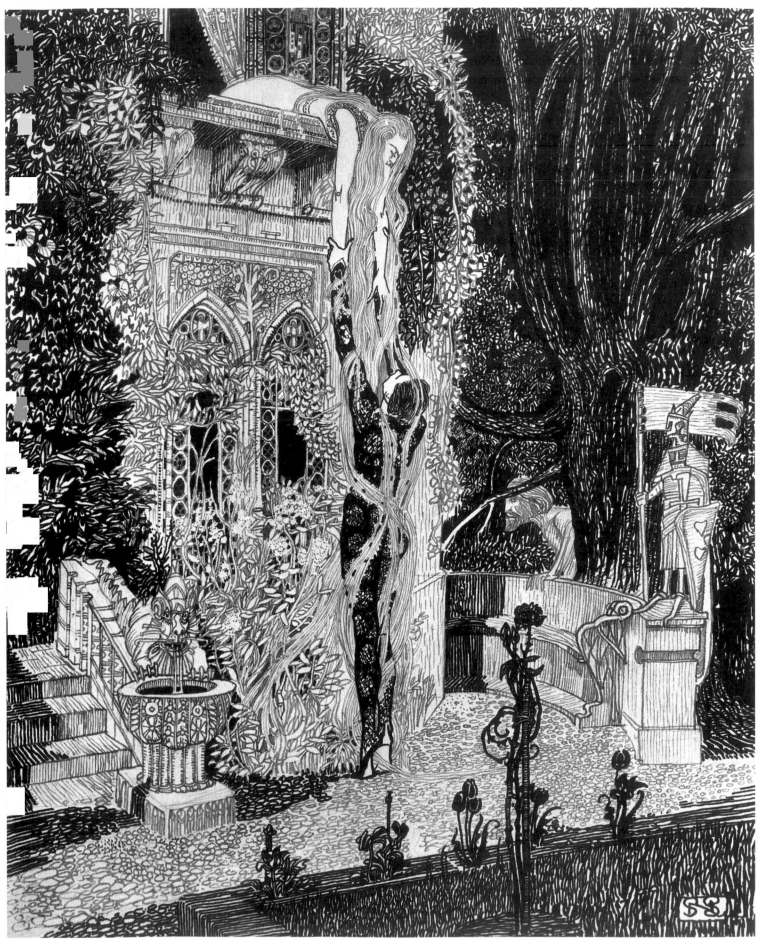

Sándor Nagy: *Pelleas and Melisande* 1912
India ink on paper, 29.3 × 23.3 cm
Hungarian National Gallery, Budapest

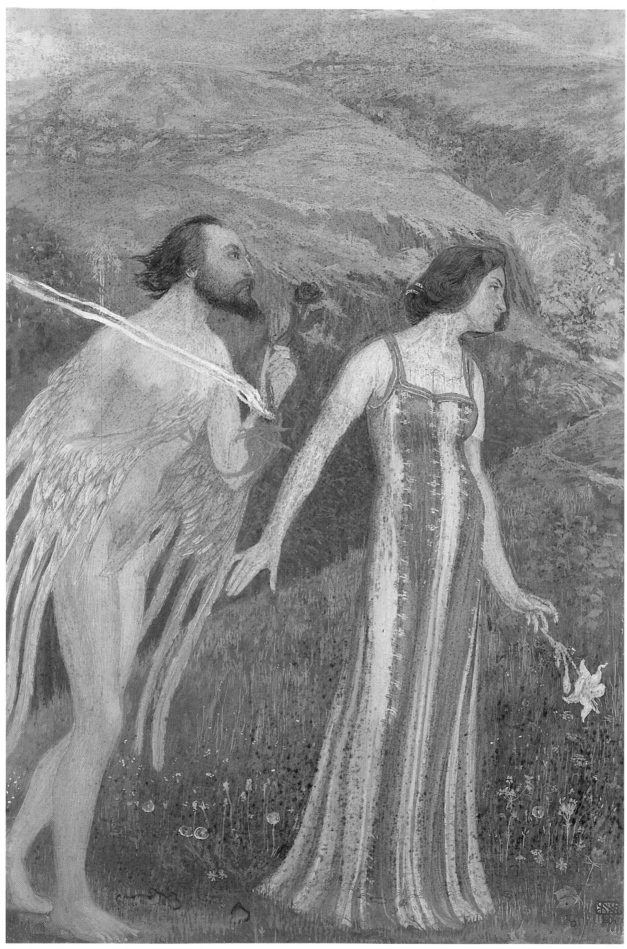

Sándor Nagy: *Ave Myriam c.* 1903
Tempera and oil on gypsum, 89 × 60 cm
Hungarian National Gallery, Budapest

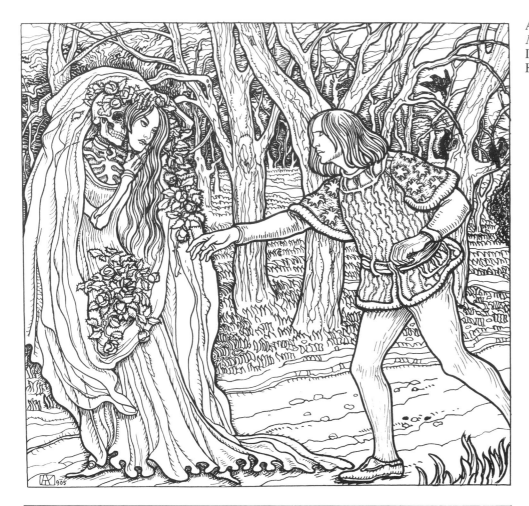

Aladár Körösfői Kriesch:
Man in Pursuit of Death 1905
India ink and pen on paper, 37.5 × 41.1 cm
Hungarian National Gallery, Budapest

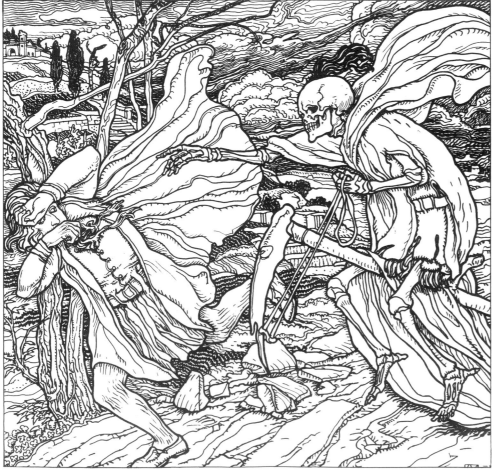

Aladár Körösfői Kriesch:
Death in Pursuit of Man 1905
India ink and pen on paper, 37.5 × 40.1 cm
Hungarian National Gallery, Budapest

Laura Kriesch-Nagy:
*New Flowers
in a New World* 1909
Aquarelle and India ink
on paper, 25.5 × 39.8 cm
Hungarian National Gallery,
Budapest

Rezső Mihály:
Stage design c. 1910
Watercolour and pen
on paper, 23.3 × 26.2 cm
Local History Collection,
Gödöllő

133

Aladár Körösfői Kriesch: *The Story of Klára Zách,* I–II 1911
Oil on panel, 101 × 195 cm
Hungarian National Gallery, Budapest

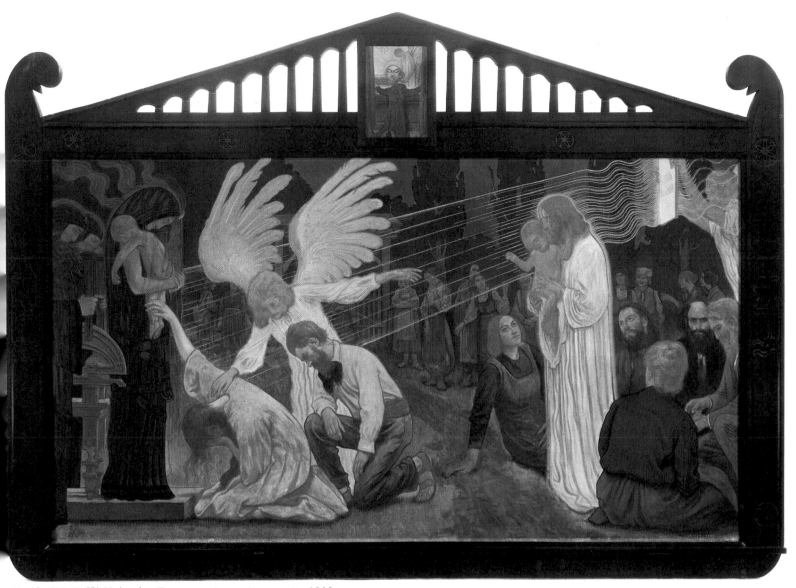

Aladár Körösfői Kriesch: *Ego sum via, veritas et vita* 1903
Tempera on canvas, 158.5 × 286 cm
Hungarian National Gallery, Budapest

Ödön Moiret: *Mary Magdalene c.* 1909
Glazed majolica, 73 cm
Hungarian National Gallery, Budapest

Ferenc Sidló: *Awakening* (the painter's wife Carla Undi) 1909
Marble, 58 cm
Local History Collection, Gödöllő

Sándor Nagy: *Bible* (Made by Leo Belmonte)
Etched, painted leather, 28.8 × 16.5 cm
Museum of Applied Arts, Budapest

Sándor Nagy: *Screen c.* 1904
(Manufactured by Leo Belmonte)
Leather with wooden frame, 49.4 × 74 cm
Museum of Applied Arts, Budapest

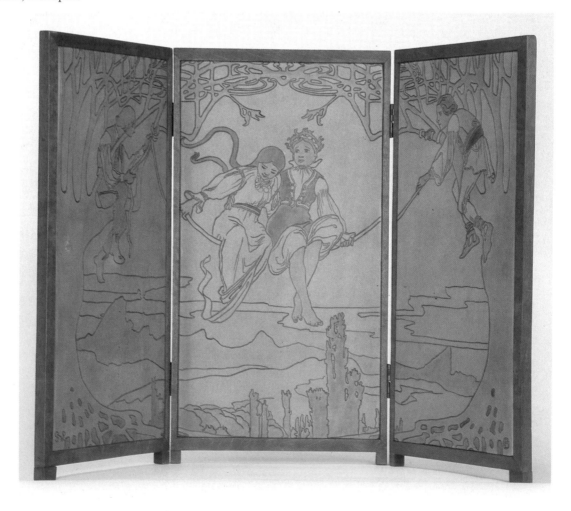

138

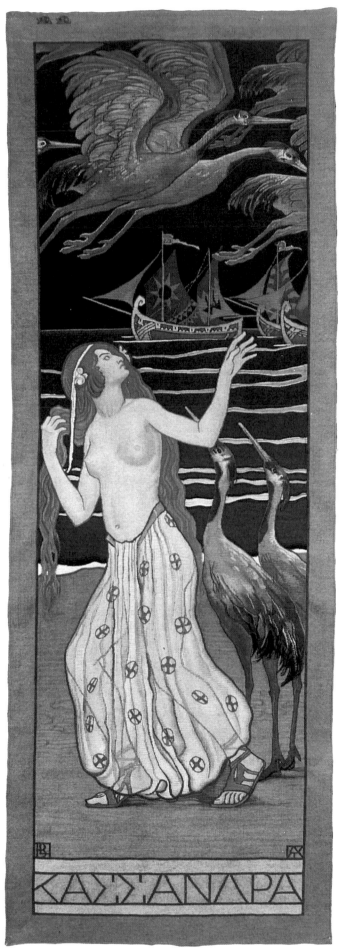

Aladár Körösfői Kriesch: *Cassandra* 1908
(Made by Leo Belmonte)
Tapestry, 200 × 71 cm
Museum of Applied Arts, Budapest

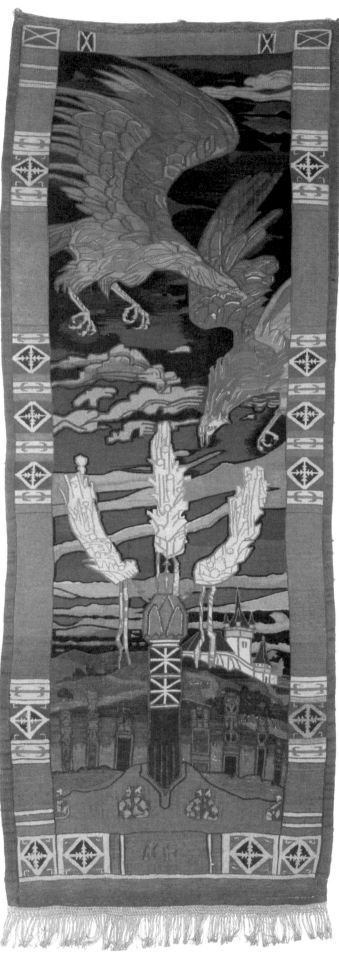

Aladár Körösfői Kriesch: *Eagles Above the Hero's Grave*
1918 (Made by Rózsa Frei)
Tapestry, 250 × 87 cm
Museum of Applied Arts, Budapest

Sándor Nagy: *Head of Christ*. Glass window in the chapel of Lipótmező, Budapest *c.* 1910
Antique glass, 68 × 49 cm
Hungarian Museum of Architecture, Budapest

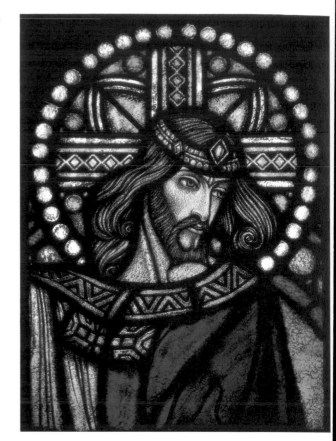

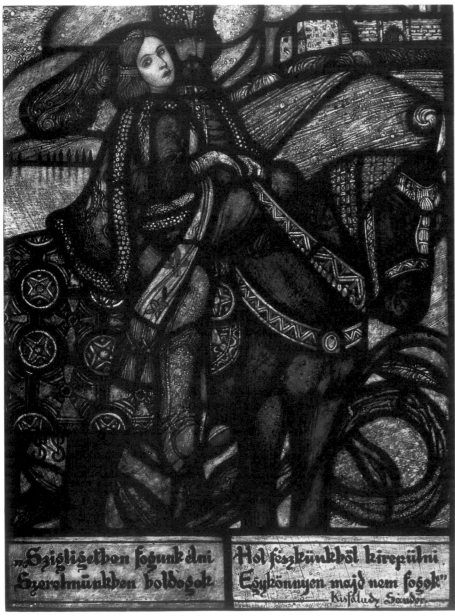

„Szigligetben fogunk élni
Szerelmünkben boldogok"

„Hol fészkünkből kirepülni
Egyhönnyen majd nem fogok"
Kisfaludy Sándor

Sándor Nagy: *The so-called Kisfaludy glass window*
1907 (Made by Miksa Róth)
Painted glass, 62 × 47.5 cm
Local History Collection, Gödöllő

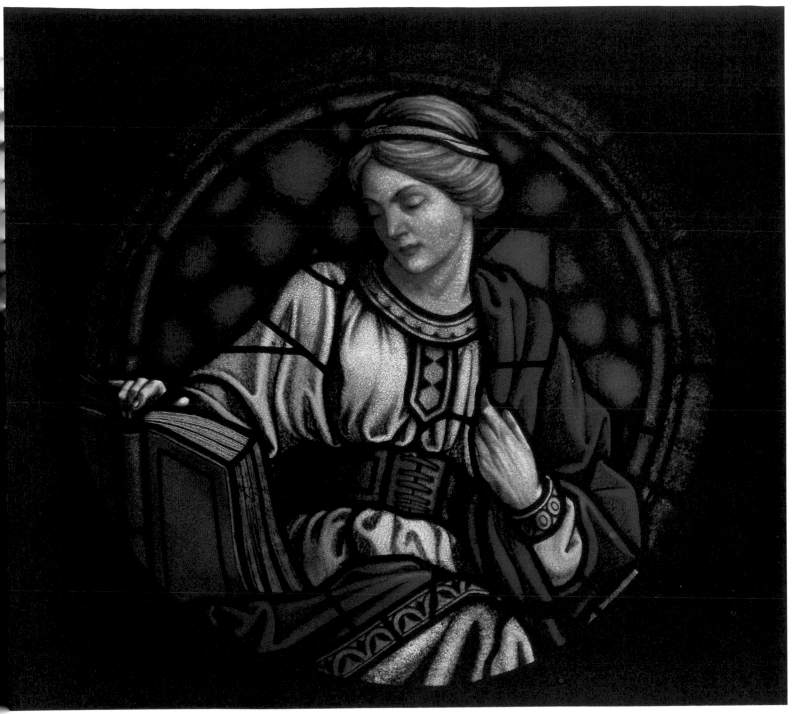

Miksa Róth: *Erudition*
Opalescent glass, 61 cm
Private collection, Budapest

Gyula Benczúr: *Portrait of Quenn Elizabeth* 1899
Oil on canvas, 142 × 95.5 cm
Hungarian National Museum, Budapest

Women and the Fin de Siècle

The representation of women in Art Nouveau is limited to iconographical types developed from a preoccupation with relatively few themes: the mystery of life and death, the relationship between the sexes, and women as the emblem of whatever was enigmatic or mysteriously attractive. *'Great dark eyes gaze into the void beyond the world with hope and uncertain desire... The dominant subject becomes an emaciated kind of beauty which embodies both passion and mortality'* wrote Hans Hofstätter in his important monograph on *Jugendstil.**

The beautiful and tragic Elizabeth von Wittelsbach, Empress of Austria and Queen of Hungary, was seen as a model of virtue. She had been educated in a more liberal spirit than was prevalent at the rigorous Burg in Vienna, and, in an effort to neutralize the influence of an intransigent court, she learned to speak Hungarian. She did much to speed the Compromise of 1867 which gave some autonomy to Hungary, and her efforts to this end won her the epithet of 'The Good Hungarian Queen'. The mysterious suicide of her son, Rudolf, the heir apparent, and her own assassination by an Italian anarchist in 1898, further enhanced her legendary status. Though she was invariably portrayed in the Academic style, she corresponded very well to the Hungarian image of the mysterious *fin de siècle* female. But woman, always seen as mysterious, airy, and unfathomable, was treated in various ways by various artists.

Woman with Bird Cage (1892), one of the finest achievements of József Rippl-Rónai's early period, is representative of the nostalgic and melancholy mood of the end of the century. The sketchy indication of space, the weightless, fashionably attenuated silhouette of the gently leaning figure and her pale translucent face and hands have an air of sadness and mystery. A healthy eroticism, typical of Rippl-Rónai, nevertheless

* Hofstätter, Hans H.: *Geschichte der europäischen Jugendstilmalerei.* Cologne, 1963

manages to penetrate the gloom. The motif and composition recur in his subsequent pictures, an outstanding example of which is his poetic study of 1898, entitled *Young Woman with Rose,* which was intended for a tapestry forming part of the decorative scheme of the Andrássy dining room in Budapest. This image is one of the most lyrical expressions of the contemporary ideal of decadent beauty.

Lady with Black Veil (1896), also by Rippl-Rónai, depicts the painter Madame Mazet as the embodiment of cosmopolitan *fin de siècle* woman. The painter intends her to be an ambiguous figure; while she appears to be in a mood of mourning, her facial expression is enigmatic, hinting at something possibly frivolous and flirtatious, even a touch of the *femme fatale.* Gyula Donáth's *Song of Lament* (1900) is notable for its sentimentality; *Portrait of My Wife* (1903), by István Csók, is provocative; while István Zádor's *My Wife* (1910) is essentially a realistic portrait in which the influence of Art Nouveau extends only to the decorative element of form.

Lajos Gulácsy's treatment of female figures tends to be nostalgic and escapist, as indeed does all his work. *Emily* (c. 1903), for example, has the ephemeral dreamy quality reminiscent of Dante Gabriel Rossetti's women. An air of mystery also characterizes Gulácsy's *Slav Fortune Teller* (1910). The *fin de siècle* had a particular affection for the figure of the witch in possession of all secrets. Here, she appears laden with meaning.

János Vaszary's *Women in Lilac Dress with Cat* (1900) is a tall, narrow picture typical of the period and ideally suited to the depiction of the slender, decadent female form much admired at the time. But the fine eroticism of Vaszary's painting is sublimated in the complex play of undulating lines.

Géza Faragó (1877–1928) was one of the most adept of minor Art Nouveau masters who made a colourful contribution to the artistic landscape of the expanding capital with their posters. His *Among Flowers* (1911) is a fine example of the

symbolic value attributed to flowers in Art Nouveau. The flowers provide a commentary on the women depicted, the lily signifying purity, the rose, consummation, and the creeper, sin.

Ferenc Helbing's (1870–1958) drawing, entitled *Dream* (1900), is a particularly potent example of the Art Nouveau escapist desire for visionary experience and makes an interesting contrast with Gyula Batthyány's painting, *In the Turkish Manner* (1914), whose rhythm conveys an atmosphere of sophisticated and stifling metropolitan eroticism.

In *fin de siècle* depictions of women, the nude constitutes a special category. In Biblical and mythological representations she is temptation or sin; elsewhere, she becomes a vampire or sphynx whose embrace is deadly; and, occasionally, she represents beauty for its own sake.

Árpád Bardócz: *Poster for furrier Gyula Elkan* 1910
46 × 31 cm
National Széchényi Library, Budapest

Dating from around 1900, *Standing Nude* by János Vaszary belongs to the latter category. The picture captures the intimacy of dressing with the immediacy of a snapshot. Rippl-Rónai's *Painter with Models* (1910) presents, through the refined beauty of its female bodies, a brilliant interplay of form. The female nude was also a recurrent theme in Rippl-Rónai's early paintings, but the mystery and melancholy of his black period was here replaced by a masterly handling of flat colour. Though Rippl-Rónai's interest in the nude was rather more abstract, something slightly provocative and frivolous remains, linking his work to the conceptual framework of Art Nouveau.

Vaszary's crayon drawing, *To Spring* (1900), is one of the loveliest examples of the nude in Hungarian Art Nouveau. Standing with her back to the onlooker, with the wreath of flowers in her hair, she is clearly an erotic symbol of spring and awakening. The compositional scheme had been popular since Ingres' *Spring*. Vaszary's painting, however, clearly reflects the mentality of Art Nouveau. This is also the case in Imre Csikász's (1884–1914) sculpture entitled *Young Girl (Spring,* 1912). Here the artist expresses the notion of spring and awakening through the innocent, unselfconscious joy of an adolescent girl on the threshold of womanhood.

Sándor Nagy's *Longing* (c. 1910) is a boldly contoured crayon drawing in which Eve is depicted as the temptress of Art Nouveau iconography. The winding, creeper-like movement of the female body follows the twisting body of the snake as it climbs the tree, almost merging with the vegetation, and becoming a decorative element of the composition in the process.

The beauty of dance and the plasticity of the female form inspired many sculptors. Though Hungarian sculpture tended to remain faithful to the Academic tradition, two outstanding Hungarian sculptors, Fülöp Ö. Beck (1873–1945) and Vilmos Fémes Beck (1885–1918), succeeded in synthesizing solid classical virtues with the lighter, more sinuous play of Art Nouveau form.

Fülöp Ö. Beck enjoyed the friendship of the Gödöllő artists and shared some of their aims. In a small bronze statuette entitled *Dancing Woman* (1914), he sought a harmony of movement to express feminine grace. His short-lived younger brother, Vilmos Fémes Beck, also dealt repeatedly with the representation of the female form,

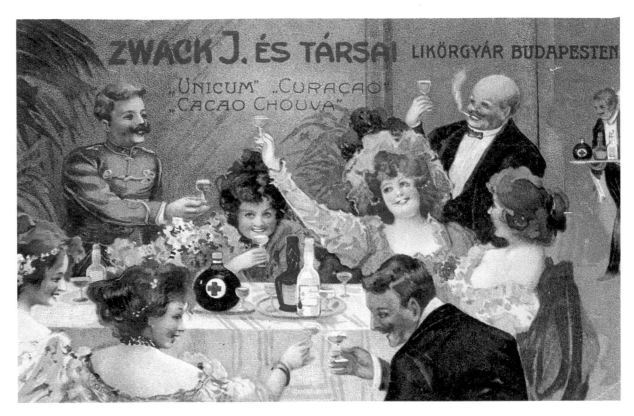

introducing a psychological tension into the formal arrangement of his figures.

Another sculptor of note, Elza Kövesházi Kalmár, began her career as a painter, but like so many of her contemporaries, worked in varied genres from sepulchral monuments to applied and graphic art. With its bizarre distortions and Expressionist style, her work reflects several trends of the Vienna Secession (she worked for the Wiener Werkstätte). She was the only representative in Hungarian sculpture of the variant of Art Nouveau which produced free and playful surfaces. Gyula Murányi's *Cleopatra* (c. 1913), too, is a sculptural version of the *femme fatale* in the quintessentially Art Nouveau vein.

The relationship between men and women also stimulated the Art Nouveau imagination, which viewed sensuality and emotion in a new light. Gulácsy, in his intense nostalgia, seized upon the subject of the illicit love between Dante's Francesca da Rimini and Paolo Malateste in *Paolo and Francesca* (1903). Dante's world was, in any case, of central importance to Gulácsy, who loved literary antecedent but, while Dante assigned the sinful lovers to Hell, Gulácsy presents them in a pure, ethereal, almost asexual manner. In another painting, entitled *Magic* (1906–1907), he depicts Dante himself with Beatrice. There is something of the self-portrait in his vision of Dante, and the picture is an apotheosis of platonic love free from sin, in which the lovers must depend entirely upon themselves for mutual support.

But sinful love, the socially unmentionable love that can be purified only by death, was also a popular subject for *fin de siècle* artists, who enjoyed sentimental and spine-chilling subjects. Pelleas and Melisande, Paolo and Francesca, and Tristan and Isolde were frequent tragic themes. The latter are the subject of a set of drawings by the Gödöllő artist Rezső Mihály (1889–1972). Sophisticated and sensual, these works invite comparison with illustrations by Aubrey Beardsley, whose works were known to the Gödöllő community.

Love fulfilled, seen as familiar love, also found pictorial expression within the Gödöllő community. Sándor Nagy's *Blessed Condition* (1903), for example, belongs to the same cycle of works as *Ave Myriam*. It illustrates the Christian idea of looking to Divine Grace for the blessing of children, and the continuity of life through children.

Woman, then, was given various, though limited roles in Art Nouveau art, from the *femme fatale* to the platonic (Beatrice). But there was a further form in which woman appeared–albeit a form with very little content–which was asexual and decorative, and which was used repeatedly

145

Divat és Irodalom 1895
Fashion illustrations

on plaques and medals. This non-symbolic female form graced the medals of such diverse institutions as the National Gardening Association (1902), the Photo Club (1905), the City of Kalotaszeg (1908), and the International Conference (1910). The supple female form also ornamented medals and presentation plates by Fülöp Ö. Beck, József Reményi and István Schwartz.

This ornamental female nude is perhaps best represented in the output of the Zsolnay works. In the 1890s, the factory in Pécs entered a period of dynamic expansion and quickly established, through the adoption of new technology, an international reputation. Many famous artists produced designs for the Zsolnay factory, including Fülöp Ö. Beck, Rippl-Rónai, Sándor Apáti Abt and Géza Nikelszky, who did much to raise the standard of applied art in Hungary.

The female form was also a favourite subject for posters and advertisements. Budapest, in common with other European cities, was witnessing a boom in poster production, and the decorative character of Art Nouveau, which suited the new printing methods, soon became the prevalent style. The appearance of desirable products was frequently announced with the sharply drawn contours of an elegant young woman coquettishly inviting the public to employ the services of some fashionable tailor, furrier, or department store.

The new feminine ideal also influenced fashions in female clothing. The full figure favoured by the nineteenth century yielded to the pale, thin, slightly angular body subject to affectations, and costumes altered accordingly. Dresses grew longer, sweeping the ground, emphasizing the slender serpentine shapes of their wearers. Hats grew vast, their enormous brims casting shadows on the face, imparting an air of mystery. In this way the feminine ideal of *fin de siècle* art appeared on the street and infiltrated everyday life, bringing with it a store of accessories adorned with plant and flower motifs made familiar by Art Nouveau.

Oszkár Tarján: *Pendant* 1904
Gold and enamel, 7 cm
Museum of Applied Arts, Budapest

146

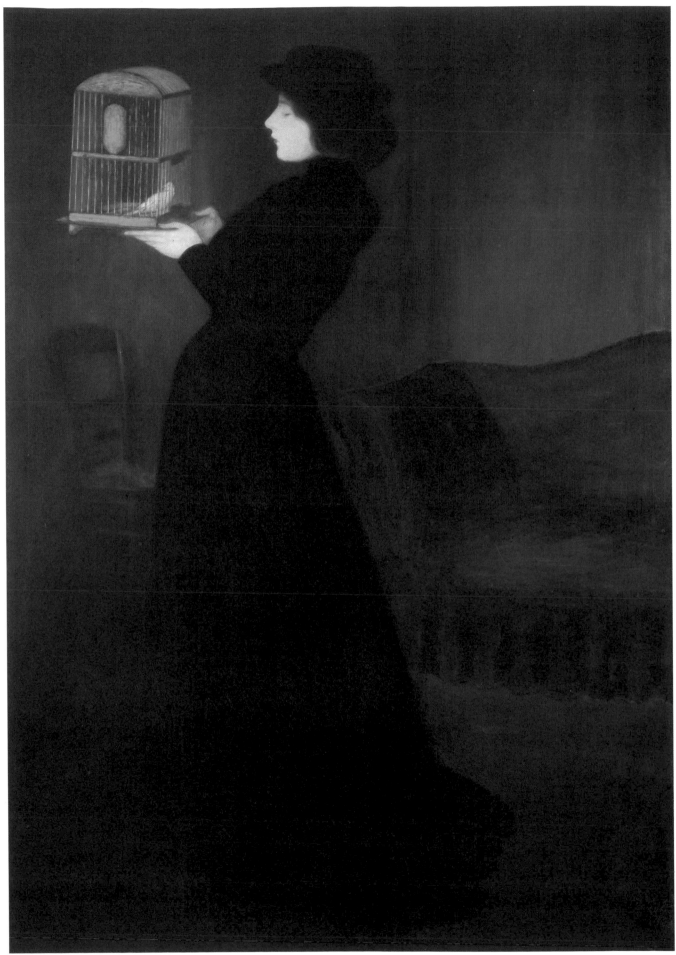

József Rippl-Rónai: *Woman with Bird Cage* 1892
Oil on canvas, 186 × 30.5 cm
Hungarian National Gallery, Budapest

147

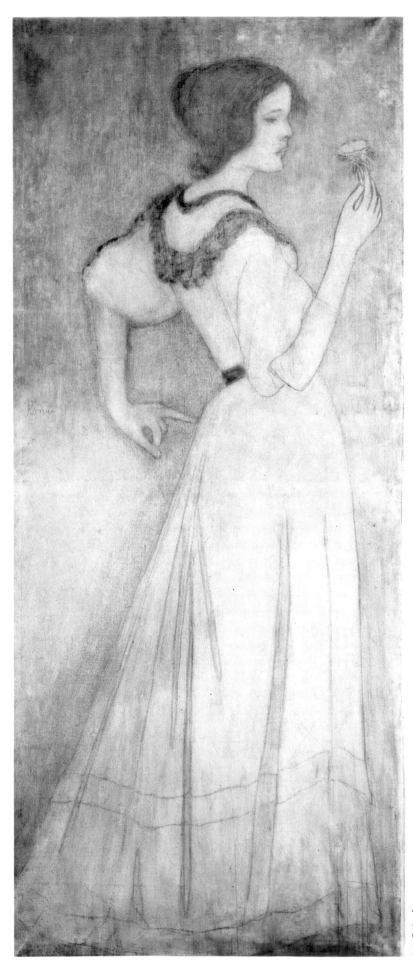

József Rippl-Rónai:
Study for 'Young Woman with Rose' 1898
Oil on canvas, 178 × 75.6 cm
Hungarian National Gallery, Budapest

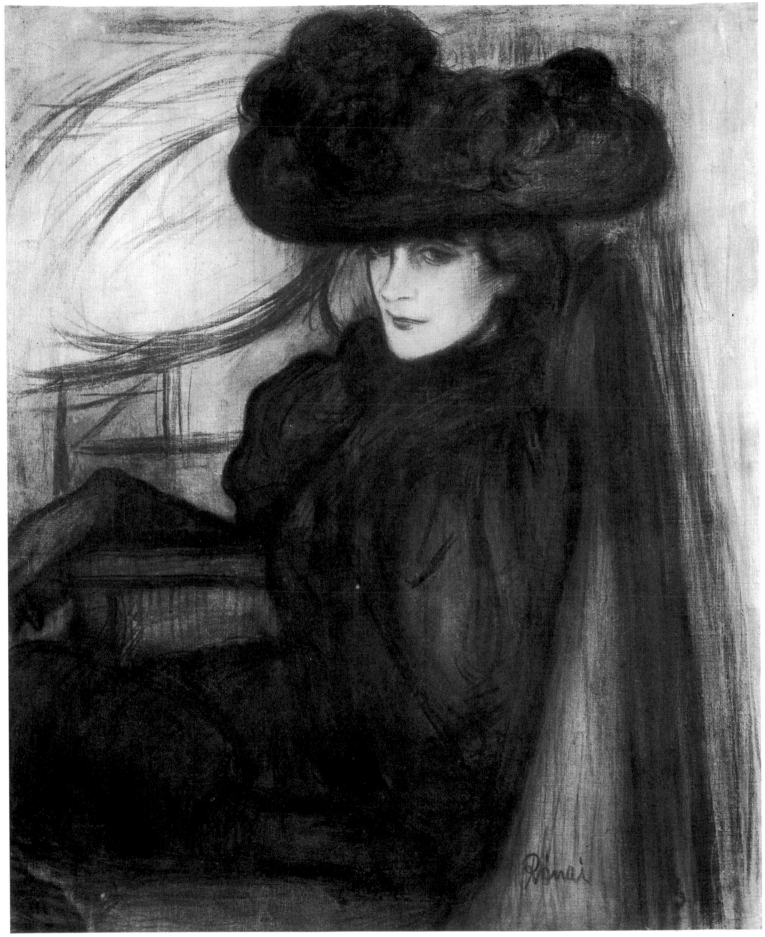

József Rippl-Rónai: *Lady with Black Veil (Mme Mazet)* 1896
Oil on canvas, 99.7 × 80 cm
Hungarian National Gallery, Budapest

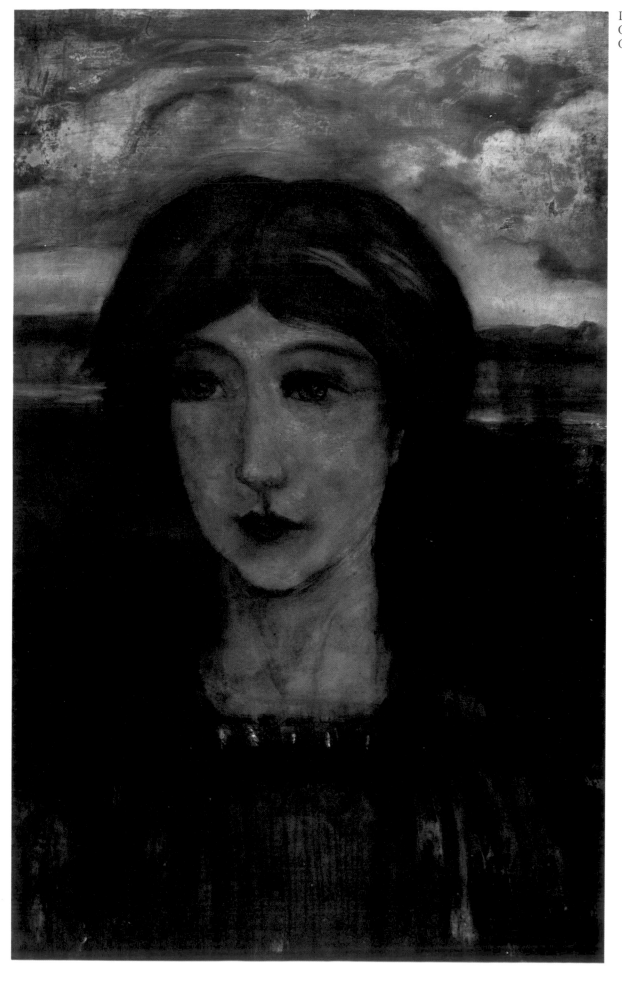

Lajos Gulácsy: *Emily c.* 1903
Oil on canvas, 36 × 22.5 cm
Otto Herman Museum, Miskolc

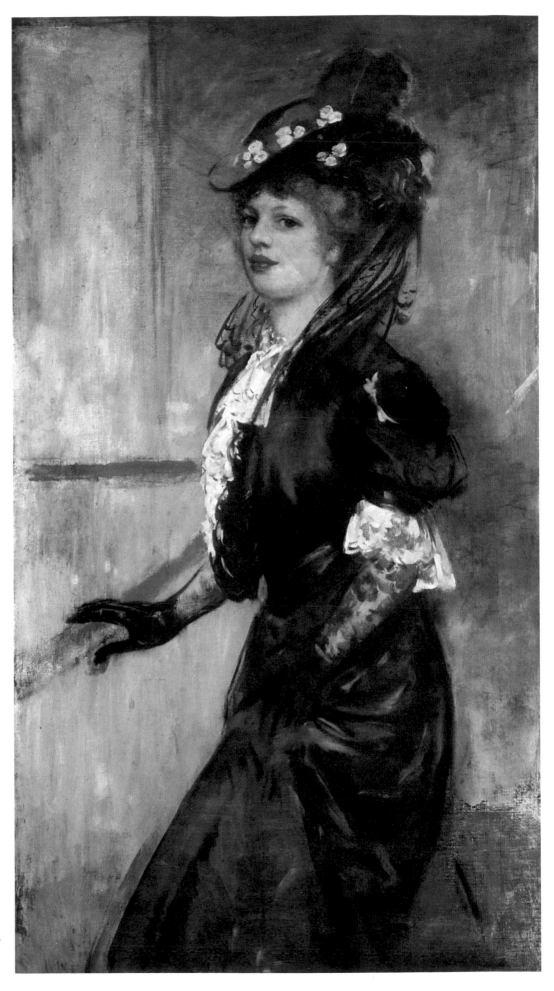

István Csók: *Portrait of My Wife* 1903
Oil on canvas, 145 × 80 cm
Hungarian National Gallery, Budapest

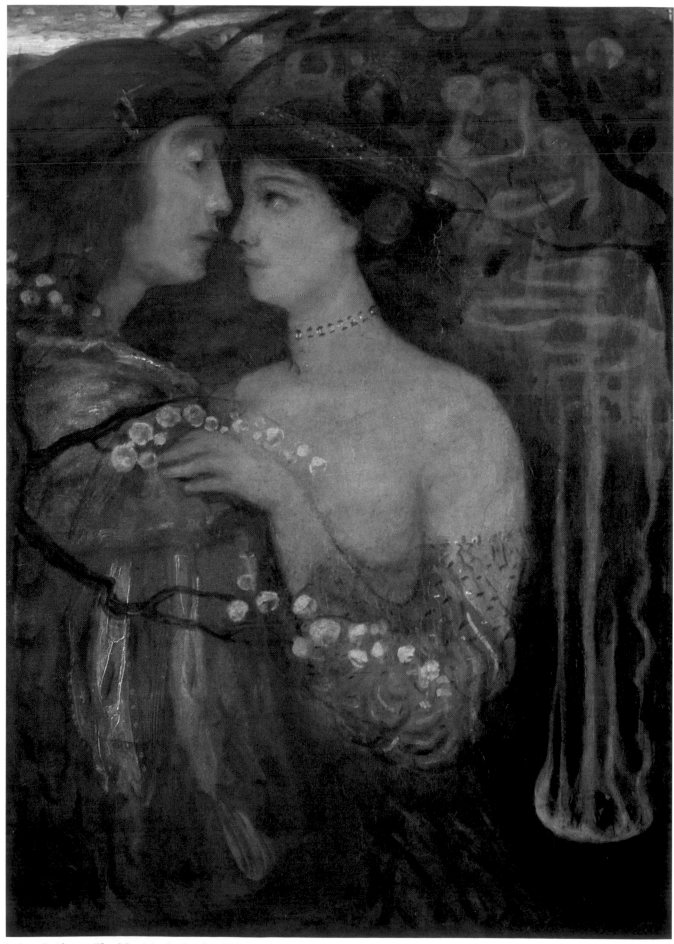

Lajos Gulácsy: *The Magician's Garden* 1906–1907
Oil on canvas, 86 × 63 cm
Hungarian National Gallery, Budapest

152

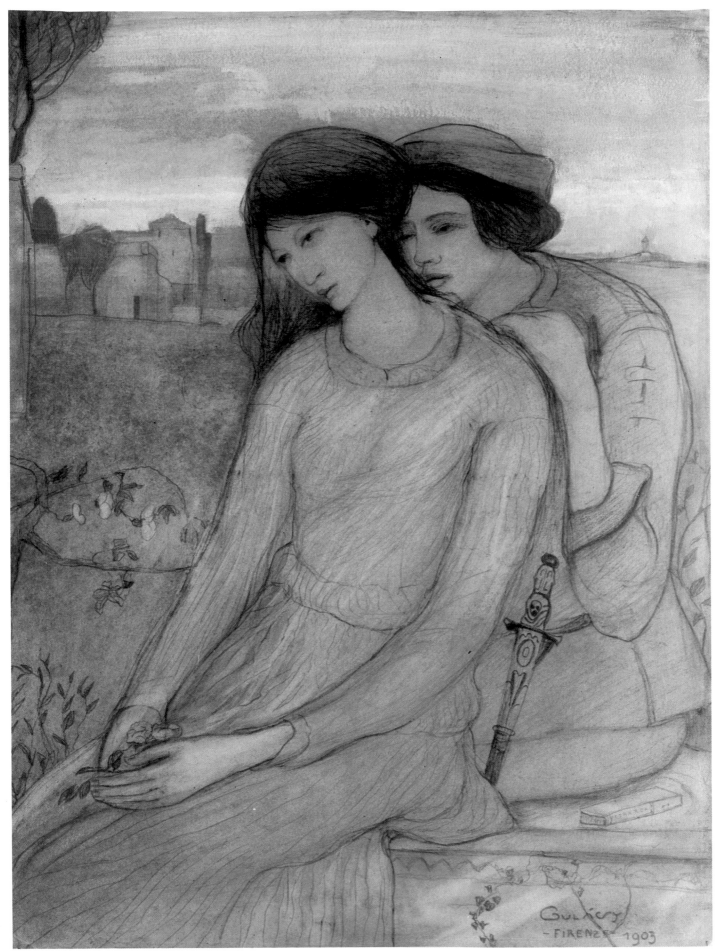

Lajos Gulácsy: *Paolo and Francesca* 1903
Pencil and aquarelle on paper, 33.1 × 25.2 cm
Hungarian National Gallery, Budapest

153

Lajos Gulácsy: *Slav Fortune Teller* 1910
Oil on canvas, 145 × 46 cm
Hungarian National Gallery, Budapest

János Vaszary: *Woman in Lilac Dress with Cat* 1900
Oil on canvas, 150 × 40 cm
Private collection, Budapest

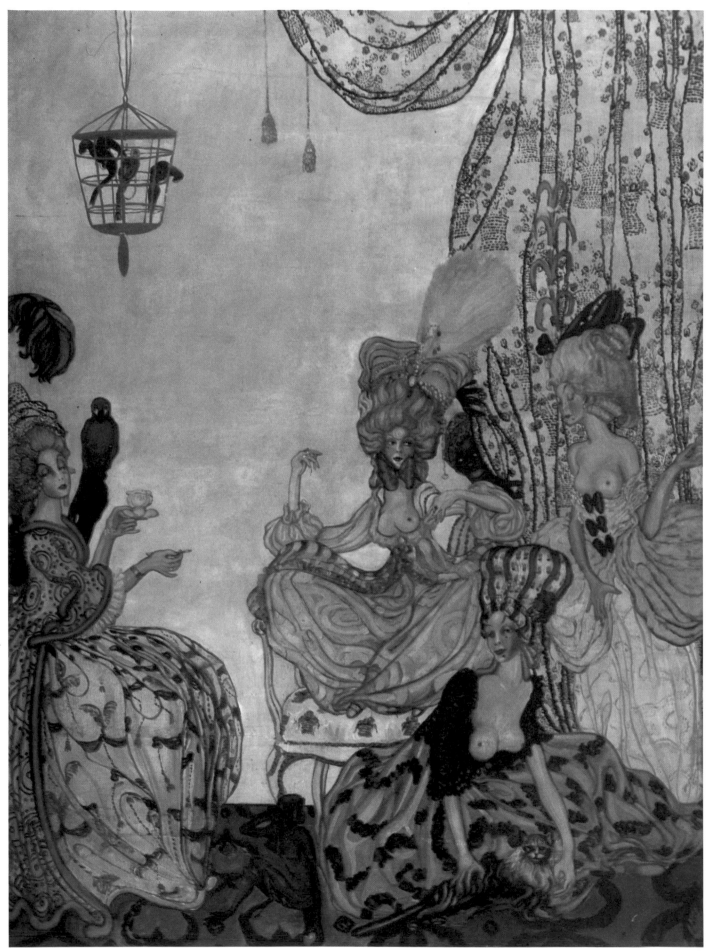

Gyula Batthyány: *In the Turkish Manner* 1914
Oil on canvas, 200 × 150 cm
Private collection, Budapest

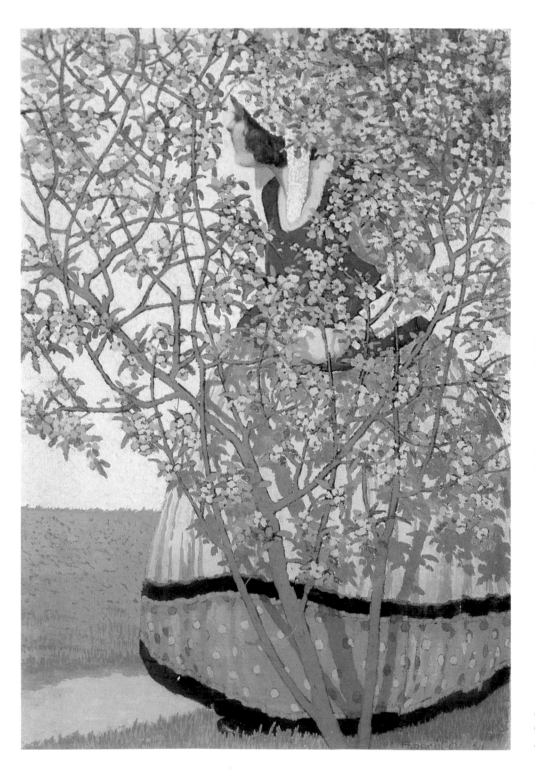

Rezső Mihály: *Tristan and Isolde* 1909
India ink and chalk on paper, 26.3 × 15.4 cm
Local History Collection, Gödöllő

Géza Faragó: *Among Flowers* 1911
Oil on canvas, 94 × 64.5 cm
József Katona Museum, Kecskemét

Sándor Nagy:
Blessed Condition 1903
Tempera on wood,
57.5 × 69.4 cm
Local History Collection,
Gödöllő

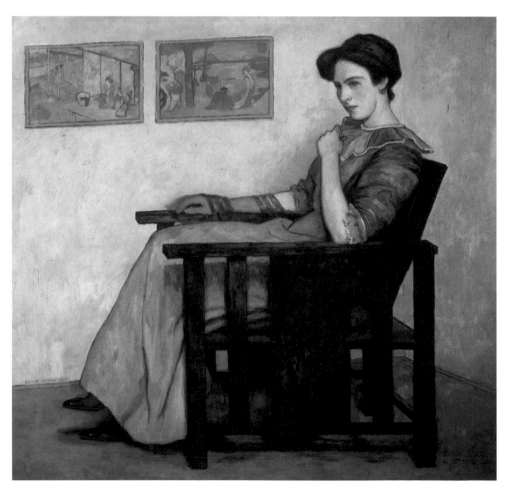

István Zádor: *My Wife* 1910
Oil on canvas, 134 × 140 cm
Hungarian National Gallery,
Budapest

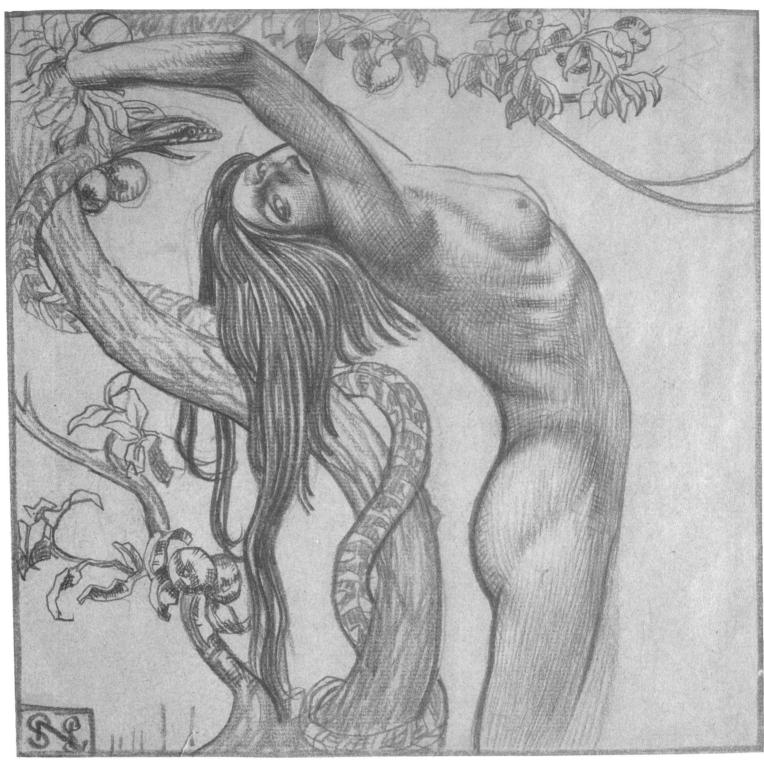

Sándor Nagy:
Longing c. 1910
Coloured chalk on paper,
28 × 28 cm
Hungarian National Gallery,
Budapest

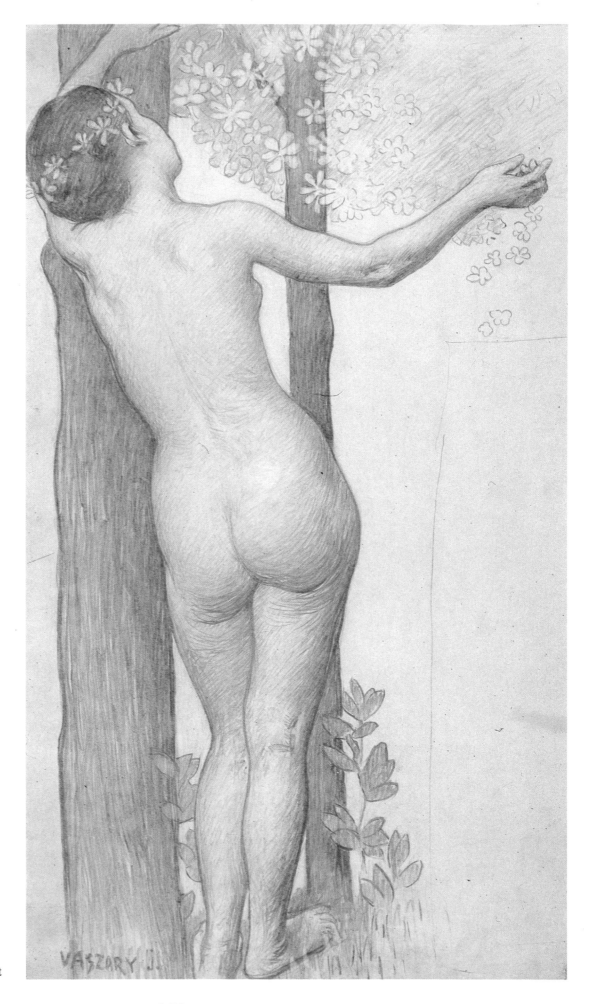

nos Vaszary: *To Spring* 1900
halk on paper, 64.2 × 45.5 cm
ungarian National Gallery, Budapest

159

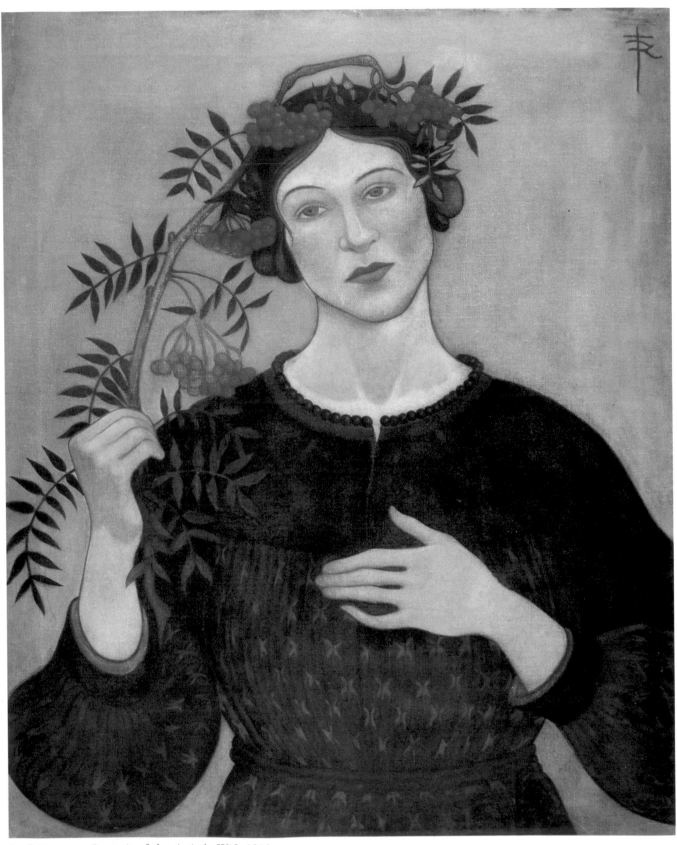

Jenő Remsey: *Portrait of the Artist's Wife* 1910
Oil on canvas, 75 × 58 cm
Private collection, Budapest

János Vaszary: *Standing Nude c.* 1900
Oil on canvas, 56.3 × 47 cm
József Rippl-Rónai Museum, Kaposvár

Elza Kövesházy Kalmár: *St. Elizabeth c.* 1912
Glazed majolica, 40 cm
Hungarian National Gallery, Budapest

Szigfrid Pongrácz: *Spring c.* 1910
Bronze, 69 cm
Hungarian National Gallery, Budapest

Elza Kövesházy Kalmár: *Leaning Woman c.* 1910
Brass, 39.5 cm
Hungarian National Gallery, Budapest

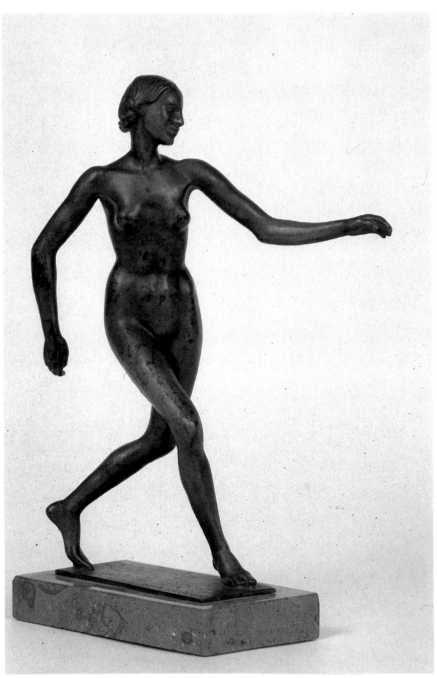

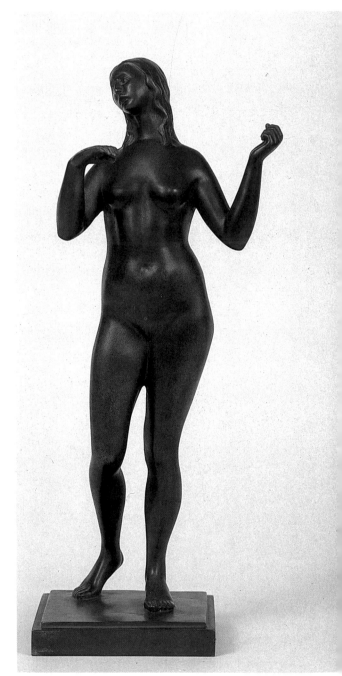

Fülöp Ö. Beck: *Dancing Woman* 1914
Bronze, 27 cm
Hungarian National Gallery, Budapest

Vilmos Fémes Beck: *Dancer c.* 1910
Bronze, 31.5 cm
Hungarian National Gallery, Budapest

164

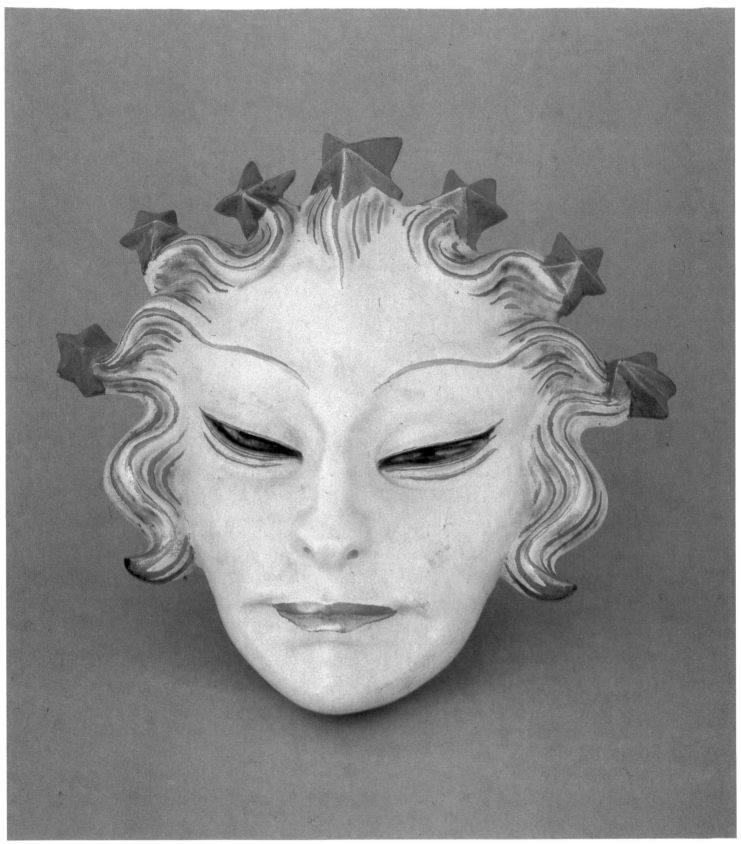

Elza Kövesházy Kalmár: *Femme Fatale* 1927
Ceramic, 26.5 cm
Hungarian National Gallery, Budapest

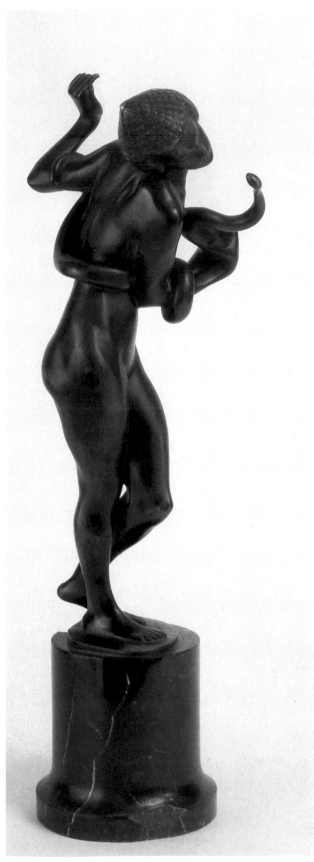

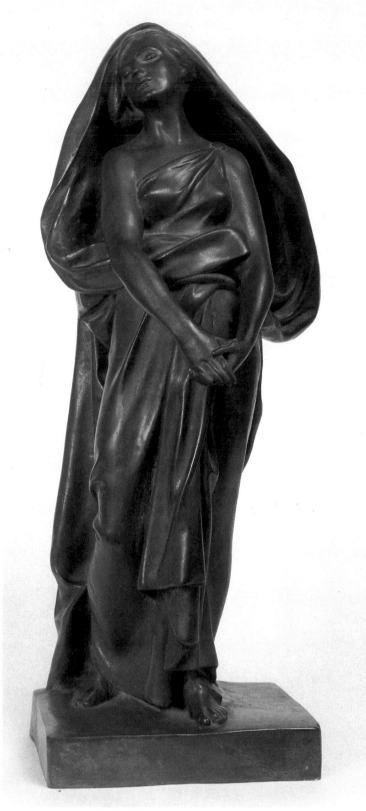

Gyula Murányi: *Cleopatra c.*1913
Bronze, 35 cm
Hungarian National Gallery, Budapest

Gyula Donáth: *Song of Lament c.* 1900
Bronze, 70 cm
Hungarian National Gallery, Budapest

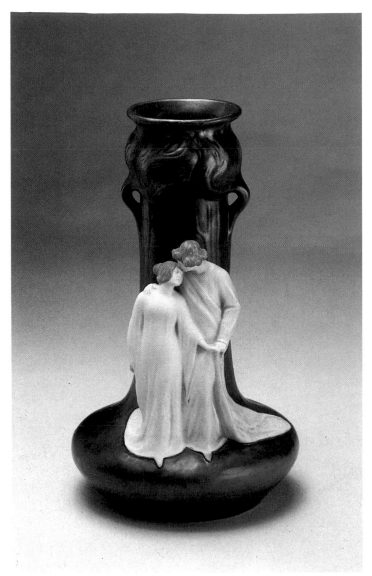

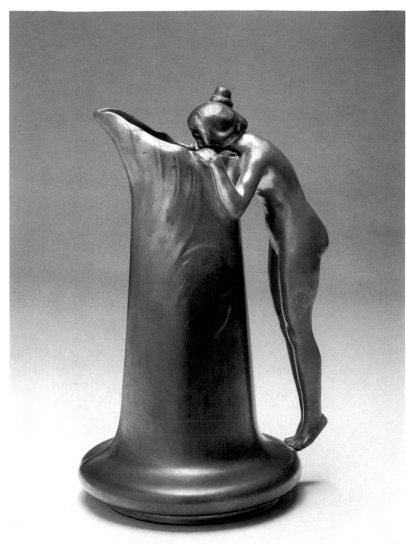

Zsolnay factory: *Vase with lovers* 1903
Eosine-glazed ceramics, 37 × 21 cm
Private collection, Budapest

Zsolnay factory:
Vase with female figure c. 1900
Eosine-glazed ceramics, 41 × 27 cm
Private collection, Budapest

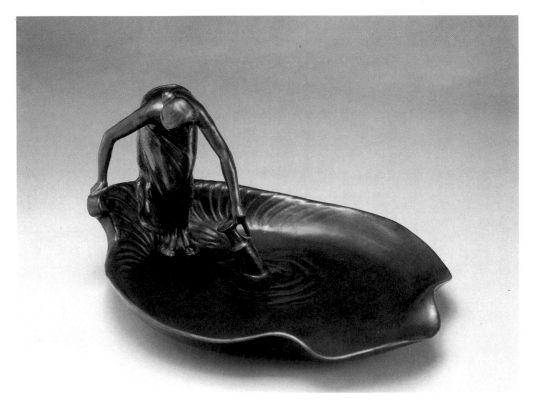

Zsolnay factory:
Dish with woman dipping water c. 1905
Eosine-glazed ceramics, 41.5 × 35 × 23 cm
Private collection, Budapest

167

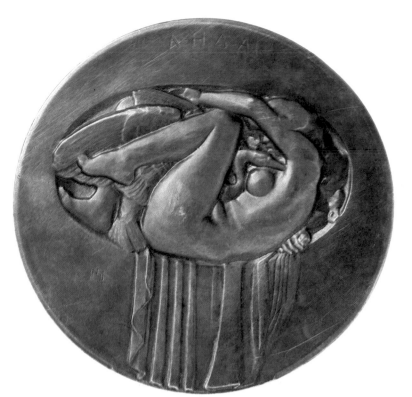

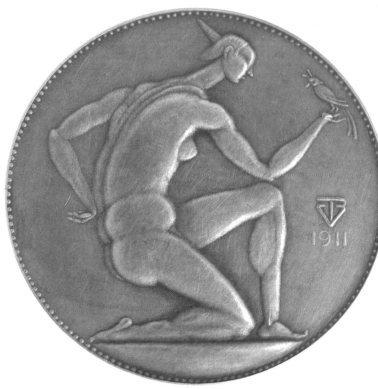

Ödön Moiret: *Leda* 1912
Bronze, pounded, 8 cm
Hungarian National Gallery, Budapest

Vilmos Fémes Beck: *Kneeling Nude* 1911
Bronze, pounded, 5.3 cm
Hungarian National Gallery, Budapest

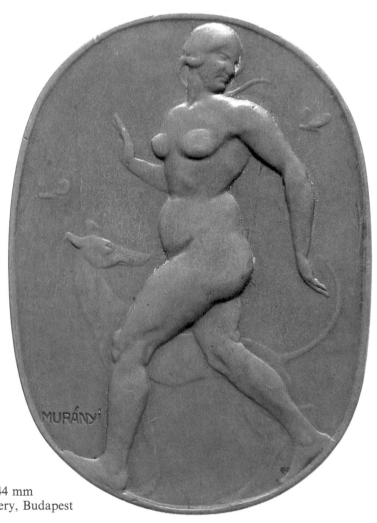

Gyula Murányi: *Diana*
Bronze, pounded, 60.5 × 44 mm
Hungarian National Gallery, Budapest

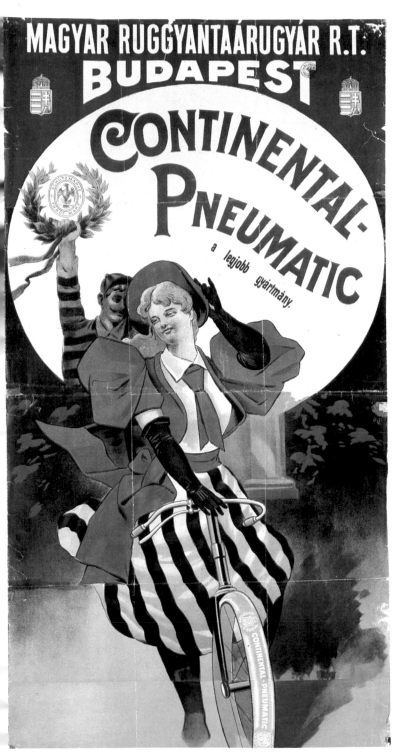

Anonymous: *Poster for Continental Pneumatic c.* 1910
120 × 63 cm
National Széchényi Library, Budapest

Ákos Tolnay: *Poster for Excelsior beer c.* 1910
187.5 × 94.5 cm
Hungarian National Gallery, Budapest

169

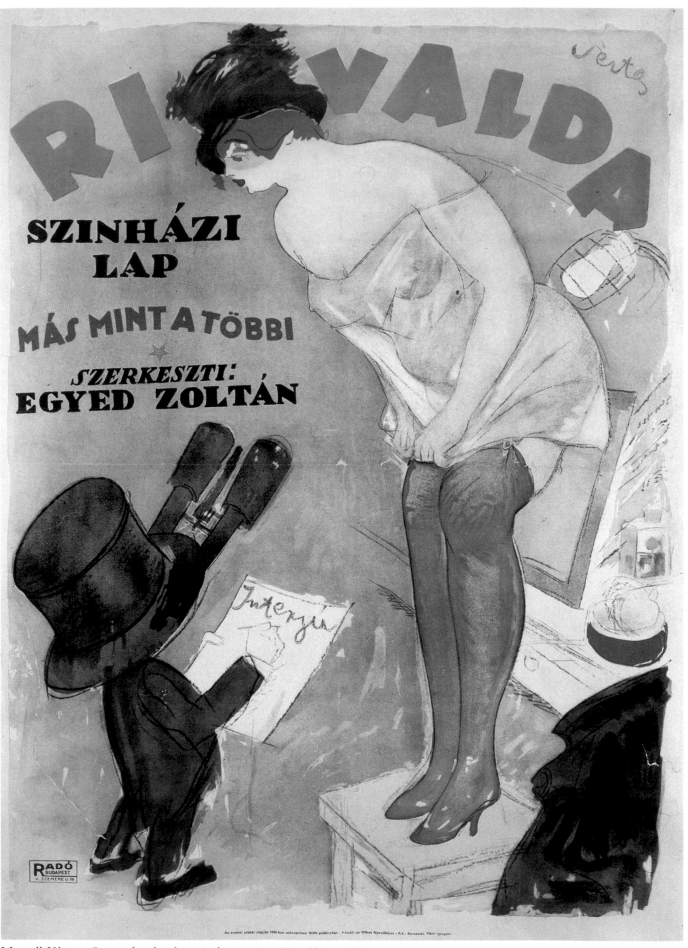

Marcell Vértes: *Poster for the theatrical magazine 'Rivalda'* c. 1910
98 × 70 cm
Hungarian National Gallery, Budapest

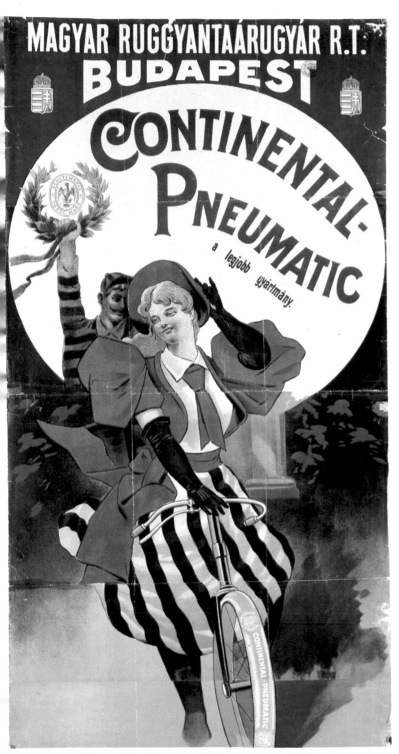

Anonymous: *Poster for Continental Pneumatic c.* 1910
120 × 63 cm
National Széchényi Library, Budapest

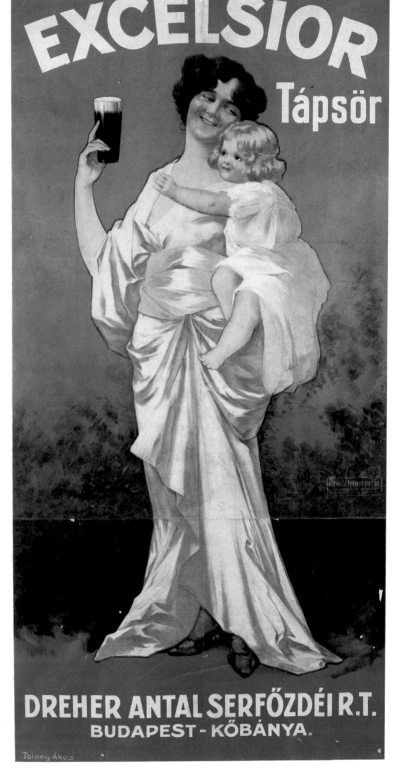

Ákos Tolnay: *Poster for Excelsior beer c.* 1910
187.5 × 94.5 cm
Hungarian National Gallery, Budapest

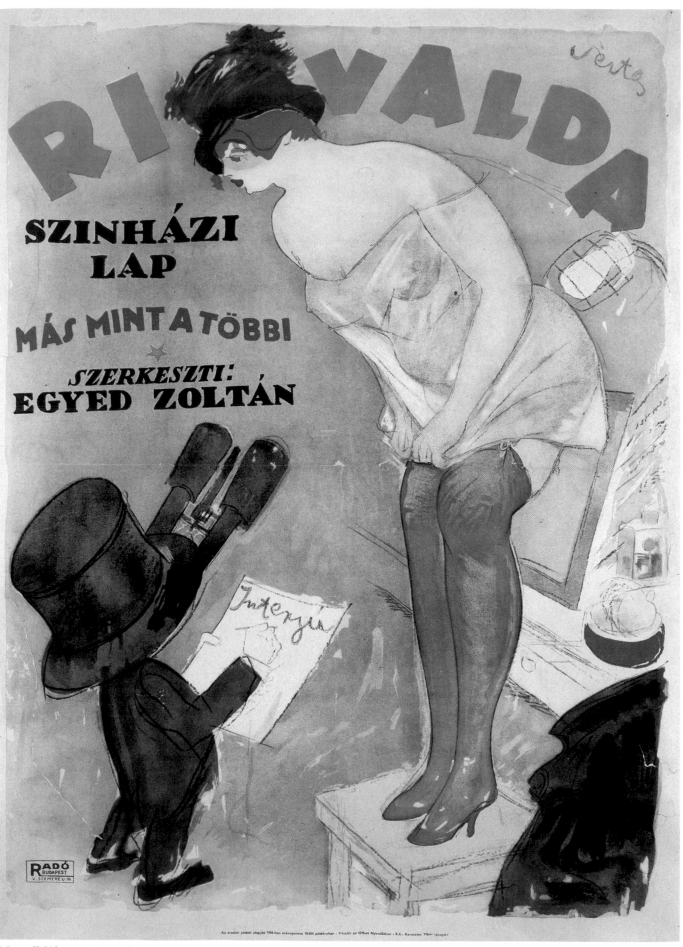

Marcell Vértes: *Poster for the theatrical magazine 'Rivalda' c.* 1910
98 × 70 cm
Hungarian National Gallery, Budapest

Gyula Tichy: *Poster for the 4th exhibition of the KÉVE group at the National Salon* 1911
95 × 63 cm
Hungarian National Gallery, Budapest

Géza Faragó: *Poster for the Holzer fashion store* 1902
21 × 96 cm
National Széchényi Library, Budapest

Greeting card for the New Year c. 1900
Private collection, Budapest

Mihály Bíró: *Poster for Tobelbad health spa, Austria c.* 1910
63 × 95 cm
Hungarian National Gallery, Budapest

Pál Horti: *Pendant and chain* 1902
Gilt silver, ceramic, pearl, 3.4 × 33 cm
Museum of Applied Arts, Budapest

Oszkár Tarján: *Comb* 1900–1901
Horn, gold and blue opal, 10.5 cm
Museum of Applied Arts, Budapest

173

Miksa Róth: *'Rising Sun'* 1900
Glass-mosaic, 171 × 76 cm
Private collection, Budapest

174

The "Hungarian Style"

In 1902, the art historian Károly Lyka published a controversial article entitled 'Art Nouveau Style–Hungarian Style', in which he attempted to draw a parallel between Art Nouveau and the aspirations towards a uniquely Hungarian art.

It is an important characteristic of Hungarian Art Nouveau that, coinciding with the struggle for the establishment of a national art, it turned its attention to folk art. In literature, the revival of folk tradition had begun half a century earlier, as can be seen in the poetry of Sándor Petőfi,* and at the turn of the century, representatives of the Hungarian style wanted to renew fine art in a similar manner.

As scientific research gathered pace, cottage industries revived in various parts of the country, mainly under aristocratic patronage. The Isabelle Cottage Industry Association, for example, was founded by the Archduchess Isabella in 1894, and its chief aim was to revive the art of embroidery. Isabella, who dressed her children in Hungarian national costume, was by no means the only such patron. Queen Elizabeth, whom the Association presented with an embroidered chasuble and altar cloth on the occasion of the Millennial celebrations, was another. Sarolta Kovalszky's carpet-weaving workshop in Alsóelemér, Torontál County (Yugoslavia), was the predecessor of the Gödöllő Weaving Workshop subsequently set up by Aladár Körösfői Kriesch. Equally important was the revival of lace techniques by Árpád Dékány, who reached public acclaim at the 1906 Milan World Exhibition where he presented the lace of Halas.

The nationalistic aspirations of Hungarian Art Nouveau architecture were first expressed by Ödön Lechner, while architects like Károly Kós, Béla Lajta, Ede Thoroczkai Wigand and Lajos

Kozma attracted European attention through their revival of Transylvanian folk tradition in architectural design.

Károly Kós did most to create a modern national architecture based on the traditions of folk architecture, specifically medieval wooden architectural structures found in Transylvania. In this, too the influence of the English Pre-Raphaelites is evident. Károly Kós also wrote several books on the architecture of Transylvania, complete with ample illustrations of his own in wich he makes clear his aim to create buildings which harmonize organically with their surroundings. The group who emulated Ödön Lechner, known as the Young Architects, also made use of the folk motifs of the art and architecture of Torockó, Körösfő and Kalotaszeg, taken partly from Malonyai's books and Kós's work circulating in manuscript form.

Ödön Lechner's pupils also designed the *fin de siècle* townscape of Szabadka (Subotica, Yugoslavia). The first building by Marcell Komor and Dezső Jakab to be built in Szabadka was a synagogue, designs for which were first entered for the Szeged synagogue competition in 1900, where they failed to win local approval. Drawing deeply on Hungarian folk motifs, this fine building also

Károly Kós: *Design for a manor house*
From *Magyar Iparművészet,* 1908

* National romanticism was essentially a phenomenon of the 1850s and 1860s and, at its height, interest in folk origins intensified, to which the music of Liszt and the architecture of Frigyes Feszl bears witness. It was only after the Austro-Hungarian Compromise, however, that folk art and music research was given any scientific basis.

175

Marcell Komor and Dezső Jakab: *Town Hall of Szabadka* (Subotica, Yugoslavia) 1907

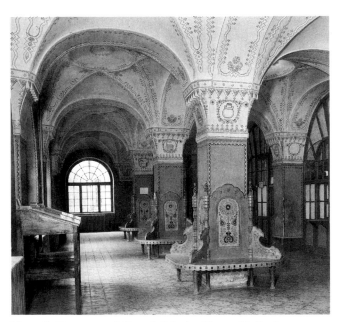

Marcell Komor and Dezső Jakab: *Town Hall of Szabadka* (Subotica, Yugoslavia) 1907
Interior

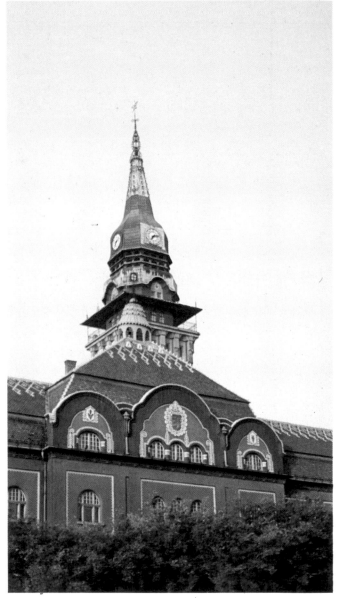

Marcell Komor and Dezső Jakab: *Town Hall of Szabadka* (Subotica, Yugoslavia) 1907
Façade

reveals an important structural innovation, whereby the dome rests on an exposed iron structure. Like Lechner, the architects employed the picturesque devices manufactured by the Zsolnay Works of Pécs.

In 1907, Komor and Jakab also designed the Town Hall of Szabadka. This building is one of the most perfect realizations of the *Gesamtkunst* essential to Art Nouveau. The two architects designed not only a building expressly suited to its function, but also every little detail, from the ceramic sculptural decoration of the exterior to the furniture and wrought-iron ornamentation, and the door-handles and chandeliers. All the decorative elements draw abundantly upon Hungarian folk art, the chief motif being the tulip, a typical Hungarian embellishment. The glass windows adorning the building were made after Sándor Nagy's and Miksa Róth's designs, in the latter's workshop.

176

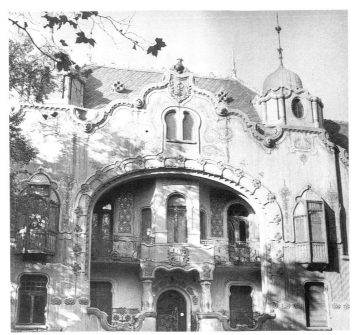

Ferenc J. Raichle: *The Raichle Palace, Szabadka*
(Subotica, Yugoslavia) 1903–1905
Façade

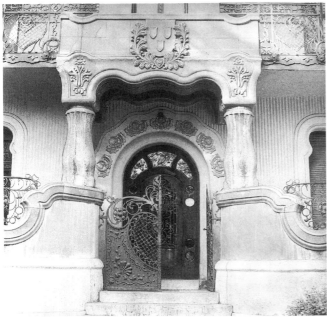

Main entrance

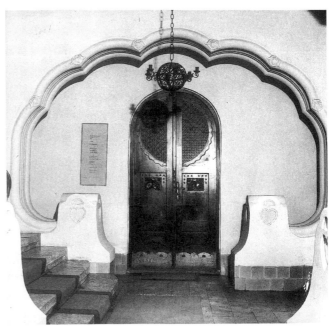

Interior

The Raichle Palace (1903–1905) is another fascinating building of the town. Designed by Ferenc J. Raichle, most of whose work was carried out in the Vajdaság region in today's Yugoslavia, it was influenced by Lechner, but with a façade of such playful inventiveness and extravagance that it has a character all its own.

Komor and Jakab were responsible for one of the other major examples of contemporary *Gesamtkunst,* the Palace of Culture in Marosvásárhely (Tirgu Mureş, Rumania), finished in 1910, which is recognized as one of the greatest achievements of Hungarian Art Nouveau architecture. The external and internal decoration of the building were shaped in the spirit of Gödöllő. Its iconographical programme was to present the major events of Hungarian history and the life of the Hungarian people. The decorations, mosaics,

177

frescoes, seccoes and wrought-iron adornment were all coordinated, and the quality of the windows in the Hall of Mirrors is particularly fine. These were designed by Sándor Nagy using the theme of three folk ballads–'Kata Kádár', 'Lovely Sára Salamon', and 'The Beautiful Maiden Julia'–and by Edc Thoroczkai Wigand, who took his subject from the legends of Attila the Hun. The making of the windows was entrusted to Miksa Róth's workshop.

The association of Transylvanian folk art with

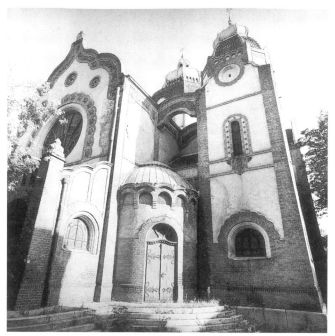

Marcell Komor and Dezső Jakab: *The synagogue of Szabadka* (Subotica, Yugoslavia) 1901–1903. Façade

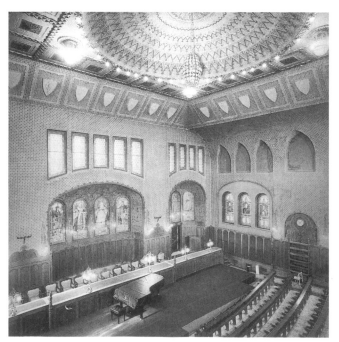

Marcell Komor and Dezső Jakab: *The synagogue of Szabadka* (Subotica, Yugoslavia) 1901–1903. Interior

the Hun–Magyar cycle of legends can be seen in *Gyöngyvér* (1905), a pastel by Sándor Nagy, which depicts the wife of Buda, Attila's brother, in Transylvanian costume. The Gödöllő artists collected most of the material for Dezső Malonyai's five volume study, *The Art of the Hungarian People,* and their pioneering work in Hungarian ethnography was to enrich their own art. They began collecting in 1904, and this was to influence many works, such as *The Cemetery of Magyarvalkó* (1908), an etching by Sándor Nagy inspired by Transylvanian timber architecture, cemetery art and various forms of wooden headboards; *Matyó Peasants* (1908), a lithograph by István Zichy; and *Young Girl of the Hódság* (1910), a delightfully ethereal ink drawing by Rezső Mihály. Another example is a series of frescoes by the Gödöllő master Mariska Undi in the People's Hotel *(Népszálló)*. This presents the Magyar people's ancient occupations in the various regions of the country and is a valuable catalogue of themes from folk ornaments.

This exhaustive gathering of folk material also influenced the activities of the Gödöllő weaving workshop, which produced two types of carpet. One employed geometrical forms drawn from folk art–Körösfői's *Women of Kalotaszeg* (1908) is a good example–the other was the so-called 'story rug' which took its themes from popular Hungarian myths and legends. An interesting example of this type is a tapestry, again by Körösfői, entitled *Puppet Theatre* (*c*. 1907), which commemorates a performance of the popular folk tale 'László Vitéz'.

The weavers' workshop at Gödöllő was renowned, both at home and abroad, for the excellence of its designs and its technical expertise. Rather than use artificial colourings, they employed purely vegetable dyes in the manner of William Morris's studio. Their carpets won numerous international prizes, and were the finest representatives of the revival in Hungarian applied arts. The workshop also accepted commissions from other leading Hungarian artists; Vaszary's textiles depicting the life of the Hungarian people were manufactured here. In these, the colourful decorative character of Art Nouveau and Vaszary's more realistic approach are happily combined.

But it was not only the Gödöllő artists who drank from the 'pure fount' of folk art. István Csók, who was initially part of the Nagybánya Colony, also enjoyed the richness of colour he

178

discovered in the Hungarian and Sokác (Slavonic) traditions. Even in his Paris period, Csók showed a fascination with the formal solutions found in folk art. The design of a traditional piece of Hungarian furniture, a dowry chest painted with tulips, the precise pattern and significance of which varied from region to region, led him to experiment with a form of painting which is amazingly ornamental in conception and unusually flat in composition (*Tulip Chest*, 1910).

The poet, painter and applied artist Anna Lesznai developed an art and style which owe much in inspiration to the art of the small Slovak-populated town of Körtvélyes. This is especially evident in the rich floral ornamentation of her embroidery designs. Her stories, too, and the colourful fairy tale world of the accompanying illustrations such as *The Wandering of the Little Blue Butterfly in Fairyland,* published in 1918, were much admired. These also resemble Hungarian folk tales in which fairies are very much like ordinary people, and Fairyland is always just around the corner.

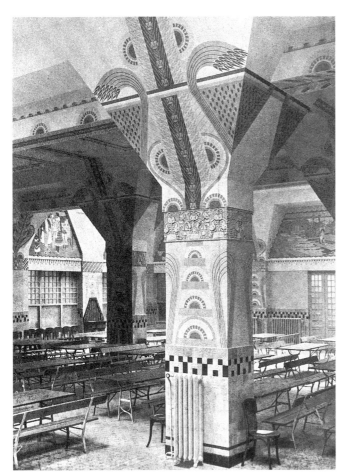

Lajos Schodits and Béla Eberling: *Restaurant of the Népszálló* Budapest 1912
From *Magyar Iparművészet,* 1912

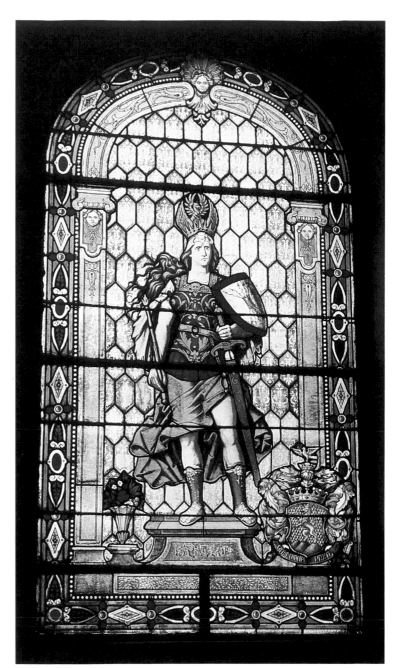

Sándor Nagy: *'Might'.* Glass window made by Miksa Róth for the Hall of Mirrors, Town Hall, Szabadka (Subotica, Yugoslavia) 1907

As we have seen, the discovery of folk art not only launched the autonomous discipline of ethnography, it also breathed new life into the art of the early twentieth century. In reviewing the importance of scholarship on folk art, Aladár Körösfői Kriesch wrote in 1908, *'The art of the Hungarian people, like all true art, is a fully organic part of the life of the people. It is called primitive because it is innocent of falsehood and opportunism... Our responsibility now is to preserve its individual and ancient forms before they disappear, and to adapt them so that they might benefit a new, more modern stage of cultural development.'*

179

Lajos Kozma: *Design for a window of the hall of*
'Lapis Refugii', a fantasy house. From *Magyar Iparművészet*

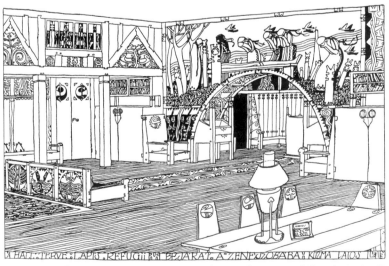

Lajos Kozma: Entrance to the music room of 'Lapis Refugii'

Lajos Kozma: The studio of 'Lapis Refugii'

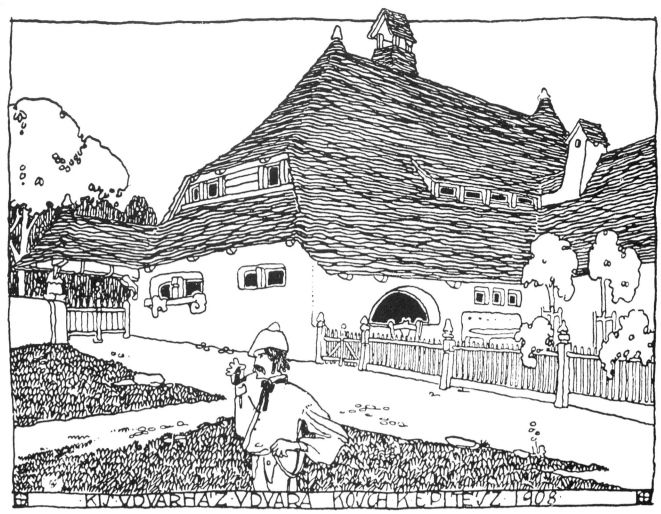

Károly Kós: *Yard of manor house*
From *Magyar Iparművészet*, 1908

Károly Kós: *Studio I*
From *Magyar Iparművészet*, 1908

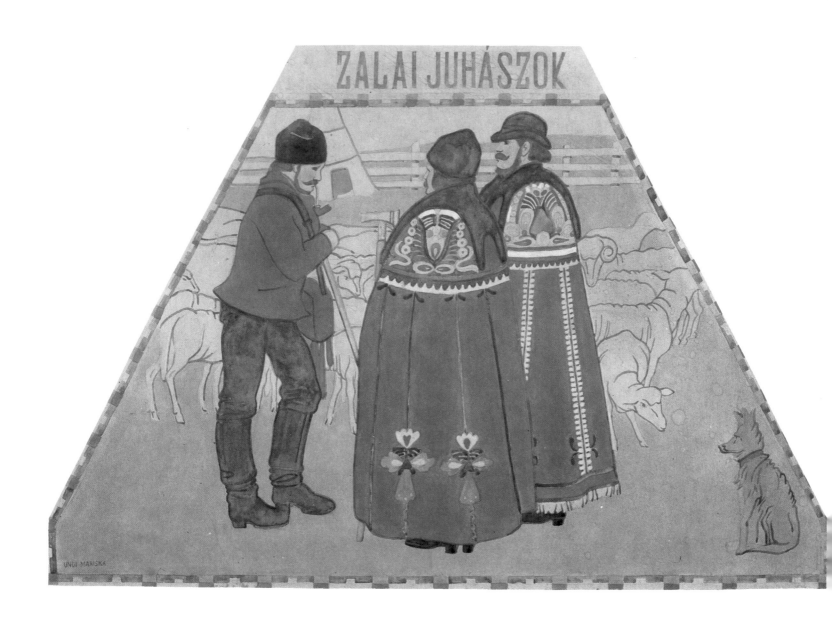

Mariska Undi: *Country Shepherd.* Study for the fresco of
the *Népszálló* 1911
Pencil and watercolour on paper, 48.3 × 60 cm
Hungarian National Gallery, Budapest

Ede Thoroczkai Wigand: *Gate of the Grand Lord* 1912
Sketch for the glass window of the Hall of Mirrors of the
Culture Palace of Marosvásárhely (Tirgu Mureş, Rumania)
Tempera on cardboard, 199 × 156 cm
Private collection, Budapest

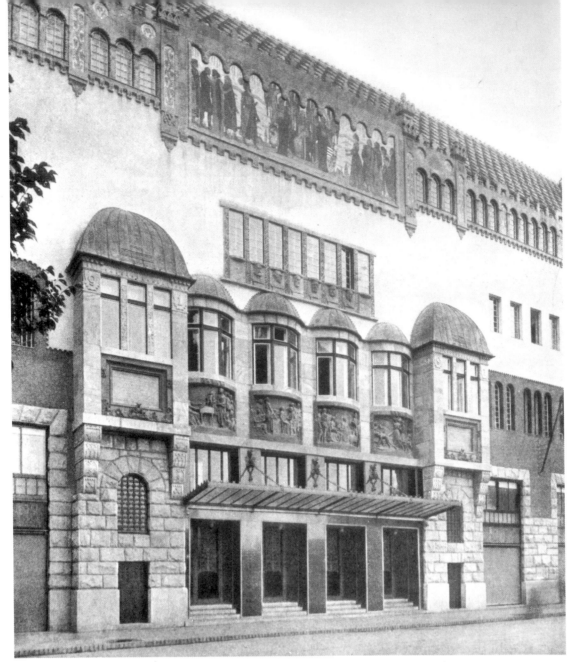

Marcell Komor
and Dezső Jakab:
*Culture Palace,
Marosvásárhely*
(Tirgu Mureş,
Rumania) 1910
Main façade

Marcell Komor and Dezső Jakab: *Culture Palace,
Marosvásárhely* 1910
Lobby with frescoes by Aladár Körösfői Kriesh

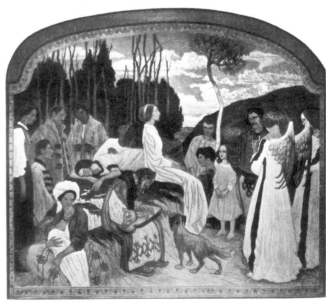

Aladár Körösfői Kriesch: *Székely Folk-tale* 1910
Fresco in the Culture Palace, Marosvásárhely

184

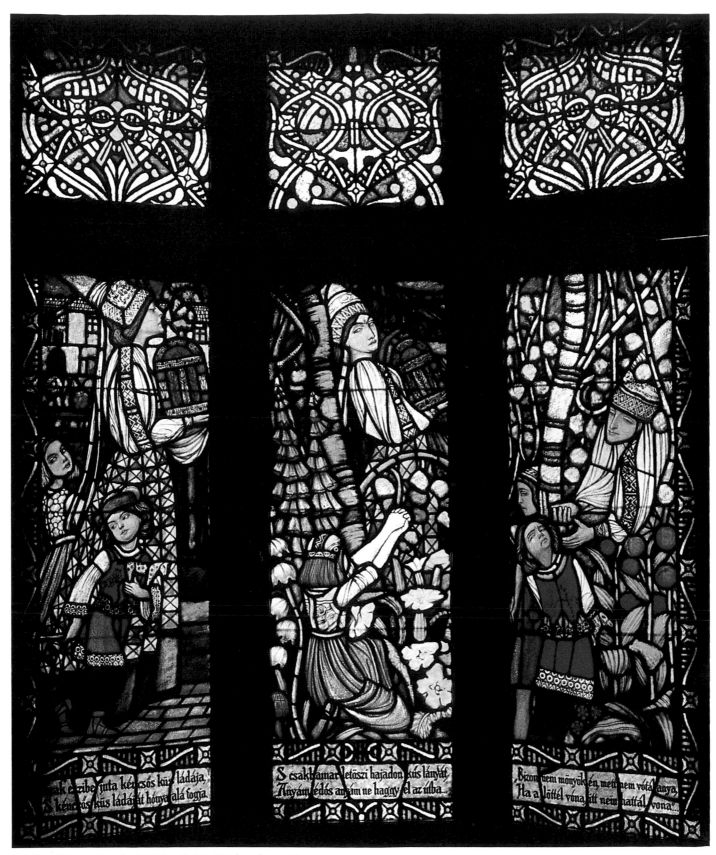

Sándor Nagy: *Lovely Maiden Julia*. Design for a glass
window of the Hall of Mirrors, Culture Palace, Maros-
vásárhely 1913

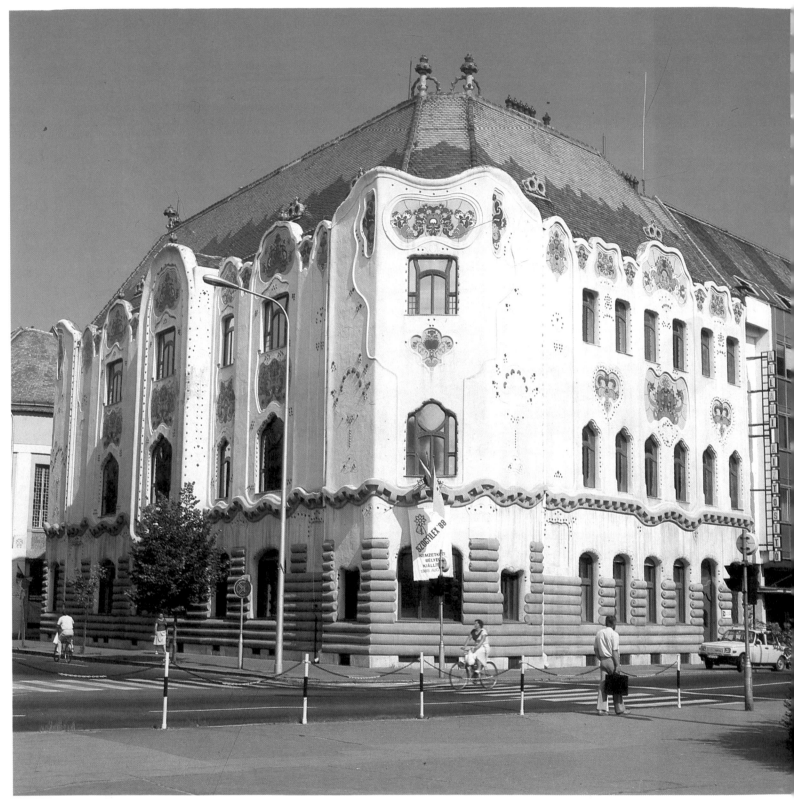

Géza Márkus: *The Cifrapalota* (Fancy Palace)
Kecskemét 1902

186

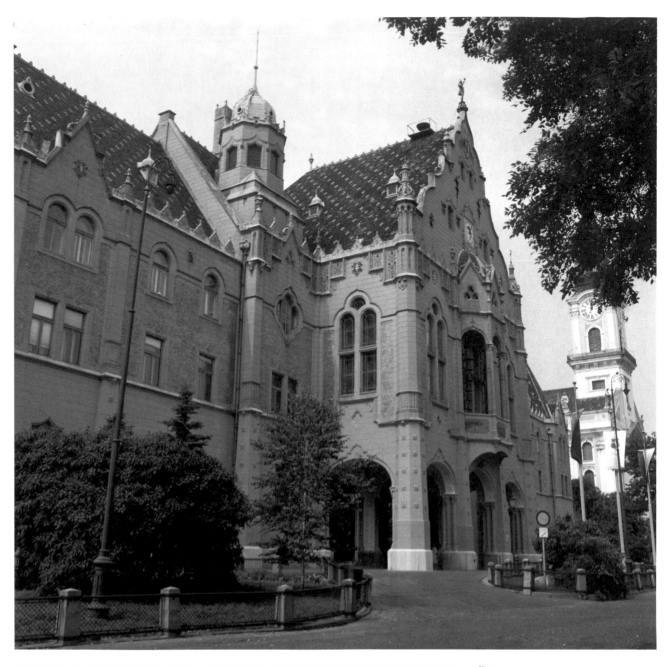

Ödön Lechner:
Town hall of Kecskemét
1893–1897
Main façade

Ödön Lechner:
Town hall of Kecskemét
1893–1897
The lobby

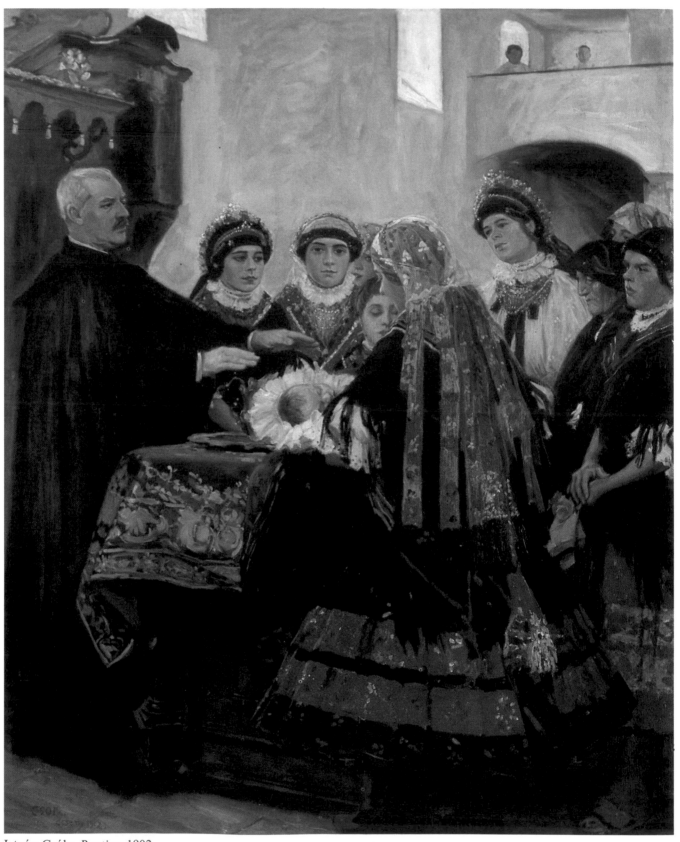

István Csók: *Baptism* 1902
Oil on canvas, 163 × 134 cm
Hungarian National Gallery, Budapest

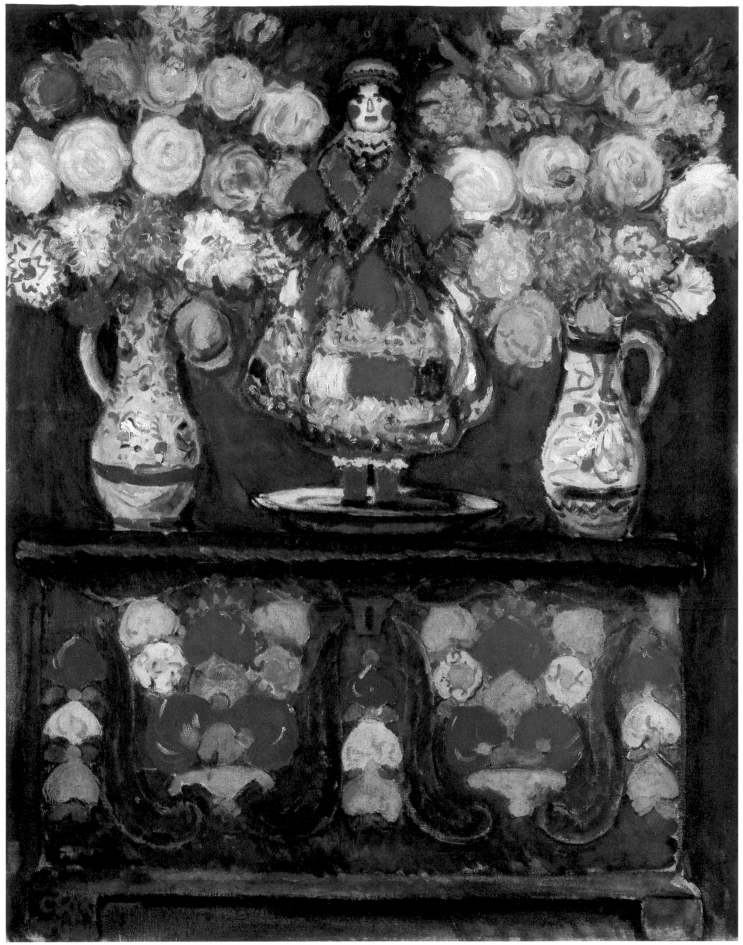

István Csók: *Tulip Chest* 1910
Oil on cardboard, 120 × 94 cm
Hungarian National Gallery, Budapest

Anna Lesznai: *Autumn Garden. Illustration to
'The Wanderings of the Little Blue Butterfly in Fairyland'*
Anilin and India ink on paper, 35.8 × 25.8 cm
Hungarian National Gallery, Budapest

Rezső Mihály:
Young Girl of the Hódság 1910
Coloured India ink on paper,
27.3 × 17.5 cm
Private collection, Budapest

190

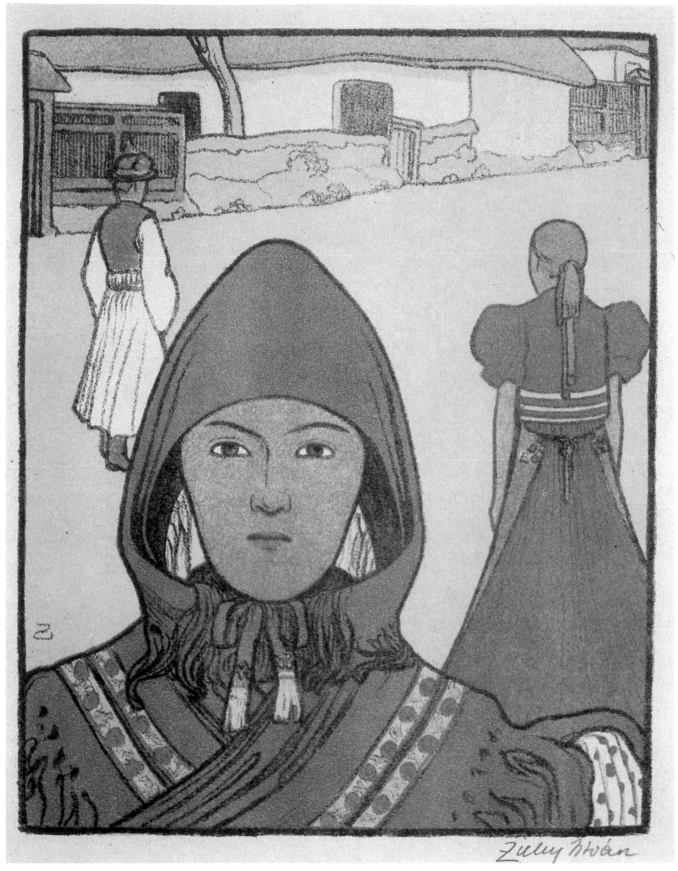

István Zichy: *Matyó Peasants* 1908
Lithograph on paper, 23.5 × 18.5 cm
Hungarian National Gallery, Budapest

191

Sándor Nagy: *The Cemetery of Magyarvalkó* 1908
Etching on paper, 22 × 140 cm
Hungarian National Gallery, Budapest

192

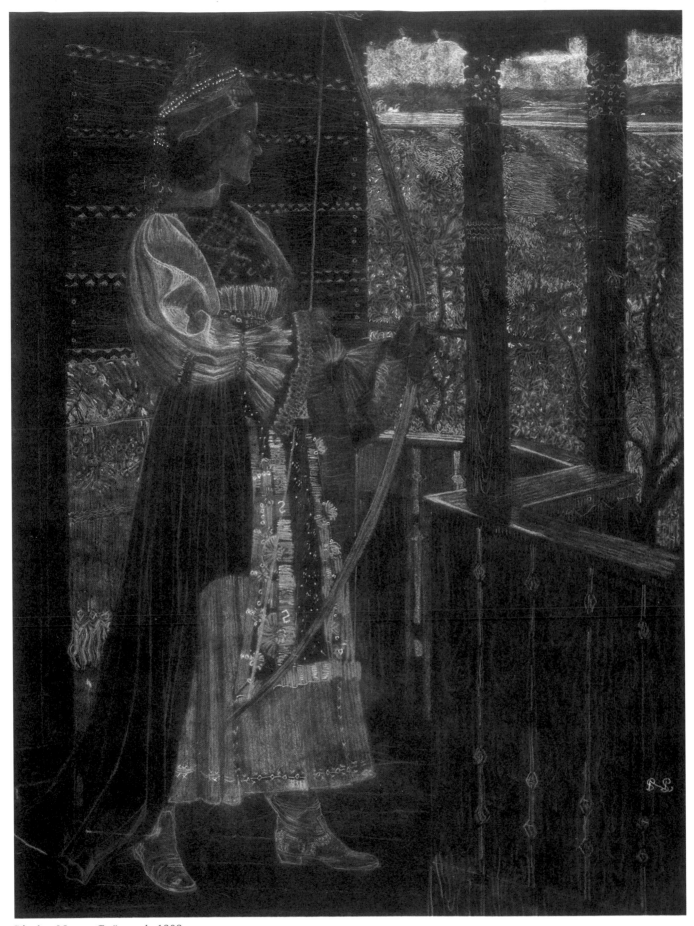

Sándor Nagy: *Gyöngyvér* 1909
Pastel on paper, 54 × 41 cm
Hungarian National Gallery, Budapest

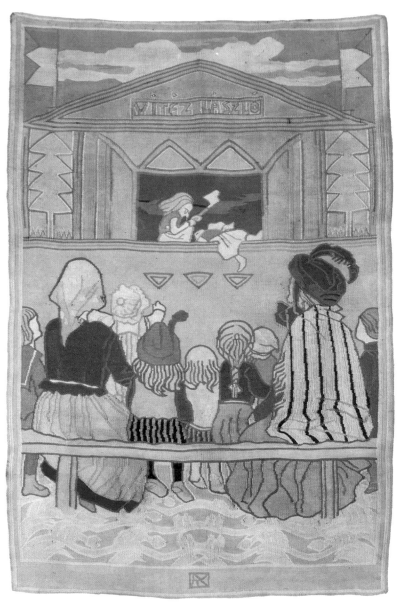

Aladár Körösfői Kriesch: *Puppet Theatre c.* 1907
Tapestry, 150 × 100 cm
Private collection, Budapest

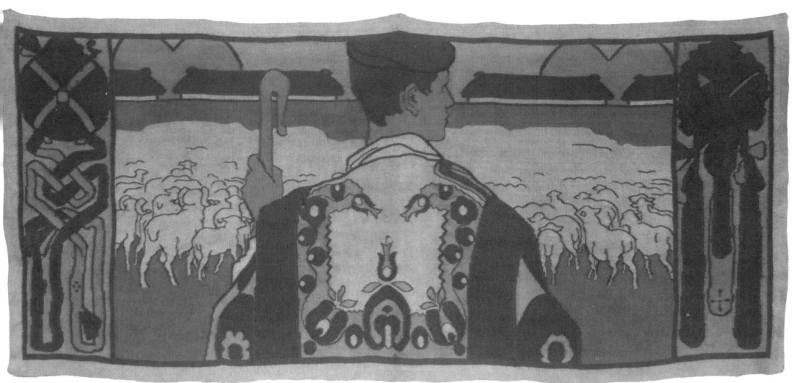

János Vaszary: *The Shepherd* 1906
Tapestry, 70 × 146 cm
Ferenc Móra Museum, Szeged

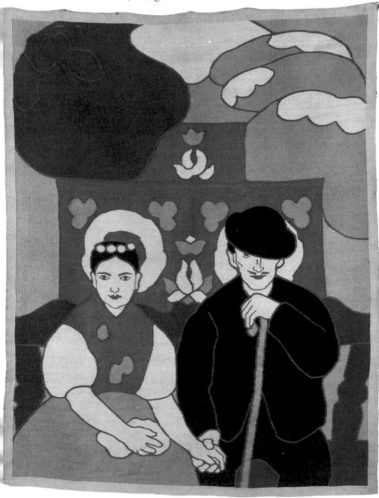

János Vaszary: *Engaged Couple* 1905
Tapestry, 152 × 116 cm
Museum of Applied Arts, Budapest

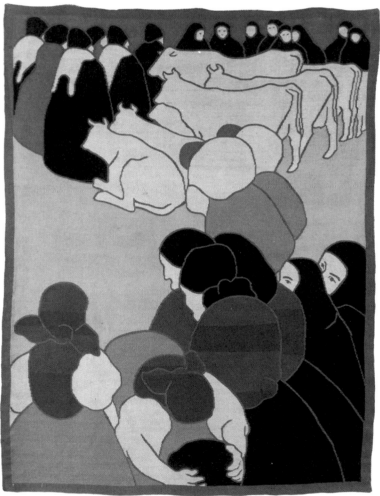

János Vaszary: *Fair* 1905
Tapestry, 152 × 116 cm
Museum of Applied Arts, Budapest

Index of Artists

(Numbers in italics refer to illustrations)

197

Printed in Hungary by Kossuth Printing House, Budapest